British Design & Art Direction
in collaboration with Rotovision SA

The Graphics Book

RotoVision

Editor
Jane Austin

D&AD Project Team
John Green
Marcelle Johnson
Jo Maude
Kathryn Patten

Book Design
NB:Studio

D&AD would like to thank
Premier Paper for their support.

We would also like to thank all
the contributors who so generously
gave their time.

Published by RotoVision SA
Rue de Bugnon 7
CH-1299 Crans-Près-Céligny
Switzerland

RotoVision SA
Sales & Production Office
Sheridan House
112/116A Western Road
Hove, East Sussex
BN3 1DD, UK

Tel: +44 (0) 1273 72 72 68
Fax: +44 (0) 1273 72 72 69
E-mail: sales@rotovision.com

First published 2002
Copyright © British Design
& Art Direction 2002
A D&AD Mastercraft Series
publication

Production and separation in
Singapore by ProVision Pte Ltd
Tel: +65 6334 7720
Fax: +65 6334 7721

Printed in Singapore.
All rights reserved.

ISBN No. 2-88046-550-8

Paper so often goes unnoticed for its qualities. Well, it's just paper isn't it?

This graphics book, for instance, is printed on Clarity 150gsm. But who'd notice? Who cares?

Graphic designers do. Every time they work their talents on paper, they pay attention to the part the paper will play in their finished effect. They see the paper as part of their design. They think about it, like we do.

They take what is essentially a plain, pale substrate and make it throb, sell, convince, persuade, and amaze. So of course, especially with a book like this, you don't notice the paper. You are looking – I hope sometimes in awe – at what's printed on it.

Graphic designers bring our paper – art or silk, thick or thin, recycled or virgin fibre – alive. That's why Premier supports design student education and so many D&AD events and publications like this one.

premierpaper

**Alan
Browne**
Communications
Director

Contents

This book is
dedicated with love
and affection to
John Gorham who
reminded us how
simple our business
really is

Foreword

by
David Stuart
D&AD
President
2001

I wish the idea for this wonderful book had been mine. I wish I could tell you that, on ascending to the D&AD presidency, my first decree had been to order the production of a sweeping documentary survey of the state of graphic design around the world, viewed through the eyes of the discipline's most eminent practitioners. But sadly, it wouldn't be true. This project was on the stocks long before my brief moment in the D&AD spotlight began. And the idea for the Mastercraft series goes back even further.

But then, that's ideas for you. Slippery, intractable customers – never turning up at the right time; always popping into other people's heads, instead of yours. The perplexing question this raises, of course, is why they pop into some heads so much more frequently than others. By allowing us to rummage around in the cerebral space of some of the people who have more good ideas than just about anyone in our business, this book may provide at least a partial answer.

And there's another thing about ideas that this book demonstrates rather well. How a good one can become a really, really good one when it's given a twist. For me, asking each of the grizzled graphics greats featured in the following pages to nominate a fresh-faced one-to-watch was a stroke of inspiration – showing us, close up, how each creative generation learns from the one before and influences the one that follows.

Introduction
by
Jane Austin
Editor

Graphic design is, at best, a visually pleasing and succinct encapsulation of a message, missive or an idea. A visual interpretation that will add power and resonance to a message whether it is for a blue-chip client or an organisation with a political or cultural agenda. This shouldn't change, although contemporary graphic designers are constantly being challenged as to how design is technically realised, and indeed, the very definition of graphic design itself.

The 90s saw a fundamental shift in how designers and clients dealt with the wholesale adoption of computers. Design practitioners were, and still are, further challenged by the definition and boundaries of graphics. Due to the fragmentation of media and the development of instantaneous electronic communications, the discipline has been stretched and developed to incorporate technological demands.

Due to technology designers have taken on board more of the production and typesetting tasks. This can be taken in two ways: from a negative point of view it leaves less time for the designer to focus on creativity. However, from a positive slant it allows the designer more control to push technology to the limits. This is one of the reasons why this book focuses on designers who are presently working, as they have seen their remit as graphic designers changed and challenged by technological innovation.

Going back even further, the last 20 years has seen design practice evolve in the business sense to establish codes of working practice and to launch industry bodies. While awards schemes have helped to raise the bar of creative standards, many of the designers interviewed for this book remain sceptical regarding the cultural value of some paid-for awards.

In line with this maturation, design education has developed and diversified to become more responsible, although the subject itself is still largely ignored in pre-art education. The majority of designers featured are largely against more business being taught in art schools, the overall consensus being that time should be reserved for pure design training. If anything, many of the designers featured argue that there should be more emphasis on design history and the heritage of design-related crafts.

A more democratic government in Britain over the last four years has offered designers and design educators more recognition and respect than the previous administration. When New Labour first came to power, it launched a series of initiatives and consultations between industry and designers to forge relationships in order to gain a better and more beneficial understanding of how the two disciplines could work together more effectively.

'The Graphics Book' is the fifth title in the D&AD Mastercraft Series. In the pages that follow, you will discover how some of the world's leading contemporary designers deal with the previous points, and successfully produce extraordinary design solutions that are not only accountable, but challenge design agendas, winning them the admiration of their peers.

The book was compiled with incredible difficulty and sensitivity. While D&AD recognised the need for a text which encapsulated the spirit and work of globally respected designers, the main issue that faced the organisation was how to select the designers for inclusion. The last thing D&AD wanted was a book containing a selection of 'the greats', all of whom had been written about numerous times before, this naturally would have ended up as a nice coffee table book. Also, have you ever tried to justify exactly who the world's top graphic designers are?

D&AD felt that publishing a volume that purely reflects the state of British or US graphics was too parochial and would fail the organisation's international remit. The solution came from Lynda Relph-Knight, the editor of *Design Week* magazine. Relph-Knight suggested the idea of asking an experienced designer to nominate his or her favourite designer with approximately 10–15 years' experience, working anywhere in the world. The list of nominators was culled from awards annuals, designers, magazine editors and museum archives.

Our collective aim for this book was that it gets dipped into as a reference source and used repeatedly, hence the rather clever Post-It theme created by NB:Studio. Each of the featured designers talks revealingly, and sometimes humorously and poignantly about their designs and the way they work, their influences, and their hopes for their futures. The text is in their language, rather than an academic tone in order for the reader to relate more directly to the content.

I see 'The Graphics Book' as an encapsulation of the spirit of the moment, which celebrates both corporate creativity and those that break the rules. The profiles of the designers serve as a valuable record of contemporary design. They shed light on the technical, cultural, political and fiscal agendas that face many designers today. The book also suggests how to deal with new challenges such as the blurring of the boundaries between all creative disciplines – sound design, film titles, animation and integrated media.

I would like to say a special thank-you to John Green at D&AD for his support and sense of fun. Thanks also to the boys at NB:Studio, now I understand the male psyche. Love to Laura and Liam.

A big kiss goes to my daughter Jess who patiently sat by my side at our home in London reading her bedtime stories as I interviewed non-UK designers on the phone at night. And lots of love to my Kushti partner Liz Vater – long may it last.

P.T.O.

"As a teenager I was interested in both art and solving problems. I would have liked to become a doctor, but by becoming a designer I encompassed both aspects.

I studied Graphic Design at St Martin's from 1979 until 1982. I was more interested in ways of working as I didn't really have anything desperate to say. What fascinated me was the tension between graphic design and solutions. St Martin's gave me no business experience but it taught me how to think.

After I left college I got a job at Island Records where I stayed for eight years designing sleeves. I really enjoyed working for the owner Chris Blackwell and consequently believed that all clients were lovely. It was very open and free and good for someone who wasn't that great with type.

My partner Anthony Michael sat next to me at St Martin's. We always wanted to work together and while I was at Island he worked as a gardener while slowly building up design work. Our first client was the record label Circa, we used to design reggae sleeves for £20. As Circa grew we designed for artists such as Neneh Cherry and Massive Attack. Then we were introduced to Jasper Conran's PR, which led to us taking on fashion work. We have an agent now, but we can track back every client we've had to a particular person.

Formally, we started the company in 1986 but informally we started from college. Our specialisms are music, fashion, packaging, retail and brand identity. Our main ambition when we launched the company was to eat and not have to work in a shop as well to support ourselves.

Our work aim is to stretch our minds. It is such a steep learning curve in design until you are in your thirties and then it declines. This is possibly why designers' work gets stereotyped, or they go off on an art trip which is one of my bug-bears – there's nothing wrong with being a commercial designer. We are constantly looking for something new and have no preconceived ideas.

People describe our work as commercially arty. I would say that we have an aesthetic – a combination of aesthetics and ideas – but we definitely don't have a style.

I've always fought with trends because they come and go, and this is the reason why I have chosen Alan Aboud. What I like about his work is that it is very fresh, never gimmicky, and never unsubtle. His work for Paul Smith is right for the brand because it really stands out and it isn't obvious."

Stephanie Nash
designer
Michael Nash

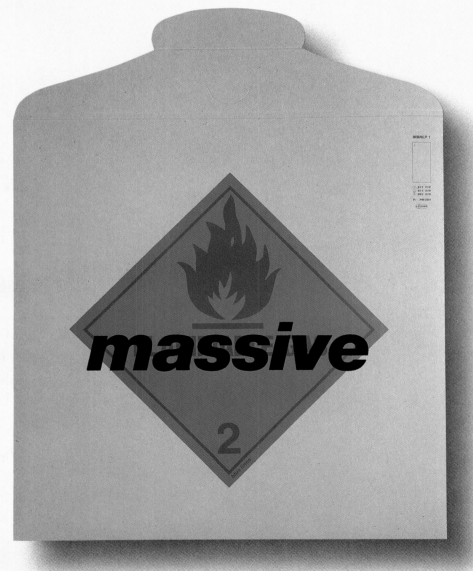

Massive Attack Protection CD

**Alan
Aboud**
designer
art director
Aboud
Sodano

"I became interested in graphic design while living in my native Dublin. I admired a designer called Steve Averill who, among other things, created the U2 visual identity, and I really liked Malcolm Garrett's work. So I became interested in the discipline through reference.

I went to the National College of Art and Design in Dublin, for two years. Recognising that I would have become brain-dead if I stayed in Dublin at this college, I moved to London in 1986 to study graphic design at St Martin's School of Art. While I was studying I worked on placements with Averill and Garrett – I'd had the opportunity to work with my heroes so I just formulated what I wanted to do from there. And at the time that was typography. Inspiration now comes from travelling, seeing different cultures and secretly enjoying my children's fascination with Batman and Robin. I like historical figures in graphic design, such as Brodovitch or

Paul Rand. But I am not a tricksy designer who must have everything in lower case.

My business partner Sandro Sodano was at college with me although we never worked together on projects then. We graduated in 1989 and were pretty much unemployable – none of us wanted to work for a design group as we all wanted to do our own thing. We were very idealistic. Also a recession had just begun.

A representative from Paul Smith came to our degree show looking for freelance designers and bizarrely enough they short-listed me and five college friends for the same job. I was hired to design for them two days a week. My main interest at college was typography and in my final year most of my work was black and white and minimal. Bizarrely, Paul Smith's designs, at that time, consisted of lots of vibrant colours, so it was very brave of them to give the work to me. I also

knew nothing about fashion so I found it a big learning curve. I worked above one of the shops and they gave me my own design space so that I could do my freelance from there; I worked for *Blueprint* magazine the rest of the week.

A friend of ours asked us to design the flotation documents for a company called Eidos. Sandro took the photographs and we designed it together. As a consequence of this job, we took office space late in 1989 and started to work for ourselves. Then it suddenly happened. We needed a photographer for some Paul Smith work, so Sandro did it and his career took off from there.

At St Martin's there was no business training, which is fair enough as you are so bogged down by business if you spend the rest of your life in design. If we had studied business at college we would have never got a creative project out. So we learnt

Guinness Ireland Campaign 1998
A six-image campaign which was worked on for approximately one year. Sandro Sodano photographed the original black and white imagery (Guinness supplied its own barman for the shoot, who exclusively works for them on advertising). Aboud Sodano replaced the dot screen with tiny pints to create an image out of other images

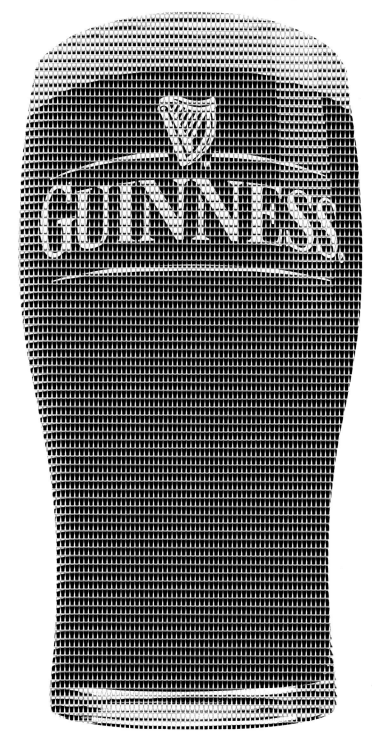

about business by letting some of our clients take us for a ride and not paying us.

We didn't really have an aim when we set the company up; we just wanted to be famous. We were really good at self-promotion when we were younger. We straddle advertising and design, so people don't really know how to pigeonhole us. This has never been detrimental to us as the best thing to do is to stay firm to your beliefs.

Aboud Sodano has always been a very fluid outfit. Sandro and I have a partnership but we have separate bank accounts so we don't infringe on each other. Although we do a lot of work together we still collaborate with other art directors and photographers. For the first time, we are doing the mainline campaign for Paul Smith, which is quite a milestone.

Currently I am doing a lot more fashion work, involving pulling a team together of the right photographer, the right stylist, the right model, the right location, the right clothes – and making sure that the images come back looking good. I still have my pipe dream of doing moving-image work – I've already done ads and films for Paul Smith, Rover and acted as a consultant for the Levi's Engineered Jeans campaign. I want to excel in fashion and become recognised as a good fashion art director as opposed to an OK designer.

We have a weird mix of clients. We've worked for film companies, a florist that manufactures artificial flowers, PR companies, record companies and a firm of media lawyers.

Most of our work comes in via word of mouth, but we have an agent that represents us. Izzy King started representing us about four years ago and basically handles all of our productions, she takes a lot of pressure off, gets the work in and handles the budget, like a producer. I don't think that our work is recognisable as art – we adapt to the client. If anything our work is really simple and it is not intentional as we start out with the busiest things and then make it as simple as possible.

Ninety-nine per cent of our work is print. I'm slowly, but kicking and screaming, coming around to the web, I hate it with a passion because I think it's so dull. Not everyone has broadband access; it's time-consuming and breaks down a lot.

Currently Sandro and I are looking at ways to move our work on. We've just published a book of our work called 'The End'. It's a symbolic full stop to the work we have produced so far, and a recognition that we want to move on. Consultancy is a way forward because you learn so much throughout your career that you can point out the most elementary things to some clients and they will think it is outstanding. In ten years time, I would like to think that we would still be going. I never want to get any bigger but we'll hopefully be doing different things. I don't want to be 85 and looking for freelance work."

Paul Smith Parfums 2000
A year-long project for Inter Parfums, Paris. Aboud Sodano worked very closely with Sophie Hicks, the bottle designer, and Paul Smith. One of the design objectives was to display the edge of the bottle in an eye-catching way. The pink and green colourways have helped to form an integral part of the Paul Smith wholesale corporate identity

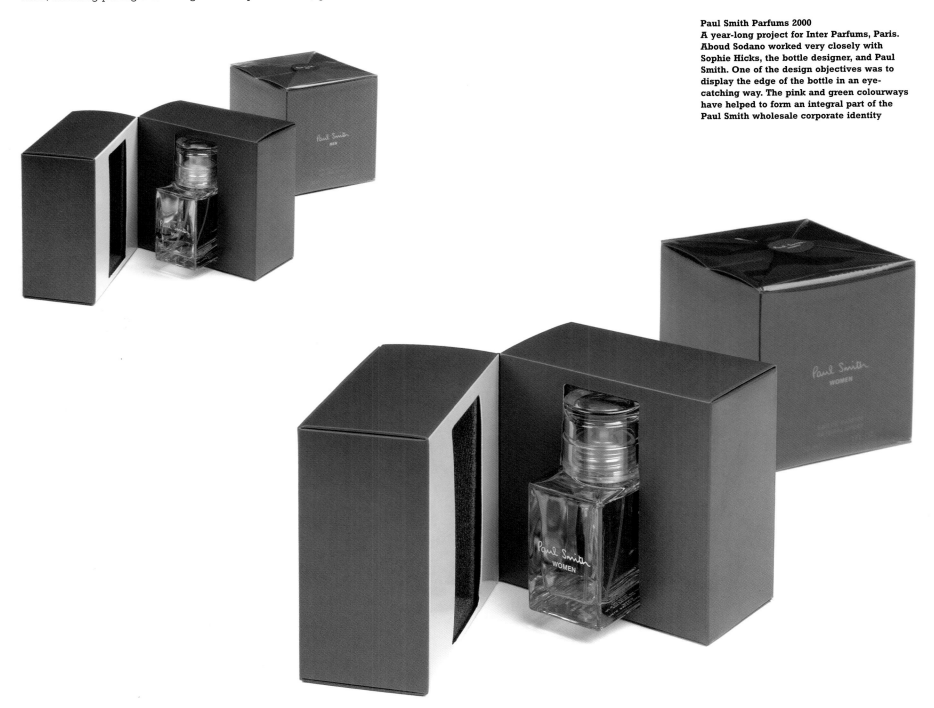

Left & below left **R. Newbold, A Division of Paul Smith 1997**
This preceded the Guinness project. A designer from the Royal College freelanced on this project and worked out a technique that turned the CMYK dots into letterforms. Sodano took the photographs. It won a Silver Pencil for image manipulation at D&AD. The freelancer subsequently got into a physical fight with both Aboud and Sodano at the awards ceremony, despite having been fully credited, and the actual award had to be used as a defensive weapon. There are marks to prove it

Below **Paul Smith Bag 1999**
Photographed by Sodano, the final solution required no post production except for some fishing line deletions. Using a series of double exposures, Aboud Sodano shot models in position with the bags suspended in front of them, mimicking the position that they would be in if actually on their body

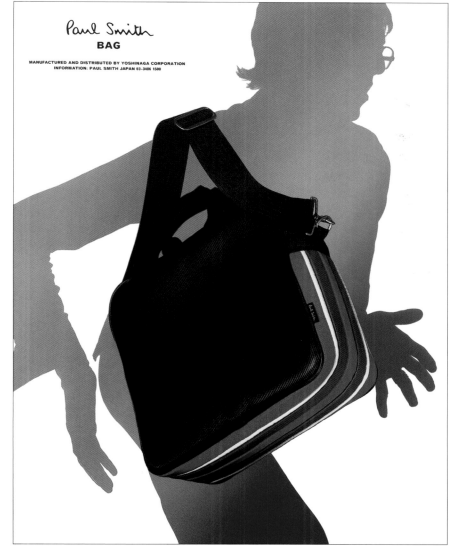

Below **Father + Son Violette Editions 2001**
While researching a book about Paul Smith
with Smith and Robert Violette, Aboud
Sodano discovered a box of images that
Smith's father had taken when he was alive.
Smith too is a keen photographer, so the
designers thought that it would be a fitting
tribute to Smith's father to produce a small
book consisting of images by both of them.
The book folds open and two individual
books appear within

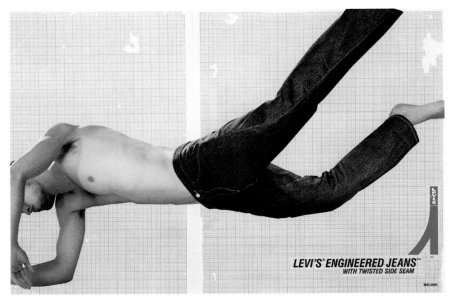

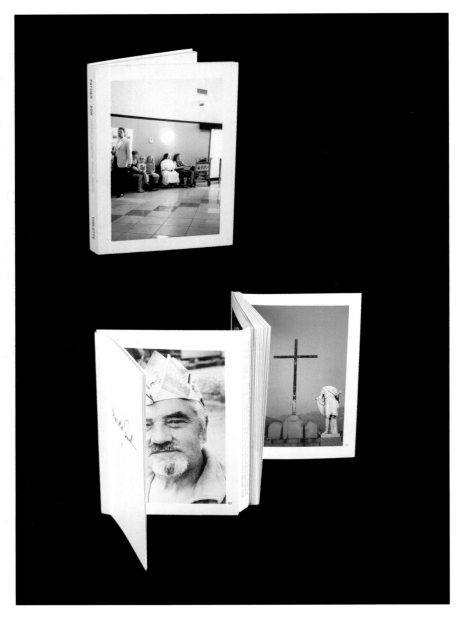

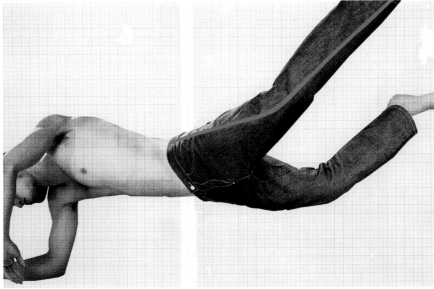

Above **Levi's Engineered Jeans 2000**
Aboud had been involved in the creation
of this line with Caroline Parent, creative
director of Levi Strauss. Subsequently he
worked with ad agency Bartle Bogle Hegarty
on the ensuing ad campaigns. Shot by Matt
and Marcus, it simply reveals the ergonomics
of the product

Opposite **Paul Smith Collection 1998**
This collection is a Japan-only line. Shot by
Hugh Hales-Tooke, this brochure was themed
'DIY'. Several of the images featured show
simple DIY acts going wrong

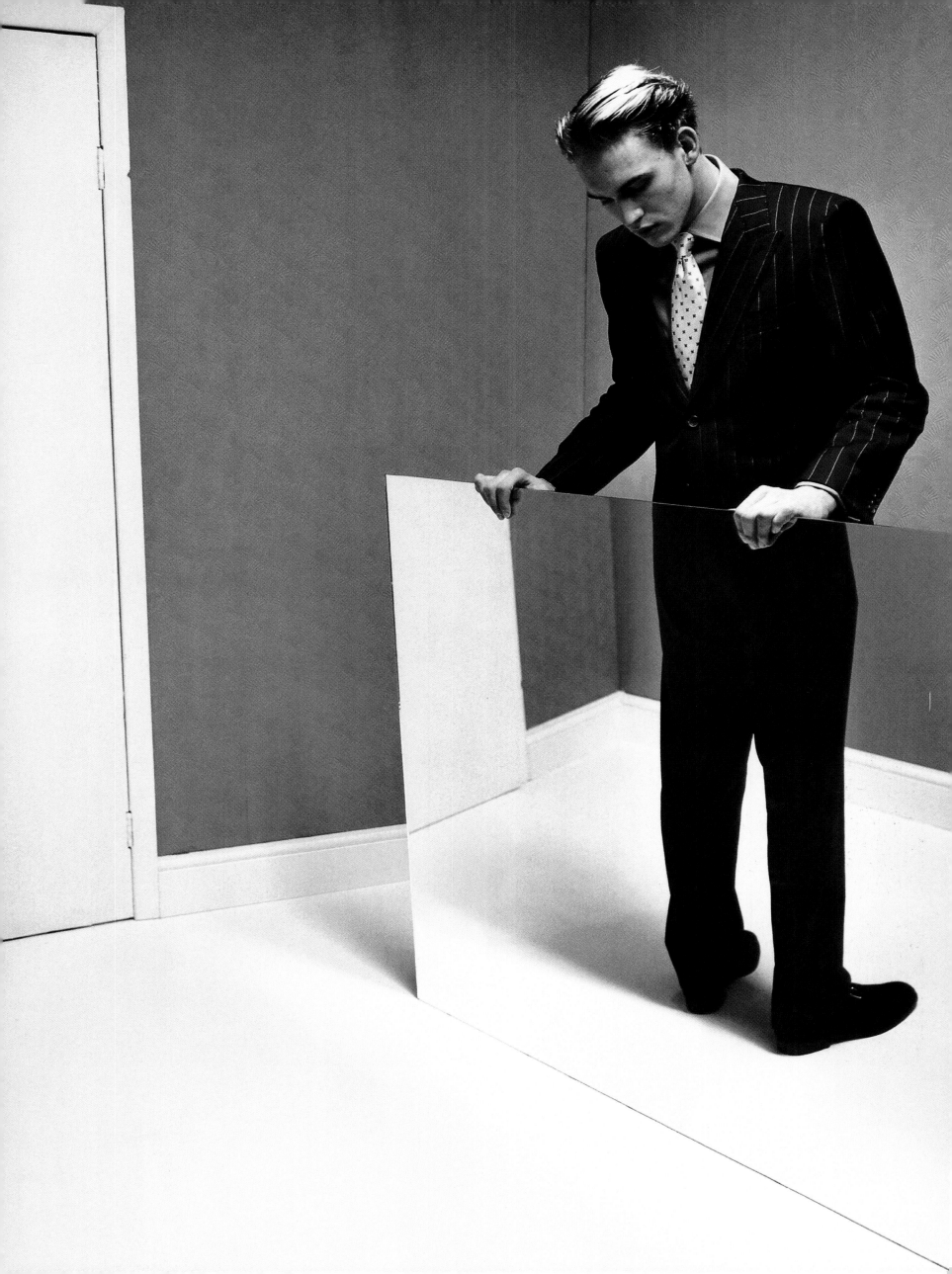

Michael Vanderbyl
principal
Vanderbyl
Design

"Initially, my interest was architecture, but I opted for graphic design because it is more accessible. After graduating from California College of Arts and Crafts in 1968, I went to work for G Dean Smith, a graphic designer who was brilliant at presenting his work. He taught me how to sell ideas.

I was trained in the strict Swiss school of graphic design – Helvetica wasn't just a typeface, it was a lifestyle. Good design was rational and rigorous. Then I saw the bright, colourful work Pushpin was doing. It had wit and a sense of whimsicality. It was very human. Another strong influence was Charles Eames, a designer with a capital D, a creative force who wasn't defined by his discipline, who developed his own visual language.

Today, my design students often inspire me [Vanderbyl is Dean of the Design School at the CCAC]. After a terrible day at the office, I can walk into

a classroom full of students who are passionate about design and excited about ideas I may take for granted. It's impossible to remain jaded. You look at the work in a fresh way.

I opened my own office in 1973 (as I am un-hireable) and kept it small even during the 80s when every client told me to expand. The studio is intentionally small – eight computers and a copier – because I like to design. In fact, I still do 90 per cent of it. Design is what matters and design guides the way I do business.

My work is about finding the best way to communicate through a logotype or literature, a retail space, a showroom, or furniture. Many of my clients say that what I do is marketing, but I am a designer. I design in multiple disciplines. It's an approach that works for me and it works for my clients. Too often, I've seen ad agencies, planners, and product managers fight each other at the

client's expense. I look for the crux of the branding idea and translate that idea into the varied ways that the client sells its services or products. What we do today is act as agents of communication.

Dana Arnett is an interesting and original designer who truly breaks the mould. His unconventional, and sometimes radical, personal and professional style refreshingly pushes the boundaries. He has an extraordinary understanding of narrative that is evident in all his work – from print to 4-D media. One of my favourite pieces is the hilarious 'Day-in-the-Life of an Art Director' promotional film made for a paper company. He's someone to watch."

Above **AmericaOne Identity**
In a traditionally tame event with tame graphics, AmericaOne stood out with its snow sport-inspired graphics. The client wanted a design that represented the cutting-edge technology that goes into the sport. The identity was carried from boat graphics to clothing, and from wet gear design to a letterhead and website

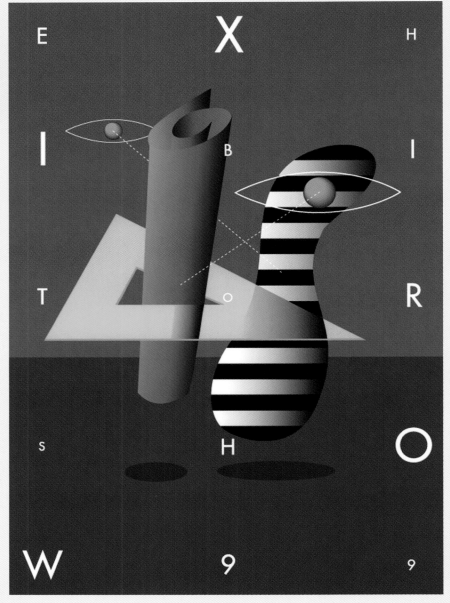

Above **Exhibitor Show Poster 1999**
One of a series of posters for the annual Exhibitor Show sponsored by Exhibitor magazine

"I went to the Northern Illinois University, where I was kicked out of the graphic design curriculum after taking an opposing view to the school's rather conventional vision of design. This event led to my enrolment in a multi-disciplinary art programme where I accumulated credit time through painting, computer-aided design, interior architecture and product design. Ultimately, my failure to succeed in the graphics programme led to a richer alternative opportunity. I was afforded the chance to play around with a variety of mediums, which encouraged my understanding of a truly dimensional definition for design.

At a time when most young design students should be stretching their wings and exploring the vastness of this great medium, American design educators are still pigeon-holing our aspiring colleagues. But those of us who practice know design to be far more dimensional than it is finite. Design lives and breathes in just about every corner of our lives – from the music we listen to, to the chair we sit in, to the package on the store shelf. If we're ignoring the expansiveness of design in the very beginning of our education, we're short selling the very purpose of what we do.

Before being formally trained as a designer, my only reference for the commercial arts were advertisements. And today, I still seek much of my inspiration through the public channels of mass media. In 1974, I recall a particular visit to the public library where I found an edition of the *Art Directors Club Annual*. It turned out to be more than a discovery, as it completely occupied my viewing for hours. I distinctly remember those early Volkswagen advertisements created by Doyle Dane Bernbach. There was such magic to those simple expressions, and surprisingly it only took a few lines of type, a compelling photograph and some brilliant language. Each one of those ads captured the pure essence of an idea, carefully rendered with a tangible and purposeful sense of visual restraint. It was ads like these that made me ask questions and form opinions, but more importantly, it was this motivation that whet my appetite and interest in design.

I worked briefly for two different firms before co-founding VSA Partners. We opened our doors in 1982, with a simple desire to build a purposeful business that produced great design. Our influences stretch from the Eames' to Elvis, from other graphic designers to the corporations which support design, such as Herman Miller and Harley-Davidson. We see what we do as a seamless integration of creativity, strategy, craft and form. With very few real experiences left, we think there is room for more believers like us. Let's face it, we are quickly becoming a commodity world, occupied by the overpowering presence of McDonald's, Wall Mart, CNN and Disney. We happen to think

**Dana
Arnett**
senior
partner
VSA
Partners

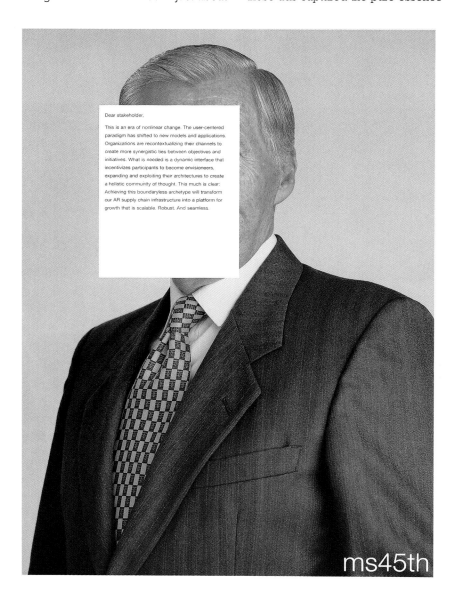

**45th Mead Annual Report Show Poster
VSA Partner, Jamie Koval and team created this poster to promote America's oldest and most respected annual report competition. The concept satirically portrays the 'faceless' state of corporate communications. Life was given to the idea by purposefully masking the CEO's portrait with overstated and meaningless text**

there's room for few more genuine experiences. And if VSA can design them, we'll be happy to help.

Today we're 50 people, assigned to a variety of challenges for some of the world's best companies. And as fate might have it, that early multi-disciplinary training in design was a prime influence for the eventual blueprint that we practice today.

VSA's range of work crosses a variety of mediums including print, film, interactive, packaging and environmental design. We augment and support our creative staff with a mixture of account directors, writers, technologists and strategists. So we partner as complete teams, striving to cover any given assignment with creative and content expertise. As our partner Robert Vogele once said, 'People will support what they help create'. Our interest is to get everyone actively involved in the authorship of any assignment. This communal

approach has been the lifeblood of our existence.

When we approach any assignment, whether it is print or interactive, we always consider the question, 'Why are we doing this?' You could say we're really pondering, 'What's at stake and how can design remarkably influence the outcome?' Ultimately, our first responsibility is to position the value of what we do – and by asking these types of questions, we're helping to justify our very purpose to create. Along with the questions, we also engage the group (client and design team) in a number of 'free-form' conversations. This iterative dialogue is the most fulfilling way of broadening our understanding of what we can and should do. When we apply this understanding to an idea, the result can begin to connect with the audience. We always remind ourselves that an idea must connect, not just communicate. Design is our catalyst for making this happen.

Having just completed our sixth year of working in the interactive area, we may have witnessed some of the most profound shifts in the infant life of this medium. Today, one could say that digital media is slowly creeping into adulthood – a moment where the power of a great idea and the positioning of information are becoming the central issues again. With the internet showing signs of maturing beyond the point of predictable gimmicks, we can look to the real value of making information retrievable. It's no longer just about the sheer 'volume of information', as much as it is about the 'value of information'. Perhaps we're finally using technology to improve our understanding of content. McLuhan's prophecy was right, 'All media work us over completely.'

A few months ago I heard an interviewer ask Jerry Seinfeld, 'Why in the world did you quit the series when it was still so successful?' He answered by saying, 'I never really cared about success, I just wanted to

have the best show on television.' When it comes right down to it, most of us here at VSA are driven by that same desire. We're 20 years young now, and we can't really imagine working if we're not focused on doing the best design that can possibly be done. We also love what we do. And if you really love what you do, you won't give it boundaries. You'll keep moving beyond that familiar zone of comfort, furthering the exploration to the other side of an idea. At VSA, we're still very excited by that unfamiliar territory, as we search for it everyday, in just about everything we do. With this kind of job, what more can you ask for?"

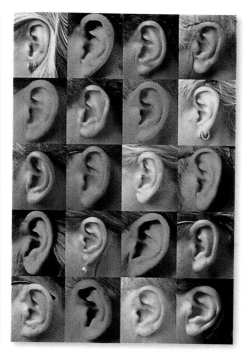

hEAr
This small book, created in conjunction with photographer Francois Robert, presents stories from 30 designers. Each designer relates a specific story that they've heard and wish to pass along. The uniqueness of these anecdotes is further emphasised by showcasing the ear of the storyteller – each being as unique to that individual as their fingerprint

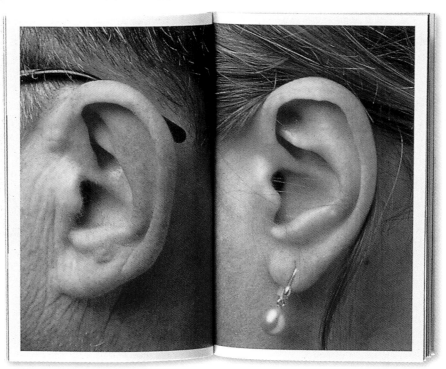

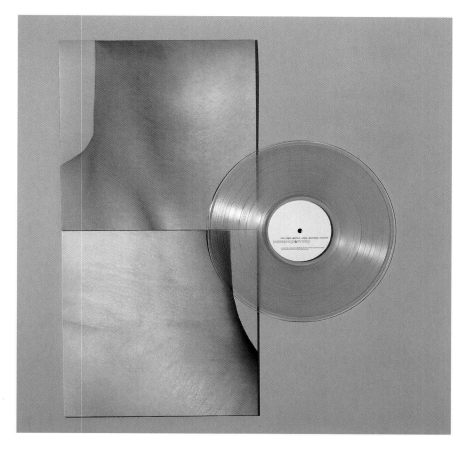

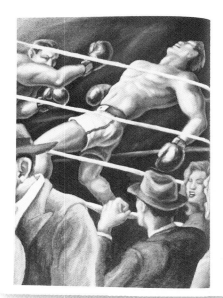

Left **Pulse Recording CD**
This cover portrays the tone and spirit of the electronic music group Pulse Recording. The strangely similar nature of the photographs, each a set of pulse points of the neck and wrist, tastefully implies the identity of the band

Below **IBM 2000 Annual Report**
VSA Partner Curt Schreiber and team created this annual report to show 'One Year in the Life of a Company'. This report clearly speaks of the challenges, victories, discoveries and triumphs of IBM. The design is styled like a 'novel', intending the audience to value the report as a 'good read'

CHAPTER 1

REPORTS OF OUR
DEMISE

CHAPTER 5

COMING
HOME

YOU'RE **ONE PAGE** AWAY
from the **NO-HOLDS-BARRED** STORY
of ONE YEAR
in THE LIFE OF A COMPANY.

It's the story of
BIG BATTLES,
STINGING DEFEATS
&
GRITTY COMEBACKS.

UNEXPECTED ALLIANCES,
DARING FORAYS
&
GAME-CHANGING
DISCOVERIES.

In many ways,
IT'S A STORY ABOUT THE FUTURE,
AS WELL AS THE RECENT PAST,
AND ABOUT ALL BUSINESS TODAY.
WHICH MEANS IT'S ABOUT E-BUSINESS.
AND ONE IN PARTICULAR.

IBM

ANNUAL REPORT 2000

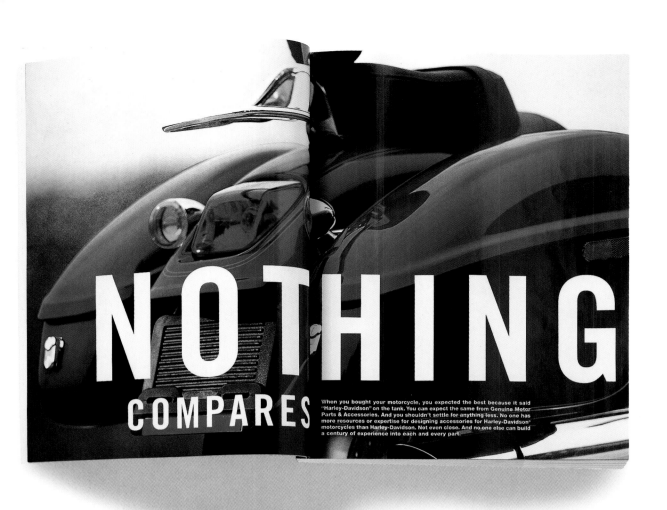

NOTHING
COMPARES

When you bought your motorcycle, you expected the best because it said "Harley-Davidson" on the tank. You can expect the same from Genuine Motor Parts & Accessories. And you shouldn't settle for anything less. No one has more resources or expertise for designing accessories for Harley-Davidson® motorcycles than Harley-Davidson. Not even close. And no one else can build a century of experience into each and every part.

Harley-Davidson Marketing Materials
For over 15 years, VSA has produced award-winning work for this venerable American brand. The examples pictured on these pages reflect the bold and honest attributes of Harley-Davidson's products and events. Important to any Harley assignment is the care given to each and every visual element. VSA is most proud of the partnership it has forged with Harley – furthering the cause of this iconoclastic motorcycle company

EAGLE

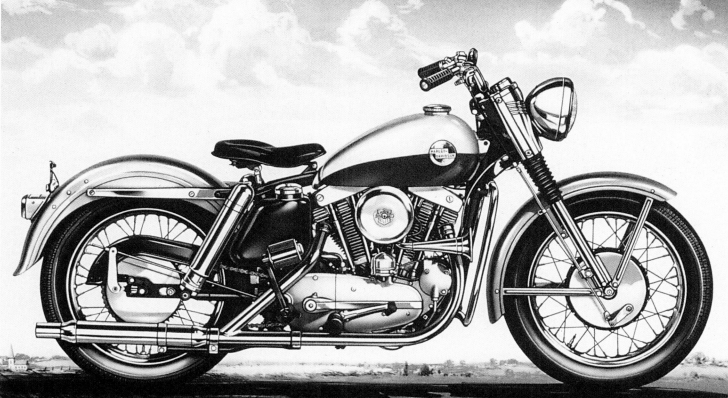

BUILDING QUALITY SPORTSTER POWERTRAINS SINCE 1957 HARLEY-DAVIDSON MOTOR COMPANY THE FIRST YEAR SPORTSTER MODEL 55 CUBIC INCH OHV

THON

SUNDAY, SEPTEMBER 12, 1999

POWERTRAIN OPERATIONS OPEN HOUSE & FESTIVAL AT THE CAPITOL DRIVE PLANT

ADMISSION

Ticket cost is $5 per person, children under 12 are free. Admission includes raffle ticket and commemorative pin. Grounds open from 10:00 am to 5:00 pm.

THIRD ANNUAL MEMORY RIDE

All motorcycles wishing to take part in the ride need to register at Signicast Corporation, 1800 Innovation Way, Hartford, Wisconsin.

ACTIVITIES & ATTRACTIONS

Bike raffle, demo-rides, Harley-Davidson motorcycle display, live auction, plant tours, commemorative items, and games for all ages.

ALL PROCEEDS TO BENEFIT THE MUSCULAR DYSTROPHY ASSOCIATION

This poster was made possible through the generous donations from the following Harley-Davidson "Suppliers Partners." Design: Ken Fox and Michael Peterson of VSA Partners, Inc. Printing and Prepress: Print International Paper: Fox River Paper Company Image courtesy of the Harley-Davidson Motor Company Archives

"My father was a block maker and during school holidays I worked in his drawing studio, so I was under the influence when quite young. In 1946, after the war, I went to the art school in Groningen. This was followed by two years' military service, before I went to Amsterdam in 1952 to begin my career.

There was no design industry in Holland then – only a couple of respected designers. One of them, Dick Elffers, got me a job designing exhibitions and museum interiors; in the evenings I studied typography. Two years later I started my own practice. One of my main clients was the Museum of Modern Art in Eindhoven and I also lectured in art schools. In 1963 I started Total Design with some friends, and within a few years we had grown to 30 people. Our work consisted of 50 per cent cultural (Stedelijk Museum) and 50 per cent corporate (Amro, SHV and Rabo).

I left in 1980 because I felt it had gotten too big and I had become a professor at the University of Delft. Five years later, I was appointed the director of The Boijmans-Van Beuningen Museum in Rotterdam until I retired in 1993. Now I enjoy working on my own projects, currently mainly exhibition work.

I've been described as a 'gridnick' – someone who loves the grid. True, I am a functionalist. But I like to think I have an aesthetic heart. For example the typography inside my catalogues is always very strict while my covers are more romantic.

Design seems very subjective at the moment and that's not my way. In my time, we had a utopian idea that you could better the world through design.

As an educator my aim was to open the eyes of the students to all possibilities, to be aware of all the trends in the world and develop their own ideas.

This is why I have nominated Irma Boom. She has really experimented with the boundaries of books and has pushed the medium to its limit."

Wim Crouwel
designer
Wim Crouwel Design

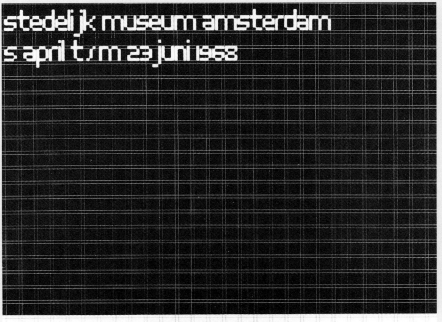
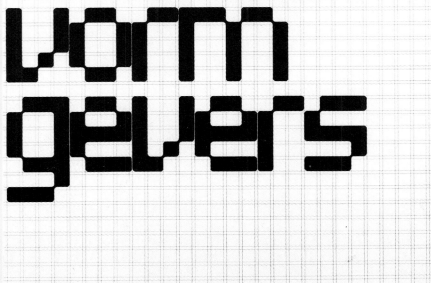

Vormgevers Exhibition Poster 1968
The grid was made visible in all catalogues and posters Crouwel designed for the Stedelijk Museum from 1964 to 1985. The text is composed as a result of this grid. In 1967, he published an experimental alphabet for this new technique, and afterwards made more posters and typography that reflected this interest in computer typesetting

Irma
Boom
designer

"I was educated at AKI (Academy for Art and Industry) in Enschede, The Netherlands, with the ambition to become a painter. But while at school I was taught by a wonderful teacher who came in every week with tons of books. He talked about why and how books were made in such an inspiring way, that I could no longer resist design. Now I design all the time. Although I do have a love/hate relationship with the profession.

My training took place at the Government Printing Office, Studio Dumbar and the design department of Dutch television station NOS. After art school I worked for five and a half years at the Government Printing Office, at that time it was the place where you could learn the required technical skills (the art school was more conceptual and ideas-based) and do all different projects. I believe that some of my best work was completed there. It was quite a dull environment and all my colleagues

had worked there a long time – too long. Consequently, I didn't want to conform to this situation and undertook a lot of experimental work, mainly for the Ministry of Culture, while working on a lot of projects that were seen outside government office such as the stamp book and the Holland Festival posters. After leaving the GPO, the majority of my work was for cultural clients but my current client list is mixed and boasts a healthy balance.

I have big and small clients, cultural (art foundations, museums, artists) and commercial (SHV, Vitra). If it's a commercial client, for example Vitra, I don't design folders or brochures, but produce a more liberated job like Workspirit (Six). Even for the commercial clients more 'cultural' projects are encouraged. I also work for the United Nations in New York as I do feel a sense of responsibility as a designer – what we do is a part of our society and culture. My clients are an

important part of the project and we work together with our collective and specific expertise.

My Amsterdam studio was established in 1991, and it is my intention to keep the office small. I don't want to become a slave of my own 'success'. A lot of people think it's crazy that I more or less still do all the things myself. I do have an assistant now, but she does specific work. I try to do only the jobs I really want to do. Not because of the money, but due to a desire to spend time on things which are interesting for the client and me. I'm not trained in business and always spend more time on a project than originally intended as I'm more interested in making something interesting – that's far more satisfying.

Print is really popular at the moment, especially books. Everyone wants a book or a website. Consequently, I think that there is too much design around and because of the plethora

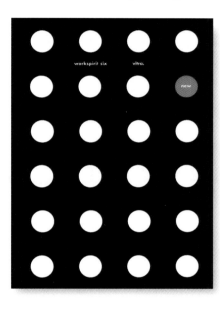

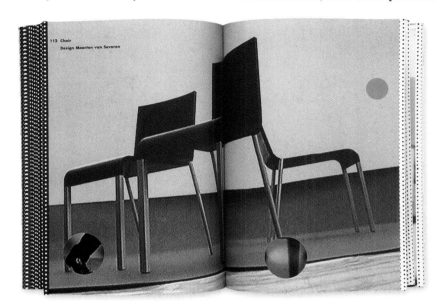

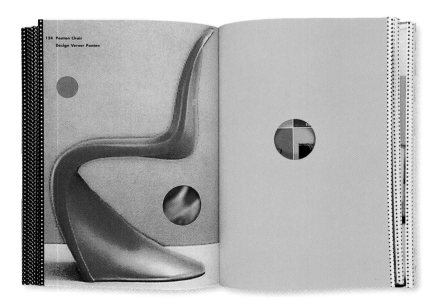

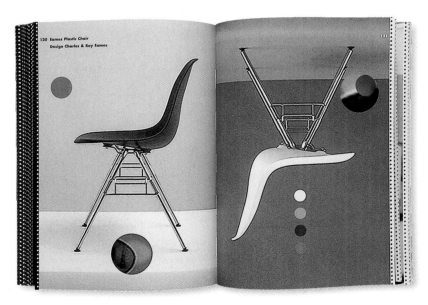

Vitra Workspirit Six 1998
For client Vitra, Boom created a narrative through the holes featured on every page in the book. Both the text and design focus on specific details of the furniture

of design richness, I currently advise clients not to go down the book route. A lot of clients come to me because they want a book but very few realise the time, energy and dedication required from both the commissioner and designer to create a great piece of design. You have to invest time to make a substantial piece of work. One of my commissioners philosophically once said: 'Time produces thought.' This is very true for me.

Mostly artists like Niele Toroni, Daniel Buren, Dieter Roth and Mark Rothko inspire me. I saw a book of Bridget Riley's work recently, which I found interesting. But my work is mainly based on intuition. Holland has a tradition of giving artists and designers work, so our commissioning culture is very well developed, which is a big advantage over other countries. This has also cultivated and led to a mutual respect between clients and creative people.

In Holland presently there is a new generation of young intelligent designers with a specific 'style' based on computer-generated imagery who use photography. I only hope that they stay close to their ideals and way of thinking when the big budget jobs start coming in.

As for me, my dream would be a multi-interdisciplinary project as well as a 'reflective' commission. I would also like to read more design writing that offered sound critical debate – that would be fantastic."

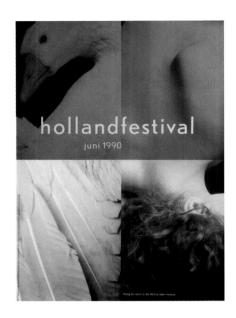

Left & below **Holland Festival Posters Designed by Boom and René Put, the poster shown left was the main campaign for the event. The other two were silk-screen prints produced on top of the basic offset print**

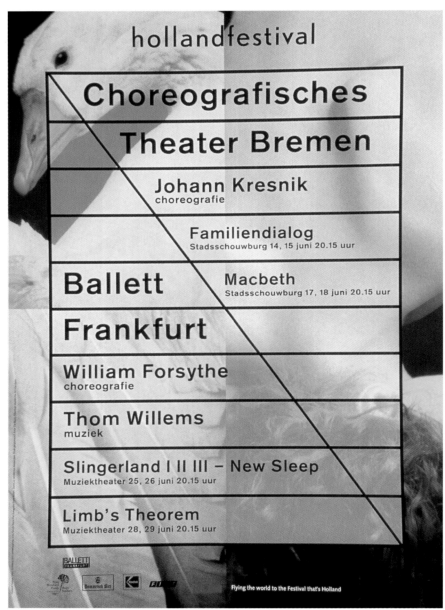

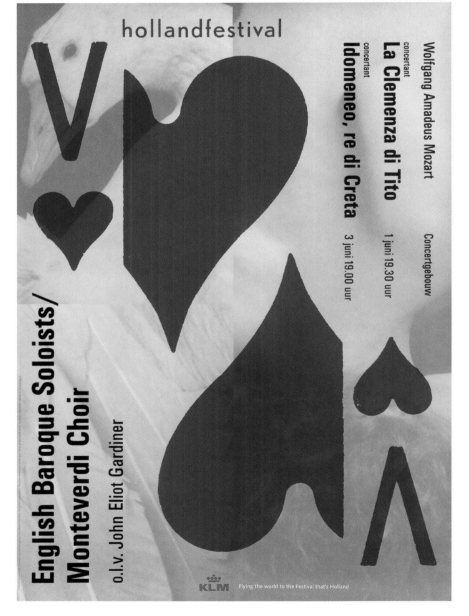

Right **SHV Book 1996**
To commemorate the Centenary of SHV, this book is a journey through time. It constitutes 2136 pages of the company's history and mentality. The project involved five years of research and design

Below **Royal PTT Post Stamps 2001**
Boom produced ten stamps on the themes of Dutch literature and photography

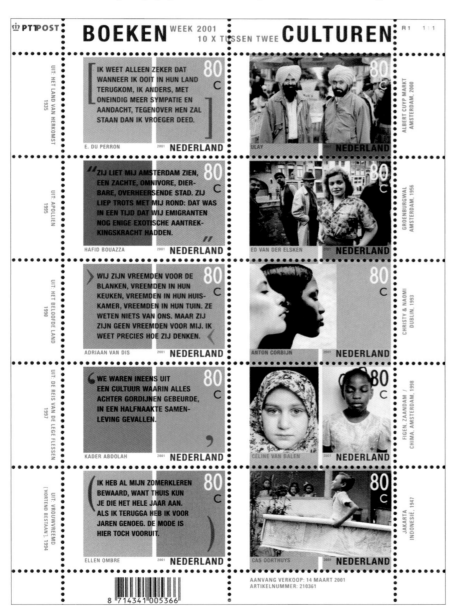

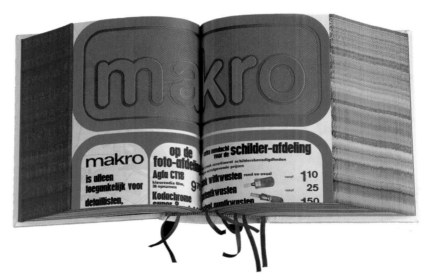

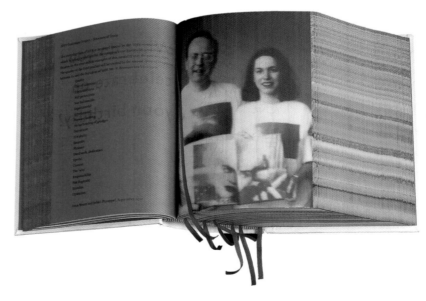

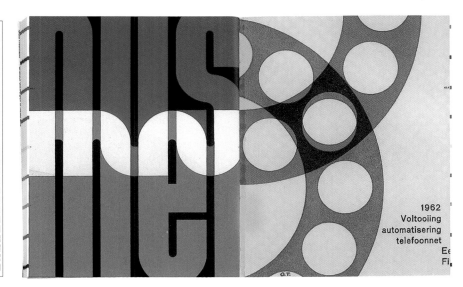

Right & below **Otto Treumann Book 1999**
Published by 010 Publishers, Rotterdam,
Treumann's work is featured very small on
the cover. While turning the pages, his work
is shown increasingly larger until his posters
are shown in their actual size, although only
as a small detail on the page

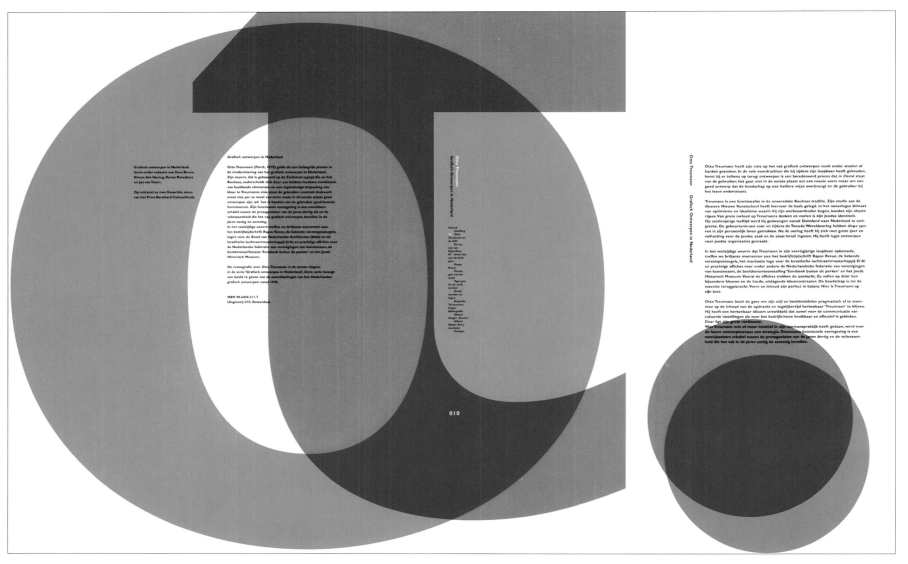

Left **Movements – Introduction to a Working Process 2000**
A book on interior and exterior design produced for Inside Outside, the Storefront Gallery, New York. When flipping the book the reader only sees interior design on glossy paper and the word 'Inside'. Flipping in the other direction shows the exterior on matt paper and the word 'Outside'

Below **Rekenkamer Stamp 1997**
A stamp commemorating 550 years of the Financial Council. The design proved unpopular with collectors because there is no image, although it was a hit with designers

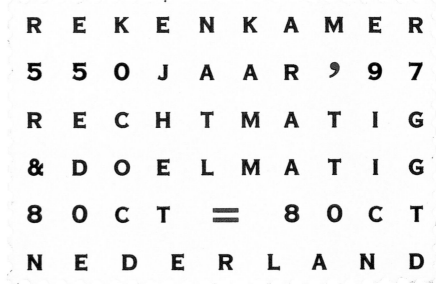

Martin Lambie-Nairn
founder
Lambie-Nairn

"The story of my working life is one of realising quite quickly that as a designer I was not in the business of creating great art – or even pretty pictures. My job was to solve problems in a creative way.

My training in the 60s at Margate and Canterbury art colleges taught me a lot about craft. It was a training that was then honed in the real world, working for companies like the BBC and London Weekend Television.

Craft is important, but it will only get you so far. It wasn't until I started my own company in the 70s that I really came to understand that the craft of graphic design has to serve a greater master: the client's business problems. In my case, those solutions were in the field of branding. But the same would be true for all the design disciplines from packaging to industrial design.

My work ever since has been about using clear thinking as a springboard

to creative solutions that help build brands. From early work like the launch of Channel 4 in the 80s, through developing the corporate identity for the BBC in 90s, up to the work I'm doing right now for NTL, the challenge has always been the same – to understand complex issues in order to deliver simple but powerful solutions. We live in a complex and over-communicated world. The true art of the designer is to cut through the clutter with originality and simplicity.

So my advice to young designers is the same as I give to my staff and myself every day: Keep it simple, stupid!"

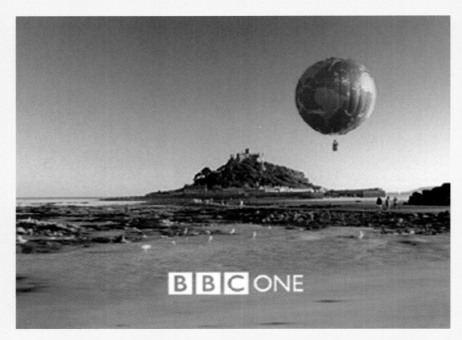

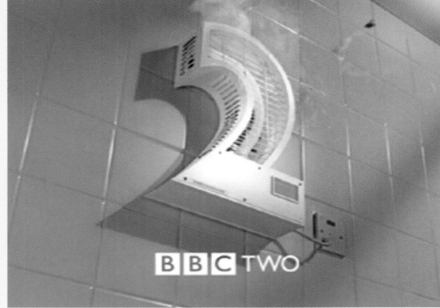

Above **BBC ONE and BBC TWO
Channel Idents**
Right **NTL: Home TV Commercial
Digital television, telephone and broadband
internet – three services down one line**

Kyle Cooper
creative director Imaginary Forces

"I drew a lot as a child, which my parents encouraged. I won a scholarship to study art at the University of Massachusetts at Amherst. While I initially concentrated on sculpture I actually left college with a degree in interior design and a minor in graphic design, although I was always interested in film.

I got an internship at Wang Laboratories as a graphic designer, but everyone there had a Masters degree from either Rhode Island School of Design or Yale. One day someone brought in a reel of main titles featuring 'Altered States', 'Take a Walk on the Wild Side' and others by Saul Bass, and that made me decide on a career in titles. I went to Yale to study graphic design as I felt that I should achieve a better understanding of typography and gain a more rounded design education.

We were the first class to get Macintoshes and the technology helped me to see the potential to facilitate a revolution in motion. The prospect of designing titles combined my interest in graphic design and film – although no one from my town ever went to Hollywood.

The people who influenced me were either film-makers or my design peers and teachers. I left Yale in 1988, but I still wasn't ready to move to Los Angeles. I really wanted to work at R Greenberg Associates and I was hired on the basis that I would design print work. Even though I had storyboards in my portfolio, upon hiring me Bob Greenberg said: 'I'm not sure that you can think in terms of motion', which was a little bit insulting. But I asked him to let me pitch on the Martin Scorsese movie, 'Life Lessons', and they chose my board; then they let me pitch motion projects.

I stayed with the company for eight years and was promoted to Creative Director of the New York office and then of the Los Angeles outfit. After Richard Greenberg left I hired a lot of new people. At the same time Bob decided he was more interested in pursuing internet possibilities. So RGLA closed and Imaginary Forces – consisting of my partners, Peter Frankfurt and Chip Houghton and I – bought out the company in 1996.

We wanted to create a company that wouldn't be just another design boutique, but in a 'pie in the sky' way would be an active content company that operated like a studio. We've now opened up a New York office and in total we number around 80. I'd like to see if it's possible to have a global design company that has a working system and succeeds in creative integrity.

I like the idea of being a content place; we don't defy categorisation, but we are doing different things and are called upon to be authors, creators and directors. I want

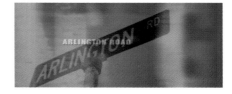

Seven Titles
Quick images of the killer's rituals and routines are spliced with hand-drawn text. Effects, such as double images, torn and scratched celluloid, and abnormal moving images all happen so quickly that the viewer can barely catch them before another one appears

Imaginary Forces to be able to take on any creative problem and solve it.

As a company I also think that we should use our design skills, which are pretty insignificant in the light of larger things, to improve and enrich our society. We are currently, for example, looking at ways to improve the availability of medication to HIV sufferers in Africa.

I try not to separate graphic design from motion graphics, motion design or live action. These are the variables and that's why I've now learnt to direct, as I've had to learn how to light and film live action. I've been directing commercials for seven years. I directed a feature 'Newport South' last year and I'd love to do it again, but I get caught up with running the business and interesting design opportunities.

I don't think I have a typical style, as I try to have a specific concept for

every movie that is born out of the script. 'Seven' looks the way it does because the protagonist was both a serial killer and a photographer who performed a traditional film optical in his bathtub. He also shaved the skin off his finger tips with a razor blade. So the graphic elements in the titles that waterfall and have a fractured and accidental feel are present for no other reason than these are the forms that are played out in the film.

After 'Seven' I got asked to do loads of satanic-themed jobs. I don't mind dark things but I don't want to work on projects that really have no point. The last time I spoke to Paul Rand, I asked him if he liked the 'Seven' titles and he replied: 'Oh, you're the one making that trash art.'

For anyone who wanted to work in this area I would suggest that they get a good basic typography and design education and learn an animation programme. Also don't give up.

People really tried to discourage me, by telling me I wouldn't get a job. Well, I think I have a good job."

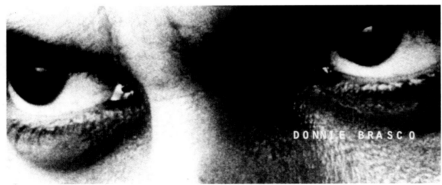

Donnie Brasco Titles
The opening title sequence for 'Donnie Brasco' created a scene, both graphically and cinematically, that told a critical part of the story. The sequence provided a sense of history to the characters before the film's opening scene. Through stop-motion photography and flutter cuts, the sequence reveals a patient predator

Below **Twister Titles**
A view through the eye of a twister. The type blows on-screen like metal siding being blown off the side of a building. Credits also blow off-screen like sand, and the logo at the end dissipates in the same way as the presenter credits

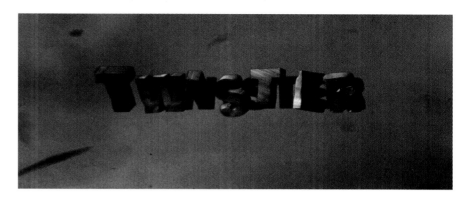

Below **The Mummy Returns Titles**
The director wanted the film to end on an upbeat note. This sequence, featured at the end of the film, takes flight and moves around as if trapped in a current or stream of air. The viewer is taken on a journey through the tunnels and the catacombs that hold the mummy

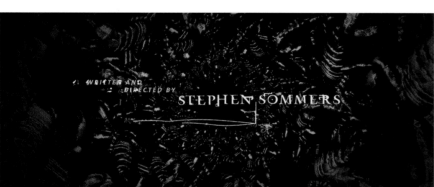

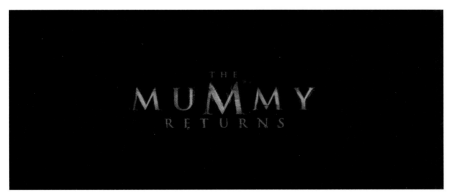

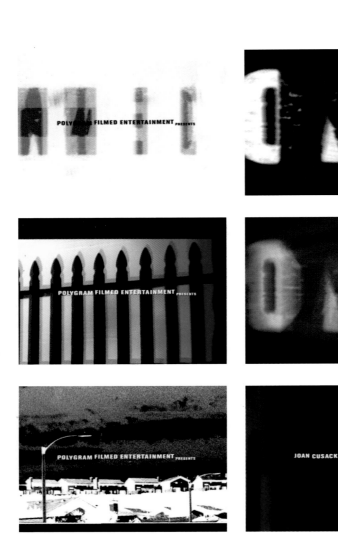

Arlington Road Titles
Tying into the film's theme of domestic
terrorism, this main title sequence questions
what many American citizens put their faith
in: America, family, material things, etc.
Suburban nightmares are suggested by
discoloured picket fences and distorted
American weekend iconography



Mimic Titles
The main title told the film's backstory
of a terrible plague, spread by cockroaches
through NYC, killing young children. The
sequence also built suspense by evoking
the constant fear of insect evolution
and infestation. Insects interacting with
sculptures were shot to create a juxtaposition
that accentuates the frightening capacity of
insects to mutate and survive. The rapid
editorial style was used for a jarring effect,
heightening the sense of multiplicity that
implies the threat of insect domination

Mary Lewis
creative
director
Lewis
Moberly

"My passion for brands began as a child. I grew up on a farm where everything was homemade. Consequently anything bought from a shop was madly exciting!

I believe that a brand has a spirit (from which it springs), an identity (its visual expression) and an image (how it is perceived). My task as a brand identity designer is to ensure that these three aspects are in line. Contemporary brands are an experience, with dimension and narrative. As a designer, I feel more in tune with this than static marques and onerous guidelines. I have always placed importance on brand intangibles and now they have become more important in the mind of the marketer and the consumer.

When I start a project, I need to experience it first hand. I tell my designers that they have to be actors or actresses, able to step into the shoes of consumers to ultimately understand their hopes, fears and dreams. Then they can start talking to them through design. Clearly presenting or creating the brand story is important to me, solving the problem through turning it on its head, considering tension, pace and charisma. This is important; the design should have an aura, an atmosphere and 'space' of its own.

Lewis Moberly has strategic planners, semioticians and technologists – but creativity is the drive shaft of the whole company.

Ultimately, I set out to win hearts before heads. We can over-rationalise, but at the end of the day people reach out to design – or don't. It's not an intellectual process for them.

In a young designer I look for independence and spirit. My nominee Susanna Cucco has both and an exceptional talent. What I admire about Susanna is that she and her work represent a force of energy – neither is a clone.

As an individual she is thoroughly modern, highly intelligent, excitable, unpredictable and passionate. While her design portrays the culture of the street, she exudes an elegant manner. Her focus is now on fashion, and she brings branding to this transient industry. Her approach is always adventurous, eclectic and cerebral.

The piece of Susanna's work that I most enjoy is the *H Stern* Book. It fulfils all my criteria for design excellence. It is perfectly paced and dramatically theatrical. The design is highly considered with superb use of colour, texture and image – a tactile, absorbing pleasure."

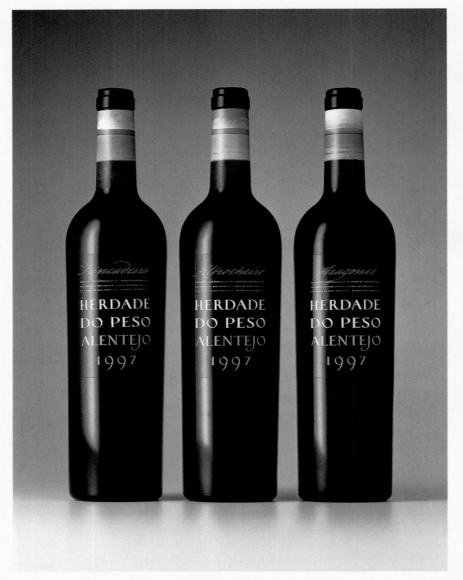

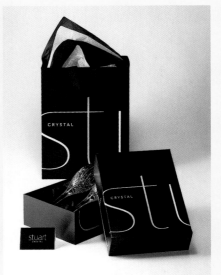

Above **Stuart Crystal Brand Identity 2000 Stuart Crystal was a brand locked in time that needed to be re-staged for contemporary relevance. Lewis Moberly's identity built on the client's design heritage and radically repositioned the brand**

Left **Herdade do Peso Brand Identity 2000 The flat landscape of Alentejo is depicted across the neck labels. The local architecture of red roofs, white walls and blue door frames gives colour and pace to the typography**

Susanna Cucco
founder
Cucco

"It's not important who I work for but when. I worked at Lewis Moberly at a good time and it was very challenging. The structure at Lewis Moberly really pushed designers to work as individuals. I had just left St Martin's after graduating with a degree in graphic design. Lewis Moberly was a very good learning experience and I learnt a lot from Mary about professionalism.

In 1991 I moved to Milan where I met my former partner Giovanni Bianco. Our first fashion client was Dolce & Gabbana and we created the image for D&G. Our attitude towards work was free and very personal, and this inspired us.

In 1994 we formed Bianco & Cucco and a year later moved to Brazil, Giovanni's home country, to open a studio in São Paulo. South America was a completely different environment and psychology and we offered a unique combination of English, Italian and Brazilian graphic backgrounds.

While in São Paulo, we art directed for the fashion company Forum, which was keen to reflect its Brazilian heritage. The photographer for the first campaign was Ellen von Unwerth and the story was that of a gangster escapade. We art directed catwalk shows, store openings and exhibitions. At the other end of the client spectrum we also created US branding literature for South American jewellers H Stern. The work was very European in its style and attitude, which was a result of our own experiences.

A cultural project, which also offered us an exercise in creative branding, was an exhibition and a book we designed for Forum and the Museum of Modern Art (MOMA) in São Paulo. The project, 'Photojeanic', involved 80 fashion photographers and journalists contributing pictures and text on the theme of jeans.

In 1997, we opened a studio in New York; a necessary base for us as it was the missing link between South America and Europe. We worked across continents art directing for different fashion labels, developing projects that included campaigns, exhibitions and events.

Most of our work was very strong and sometimes provocative. For fashion label DSquared we created a gay guide catalogue that showed all the cruising points for truckers in New Jersey. We worked with text that was taken from pick-up sites on the internet.

I split from my partner a year ago and started a venture on my own. I stopped working with all previous clients as they were so used to the two of us and the company is now called Cucco.

I now concentrate more on global, pure and timeless branding that, when appropriate, works for all the

Brand Development of Agnona
Book and campaign project mixing
photography and illustration to present
the new brand concept

paraphernalia of fashion. My clients now include Valentino, Jil Sander, Frette and Agnona.

They are diverse because I don't like to be put in a niche, I've always been about identity and no brand can survive now without brand identity. But the majority of my work is for fashion companies and concerns all the creative elements involved in creating a brand identity.

Fashion clients understand the importance of putting together the best people for teams and the diversification of skills. The fashion designer and art director have to share the same aesthetics with regard to the collection and be ahead of trends. I have to take the ideas behind the clothes into another arena.

Understanding the difference between branding, which is timeless, and fashion, which is of the moment, is the skill. I try to combine powerful

branding while allowing trend and contemporary perception to transmit through. In the fashion business, the client is a brand, but the brands are designers. I have to like what the designer does with fashion. Fashion designers are so self-centred that they like to think that they are working with a person and not a big company. It comes as a shock to them when they find that I also work with Unilever.

Creating an identity for fashion designers is difficult as they tend to reject any notion of branding. The Valentino identity, for example, took 12 months and involved a very large group of people trying to reconstruct the brand, therefore it was a fight against its heritage, which was very difficult to change and update. My approach for Winston was unconventional as I created an identity for a traditional brand where the logo could be cropped to work across all mediums.

What used to be considered a graphic designer is now obsolete. The profession has evolved so much across mediums and cultures, that to survive a designer has to keep abreast of world trends, especially if one is based in Italy. All my designers are encouraged to research, travel and pursue their own interests.

Milan is the worst place to open a design consultancy, because the creative community is not stimulating in terms of graphics and art direction. What I am doing now is breaking boundaries by working across countries and cultures, while maintaining my specialism."

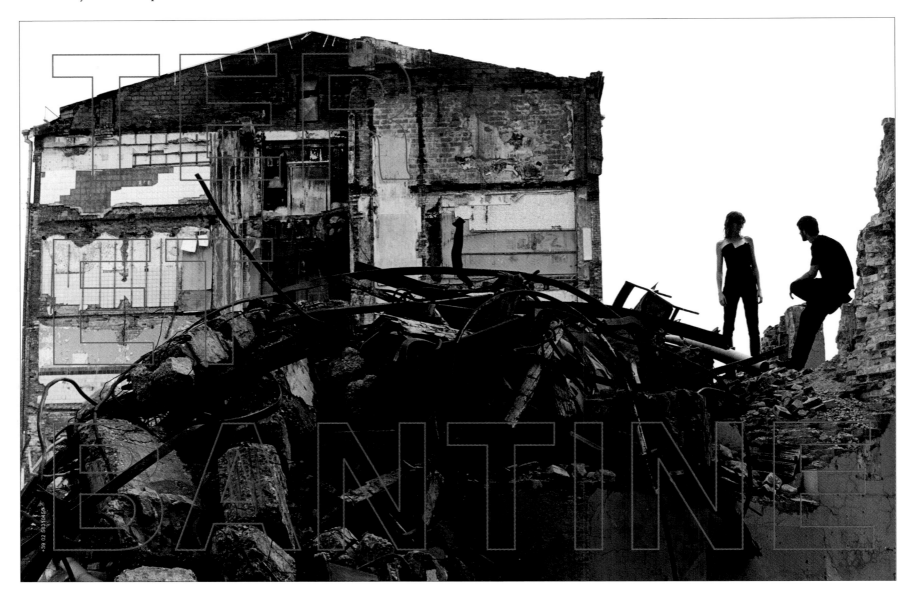

Ter Et Bantine Campaign
Each season a different project is developed using young talent in different countries. This campaign was shot on the streets of Moscow using an all-Russian team

Left **DSquared Catalogue**
**Biology, medicine, the body and desire –
all packaged in a latex envelope**

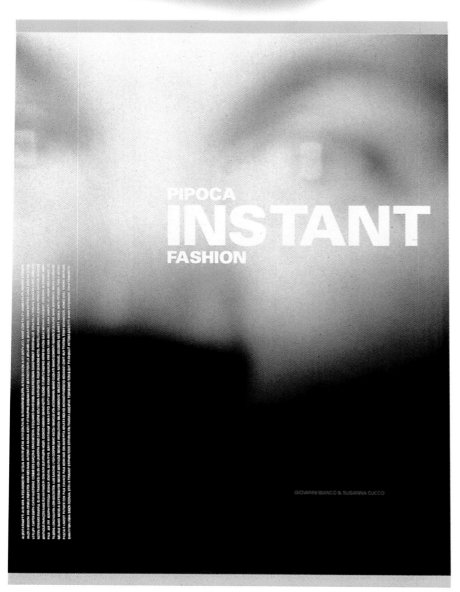

PIPOCA
INSTANT
FASHION

GIOVANNI BIANCO & SUSANNA CUCCO

IDÉE FIXE

Above **Pipoca Polaroid Book**
**A project created with Giovanni Bianco.
Bianco & Cucco sent 200 Polaroid cameras
to 200 fashion people all over the world and
asked them to take pictures of what fashion
meant to them. A book of the resulting work
was published to accompany exhibitions in
Paris and Tokyo**

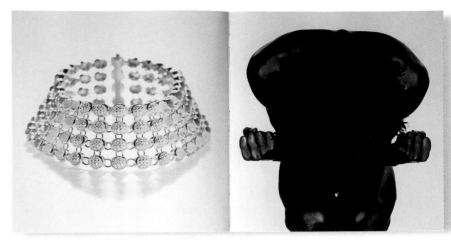

Below **Photojeanic – The Jeans Cult Book**
A book and exhibition collecting the work
of fashion journalists and photographers
on the subject of jeans

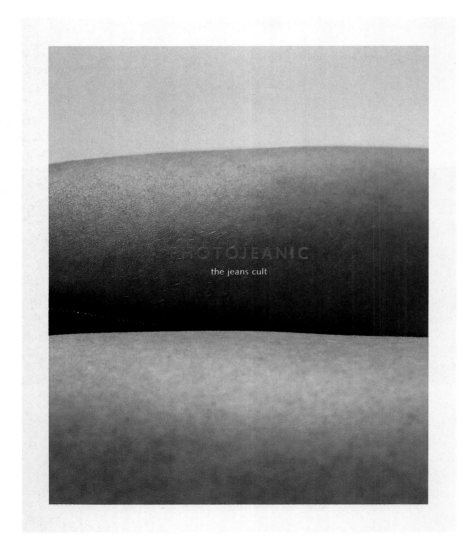

Above **H Stern Book**
The idea was to avoid showing the jewellery
being worn on the body by featuring a series
of different people, and allowing the shapes of
their bodies to express the design of the jewels

VALENTINO

Above **Valentino Logo**
The new Valentino logo and symbol was a
difficult balancing act for Cucco. Her aim
was to modernise the overall identity without
losing the incredible heritage of the brand

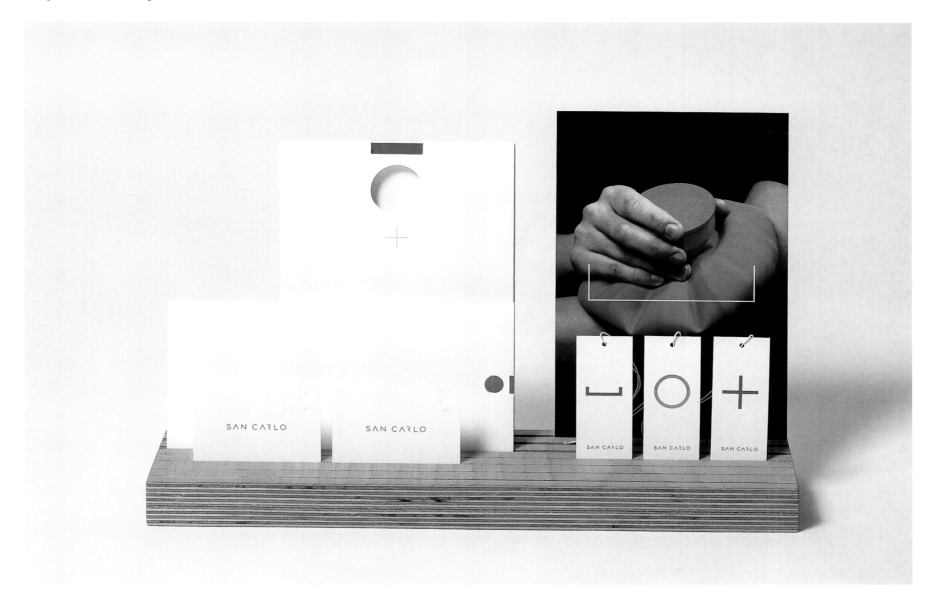

Above **San Carlo Dal Campaign**
San Carlo Dal is a luxury department store in
Italy. Cucco's work for the company involved
developing a flexible identity package that
was applicable to special packaging, window
displays, exhibitions, public events, music
label and website

Gert Dumbar
designer
lecturer
founder
Studio
Dumbar

"My grandmother was a very good painter and the smell of her paint encouraged my interest in art. One needs something to rebel against when one is going through puberty, so as a 15-year-old I was into painting and modern jazz. My parents were very bourgeois and when I finished high school they wanted me to become an architect or an engineer – they thought art school was full of communists. But I ignored them and went to the Royal Academy of Art in The Hague.

While there I became interested in graphic design as I found painting too easy, there isn't a difficult or nasty climb when you start painting on canvas. So I swapped direction and looked towards graphics. Then I had to do my national service and was chosen for the officer's education. I came top of the class in the exams but I was failed because of artistic nonchalance, mainly because I was doing abstract drawings in the evenings instead of going to the pub.

After studying in The Netherlands, I went to the Royal College of Art in London, where I now teach one day a week. It was three years in paradise for me. After my degree show, Unilever offered me a job as my exhibition featured experimental packaging. When I visited the offices I saw more than 200 designers working on packaging, so I walked out. After this I was offered the opportunity to design the Dutch Railway's identity.

I don't think I would sell my company because we would lose our flavour and the fun we all have working together. There is no hierarchical structure at Studio Dumbar; it's as flat as a pancake. Also, I despise the Interbrands, Enterprises and Landors as they ruin our profession. Design isn't about people in pinstripe suits talking nonsense about marketing strategy and design.

My main advice is not to listen to clients because they are stupid.

I don't mean to sound arrogant but the key to success is to de-brief yourself and de-brief your client in a modest way as clients always agree to things that are totally wrong for them.

Studio Dumbar now has offices in The Hague, Rotterdam and Frankfurt and is planning to open one in Shanghai."

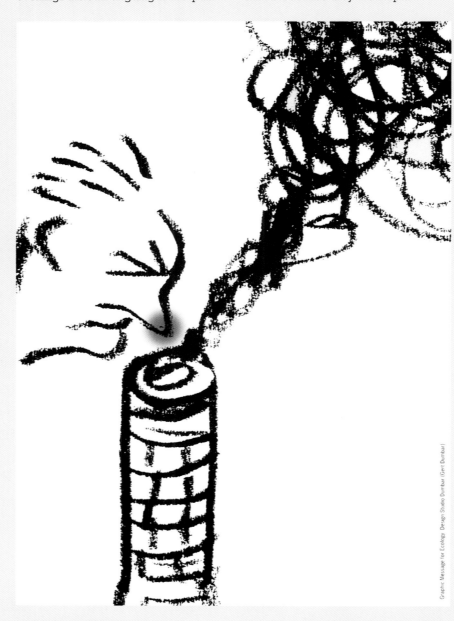

Ginza Graphic Gallery (GGG)
Tokyo, Japan, 1999

Graphic Message for Ecology. Design Studio Dumbar (Gert Dumbar)

I studied Graphic Design at the Royal Academy of Fine Arts in The Hague and graduated in 1991. At that time there were only three design studios that I wanted to work for: UNA in Amsterdam, Grapus in Paris and Studio Dumbar in The Hague.

After an internship at UNA I got offered a job at Studio Dumbar. There I learnt a lot about being true to myself in design. Studio Dumbar gave me the opportunity to have both a personal and positive fight with the profession, without feeling the pressure of making money. I feel that they gave me my freedom.

I also began to understand the difference between an artist and a graphic designer. As an artist you can make your things and hopefully people buy them, but as a designer you always do something for somebody else. When I did my projects at the Academy I always had to deal with 'professionals' (my

teachers). They 'know' the process. In 'real' life, you mostly have to deal with people who are not professionals otherwise they would do their own design. They want your design knowledge, so it is really important for the designer to be able to explain what he or she is doing and why. Communication between the designer and client is key.

Gert Dumbar has always been a great inspiration for me from both a personality and design point of view. I also admire the way he deals with his work colleagues. The way he inspires enthusiasm in designers is unique; he is the boss, but never acts like one. The man has a lot of positive energy.

I opened my studio in July 2000 and the majority of my clients are Dutch, although I have worked for Leagas Delaney in London as a freelancer for Telecom Italia. The interesting aspect of this job for me was meeting Tim Delaney. I liked the way he took on

board what I said about the power of graphic design. He is such a big name in advertising, but is still open to learning new skills.

I was a teacher at the Academy in Arnhem for a year, which I really enjoyed. From this experience I learned that education is not about taste, but about respecting certain qualities. As a teacher, it is important that your students don't become the new 'Bob van Dijk'. They have to have their own approach.

Sometimes when I was teaching I saw work that I didn't like, but I could still perceive its qualities. I also found that it was a useful exercise to justify to myself when I thought something was not that good. I like lecturing. but I never tell students how design should be, but show them my enthusiasm for the profession by telling them something revealing about my process and ideas. I always hope that that my enthusiasm will inspire.

**Bob
van Dijk**
graphic
designer
Studio
NLXL

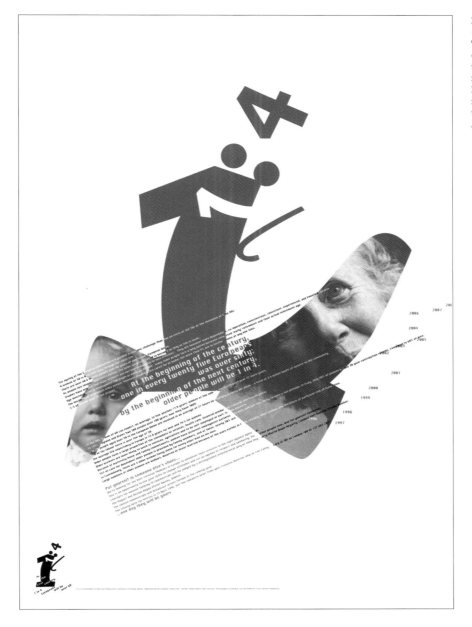

**Pan European Project
(Designed while at Studio Dumbar)
This campaign was devised to stimulate creatives (agencies and students) in Europe to come up with ideas for dealing with issues involved in care for the elderly. The design is based around the fact that one in four people is a senior citizen, while the walking stick is used as a symbol of old age. Photography by Ad van Dijk and Lex van Pieterson**

At the moment I work for a mixture of big and small clients. I like to struggle with a white piece of paper. I am not the person that wants to work with ingredients that already exist, I want to create.

One of the projects that I'm working on at the moment is the visual identity of a Japanese restaurant called Oni. I created a flexible 'Logo-system' and language. The owners asked me to also come up with some ideas for the interiors. My idea was to have as little interior design as possible, but to play with light by using slide shows and moving images. I am currently filming a swimmer from below in a pool and I plan to project this film on the ceiling so that the diners have the feeling that they are immersed in water.

I don't get my inspiration from looking at design books, I get it from everyday life, by looking around and watching people, and by looking at the work of artists. There are so many talented

people that can inspire you to look at things in another way. These things really make me happy.

Recently I started a new design studio with four partners, NLXL, to specialise in visual communication and interaction design. Combining integrity, enthusiasm and other disciplines feels like a big new step forward to me. We are all very different, but the differences keep us sharp. The combination of our team is about content, creativity, technique and experience. We have that together, which is unique."

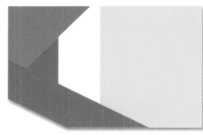

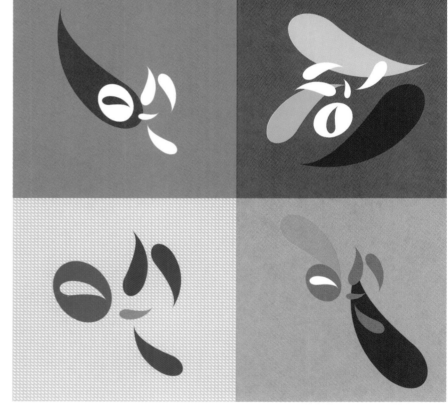

Above **Tresparc Identity**
Tresparc is a personal digital place on the internet. This platform enables users to control their own data and maximise their communications within a strictly safe environment. The 'T' represents a mailbox or sign in the landscape. The cards are cut on the right-hand corner to give a more 3D effect

Above **Oni Identity**
In Japanese the word 'Oni' means unique. The symbols represent ingredients related to a Japanese kitchen: water, fish, wasabi and soya sauce. Van Dijk likes the fact that the forms are simple and recognisable but allow for open-ended design possibilities

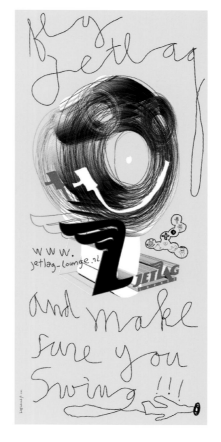
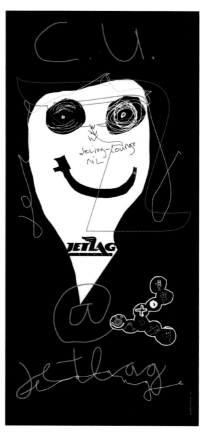

Jetlag Lounge Discotheque Publicity 2001
Each month, the club's owners ask a different
artist, designer or photographer to create
publicity material for the club. Van Dijk's
idea was to come up with a series of hand-
drawn faces based on the arm of a turntable

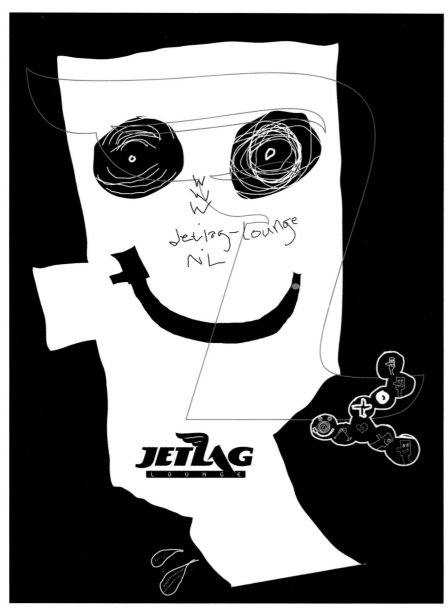

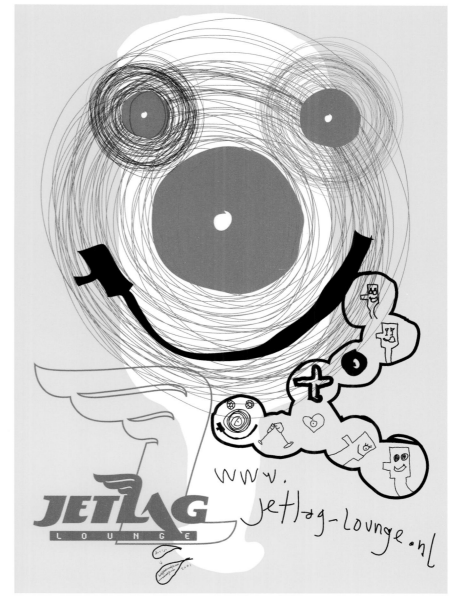

Below & below right **Holland Dance Festival Poster 1995** (Designed while at Studio Dumbar) The theme was 'music for dance'. Van Dijk combined music symbols and photographs to reveal emotional movement. The poster was awarded 'The Dutch Design Prize' in 1996, and forms part of a collection at The Museum of Modern Art in New York. Photography by Deen van Meer

Right & opposite **Holland Dance Festival Poster 1998** (Designed while at Studio Dumbar) The theme was 'a dancer's tale'. Using the same images as in the 1995 campaign, van Dijk played with them in a sculptural way. Black was chosen as a background to make the work more intimate. This series of posters received a Premier Award at the STD in London in 1999 and a Typographic Excellence Award at the New York Type Directors Club in 1999. Photography by Deen van Meer

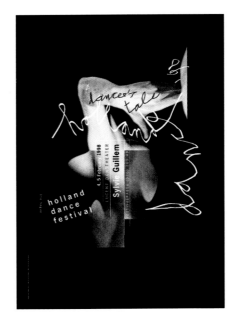

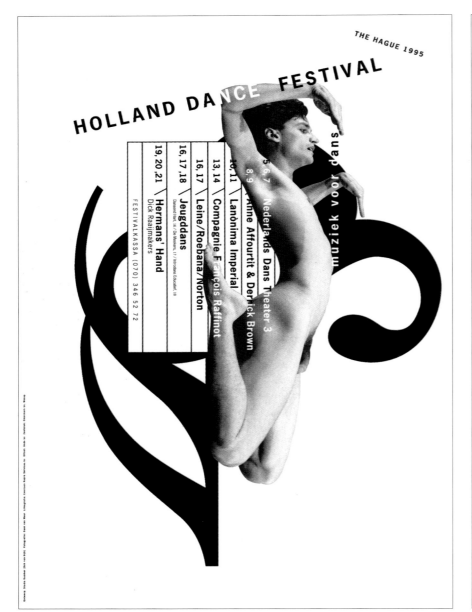

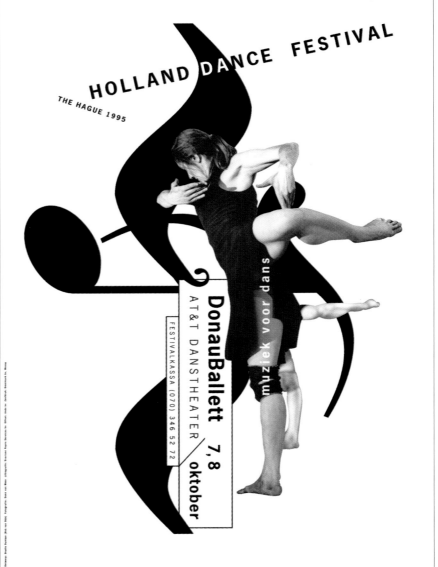

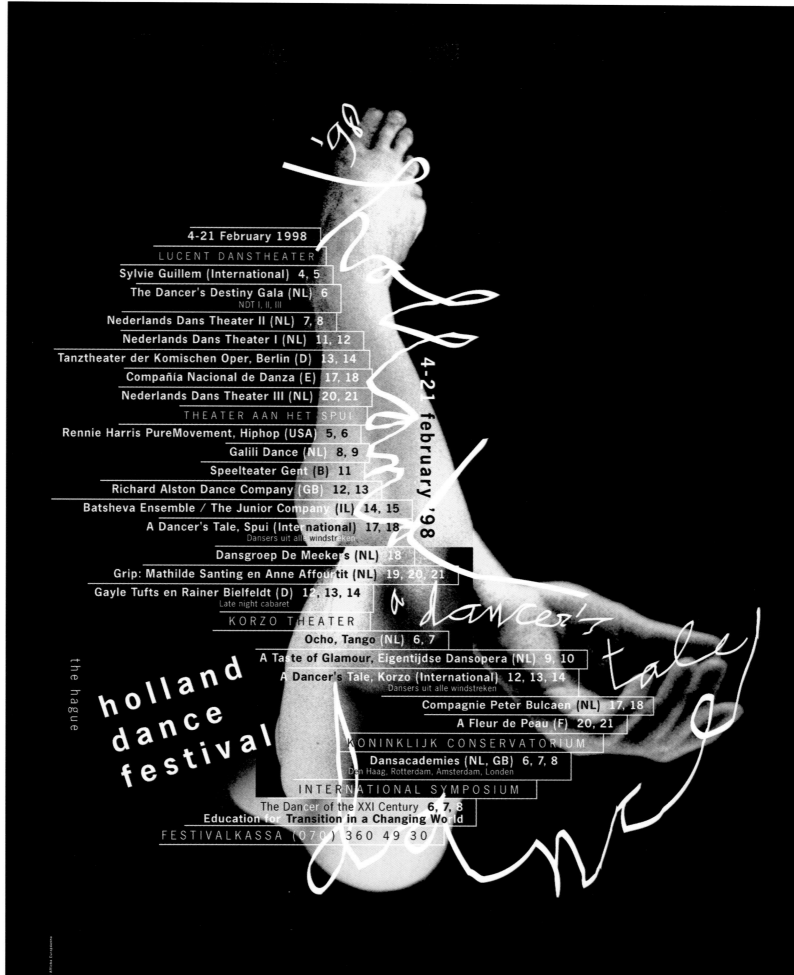

4-21 February 1998

LUCENT DANSTHEATER

Sylvie Guillem (International) 4, 5

The Dancer's Destiny Gala (NL) 6
NDT I, II, III

Nederlands Dans Theater II (NL) 7, 8

Nederlands Dans Theater I (NL) 11, 12

Tanztheater der Komischen Oper, Berlin (D) 13, 14

Compañia Nacional de Danza (E) 17, 18

Nederlands Dans Theater III (NL) 20, 21

THEATER AAN HET SPUI

Rennie Harris PureMovement, Hiphop (USA) 5, 6

Galili Dance (NL) 8, 9

Speelteater Gent (B) 11

Richard Alston Dance Company (GB) 12, 13

Batsheva Ensemble / The Junior Company (IL) 14, 15

A Dancer's Tale, Spui (International) 17, 18
Dansers uit alle windstreken

Dansgroep De Meekers (NL) 18

Grip: Mathilde Santing en Anne Affourtit (NL) 19, 20, 21

Gayle Tufts en Rainer Bielfeldt (D) 12, 13, 14
Late night cabaret

KORZO THEATER

Ocho, Tango (NL) 6, 7

A Taste of Glamour, Eigentijdse Dansopera (NL) 9, 10

A Dancer's Tale, Korzo (International) 12, 13, 14
Dansers uit alle windstreken

Compagnie Peter Bulcaen (NL) 17, 18

A Fleur de Peau (F) 20, 21

KONINKLIJK CONSERVATORIUM

Dansacademies (NL, GB) 6, 7, 8
Den Haag, Rotterdam, Amsterdam, Londen

INTERNATIONAL SYMPOSIUM

The Dancer of the XXI Century 6, 7, 8
Education for **Transition in a Changing World**

FESTIVALKASSA (070) 360 49 30

the hague

holland
dance
festival

4-21 february '98

a dancer's tale

Lynn Trickett
co-founder
Trickett
& Webb

"I fell into graphic design. I did my foundation at Chelsea School of Art in the early 60s and wanted to go on to do sculpture. But the Head of School said women weren't strong enough to be sculptors – and that was that. I had a friend in the newly formed graphic design department and she persuaded me to apply.

Graphic design was quite new in the 60s – a quantum leap from 'commercial art'. The tutors were fantastic and they were topped up with visiting lecturers like Bob Gill and Robert Brownjohn, who taught us that design was about ideas and not style. Design is about problem-solving – not self-indulgence. After graduating, I worked for Wiggins Teape Paper, designing paper promotions for designers – a brilliant job because it combined creative freedom with generous budgets.

After a stint with a New York advertising agency and a London design consultancy I was lucky to meet Brian Webb and, within weeks, we founded Trickett & Webb. We worked off our dining room tables and turned tiny little jobs into mega productions because we were obsessed with detail. Every job had to include a specially made envelope, which cost more than our design fee.

Our aim, rather idealistically, was to be in control of our own destinies. Now, 30 years on, we are still trying to control our destinies. Brian and I are still both closely involved in the whole design process. We argue quite a lot about ideas, which luckily we both feel are the most important part of being a designer. The greatest satisfaction is when we can convince our clients to go with something more wonderful than they, or we, expected at the outset.

I try to keep my eyes open – to absorb everything. Like the 'phone box where, among the usual rude postcards, one stood out. A plain white card with a single line of type 'I like my job' accompanied by a phone number. A perfect piece of communication.

For me design and image-making needs to have an individual and unique handwriting, which is why I've chosen to nominate Sara Fanelli. Nobody can rip off her style, which is very much her own. I've never been able to understand why you're allowed to make people laugh in advertising, but you're not really supposed to in design. As a designer you have got to feel good about what you are doing, because if you don't feel good about it, then no one else will. I love Sara's work – you can tell that she has enjoyed doing it."

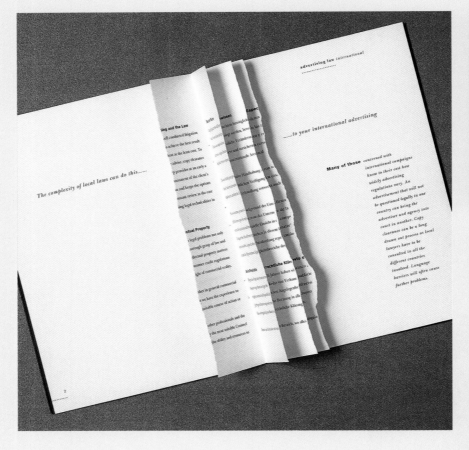

Advertising Law Brochure
Advertising Law is a consortium of specialist advertising lawyers located throughout the world. Trickett & Webb designed a launch brochure aimed specifically at advertising agencies with global clients. By consulting Advertising Law they can check the legality of campaigns in various countries. Trickett & Webb demonstrated what could happen to a campaign if the ad wasn't researched properly by ripping all the words out.

It is one of Trickett's favourites for several reasons: firstly it is all 'idea' with no pictures to help it along. It also knows its market – it doesn't try to compete with the agency it is talking to, but relies on a strong idea. It is 'fit for purpose' too. Solicitors are known for spending their clients' money, but aren't generally keen on spending their own. So Trickett & Webb produced a non-wasteful two-colour job – with a twist. The problem of simulating torn pages was solved manually

**Sara
Fanelli**
illustrator
designer

"I come from Florence and moved to the UK to study design and illustration at Camberwell College of Arts in 1990 and then went to the Royal College of Art in 1993 to complete an MA in Illustration.

Naturally, I was very influenced by my surroundings in Florence – its art and architecture and its natural beauty – but it was only when I moved to London that I appreciated how much I had taken my childhood habitat for granted. This 'habitat' included my immersion in the history of art, which was a natural consequence of both my parents being art professors.

My work tends to feature a combination of drawing, painting, printmaking and collage. I like my work to have many levels and layers and that is why I find collage an inspiring medium to tell a story with. It has so much more richness than a flat piece of paper or colour.

I've published seven children's books with my own stories and pictures. I keep a strong sense of my own childhood alive inside me and I am interested in creating a world in my pictures that a child's imagination can inhabit. Perhaps because I was lucky enough to have my first book published while I was still at college, I have always tried to keep my ideals uncompromised by commercial pressures. I am very happy that my books have been published more or less the way I have wanted.

Commercial pressures are even greater on young illustrators starting their career now; however I believe that if the big bookchains have the intelligence to display and support original books that do not necessarily fit into their preconceived categories of selling and display, then the public responds positively.

My picture books are visually led; I devise a story around the characters

that I am interested in drawing. For instance, I noticed that children particularly responded to the character of the wolf in my first book, *Button*, and I enjoyed drawing it, so I devised a story for this character, which became my book *Wolf*.

I have always collected old stationery with different patterns of lined paper, as well as old labels of all sorts and even old packaging and advertisements. For my book *Dear Diary* I constructed a story with seven different diary entries (each graphically entirely distinctive) by seven different characters in which I could finally use the materials I had been collecting.

I also design the typography in my books and I often use handwriting. I think that the design of the text is an integral part of the appearance of the book and plays its part even in telling the story. For me the simplified, computer-generated designs you

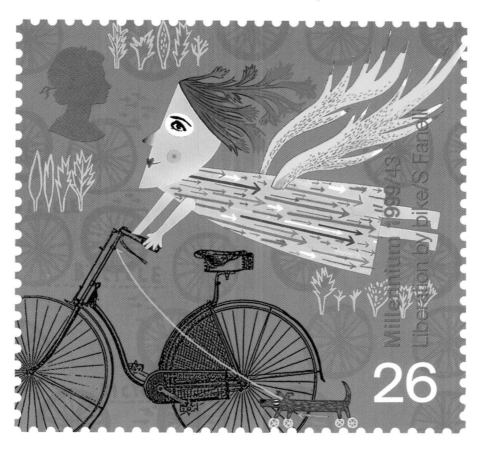

**Royal Mail 1999 Millennium Stamp
Commemorating the invention of the bicycle**

often see in children's books are flat and uninspiring; although some designer/artists do use the computer beautifully.

I would love to do illustrated books for adults. But there seems to be a general misconception – especially in the UK – that illustrations are just for children. I wish commissioners would realise the potential of illustrated adult books and the use of illustration in other, rarely seen contexts.

Apart from books I also do many one-off images for short-term commissions (book jackets, posters, design and magazine work).

One of my best-known images is the stamp I created for the Royal Mail Millennium series. I was asked to celebrate the invention of the bicycle and how it contributed to the emancipation of women, but also to convey the bicycle's environmentally-friendly nature. As part of my research I looked at early Art Nouveau posters and, in a way, my design is a contemporary variation on those themes. The Millennium Stamps series won a Silver D&AD Award in 2000. My work has received several awards and this helps to give me courage and confidence for the future.

It can be difficult working on your own as a freelancer. Inevitably I am forced into running a business as well as doing creative work. Phone calls, meetings and negotiations can easily take a disproportionate amount of one's time. So the hardest thing in organising my working life is to keep enough time for experimentation and learning – which are so vital for refreshing one's creative energy."

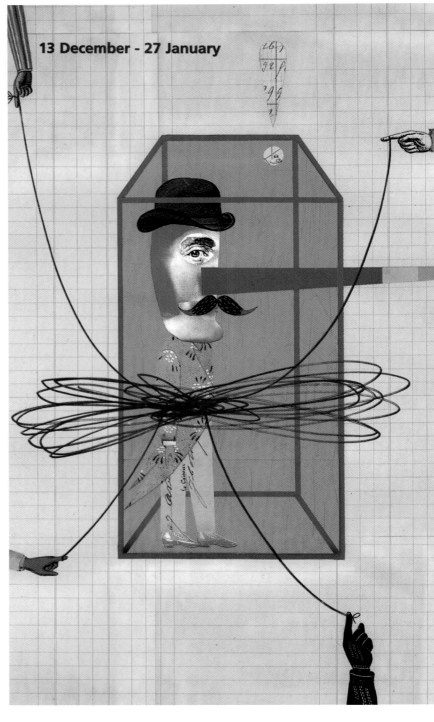

Right **The Magistrate Poster 2000**
Poster for the play by A.W. Pinero at the
Royal Exchange Theatre, Manchester
Opposite **Etching 2000**
Featured in Fanelli's personal portfolio

Below **Orpheus and Eurydice 1996**
An example of personal work

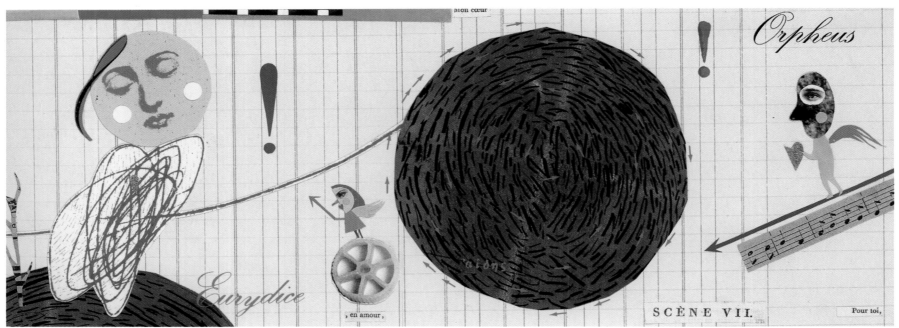

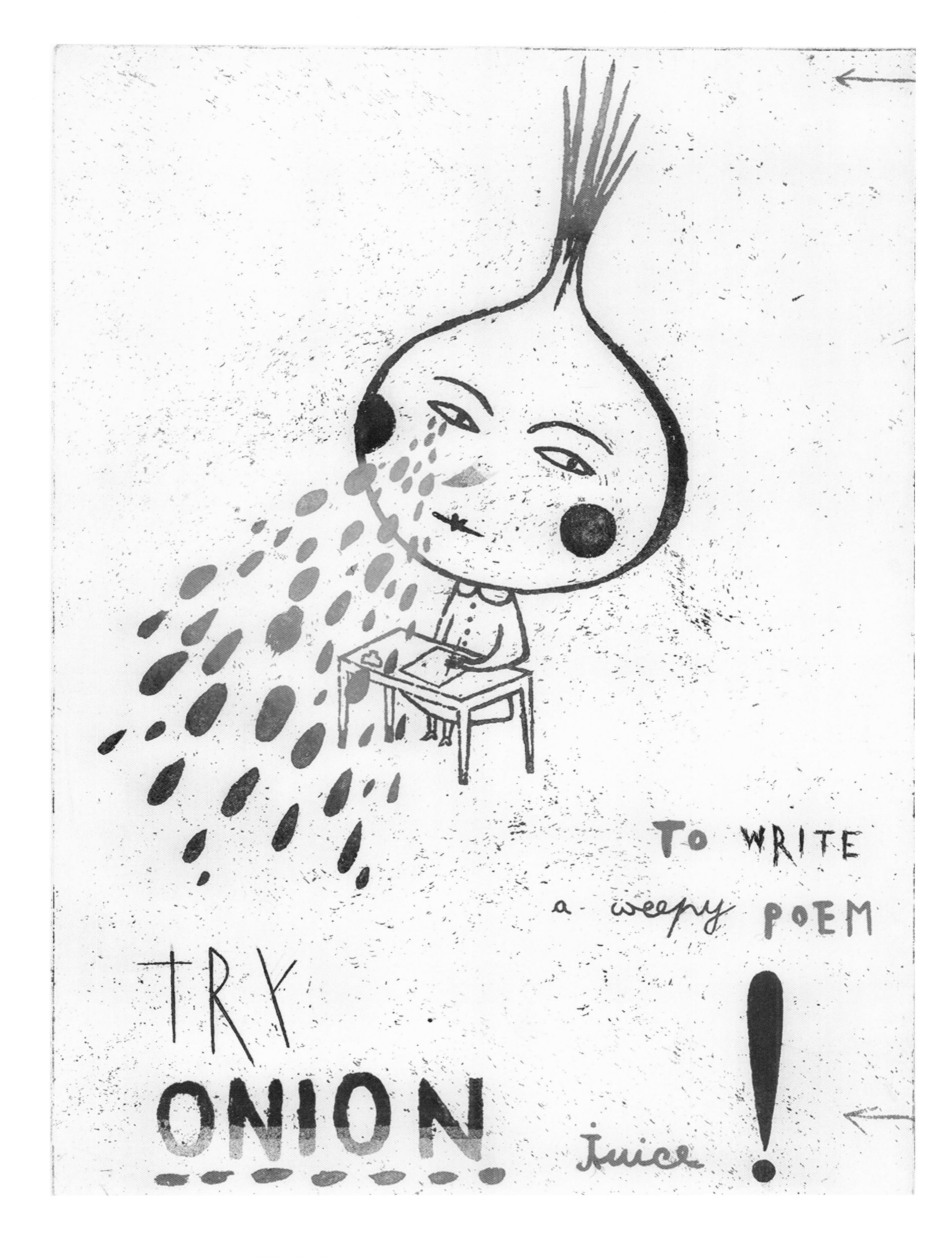

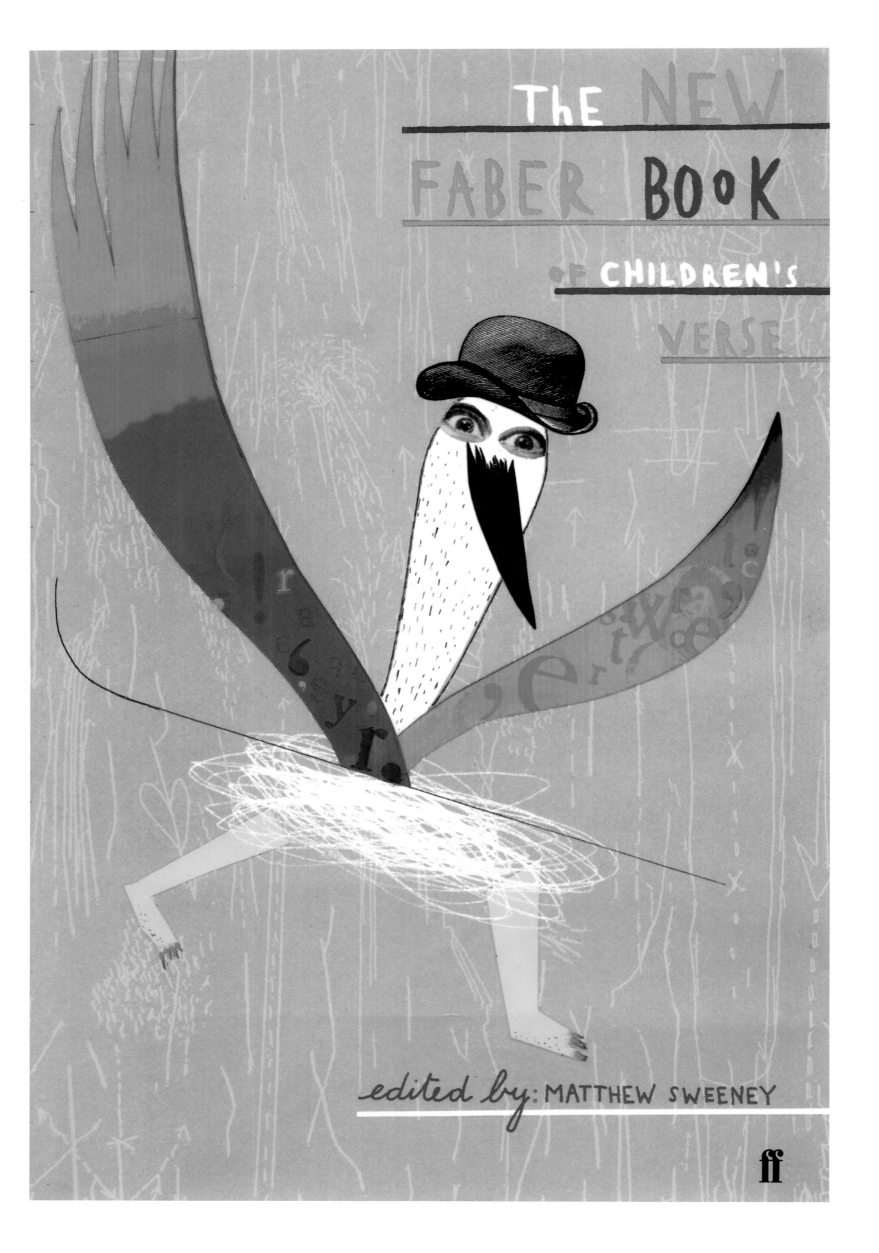

THE NEW FABER BOOK OF CHILDREN'S VERSE

edited by: MATTHEW SWEENEY

ff

Below & below right **First Flight 2002**
Children's book cover and spread.
Published by Jonathan Cape

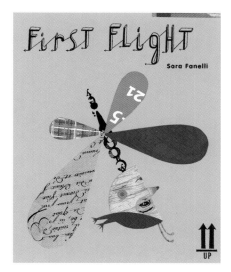

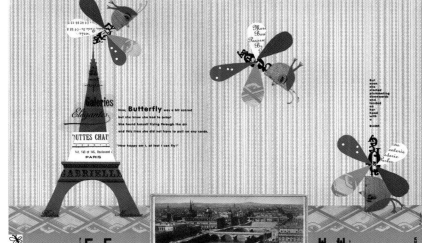

Opposite **The New Faber Book**
of Children's Verse 2001
Book cover for publisher Faber & Faber

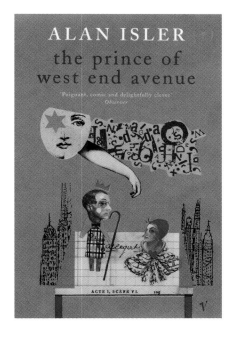

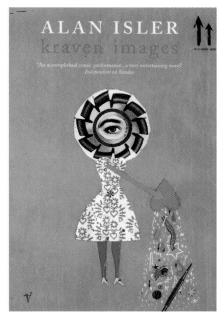

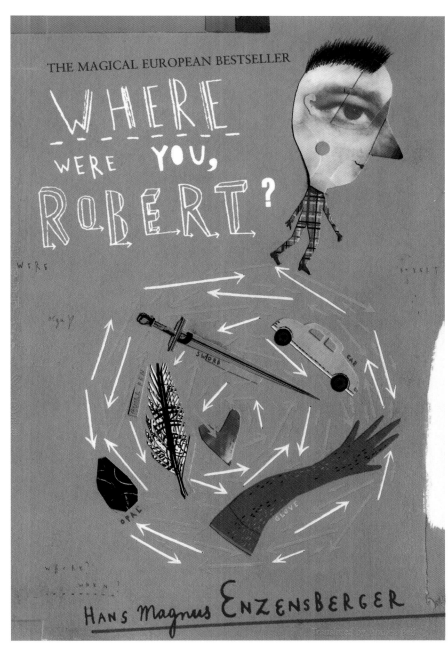

Above **The Prince of West End Avenue 1996**
Book cover for publisher Vintage

Above **Kraven Images 1996**
Book cover for publisher Vintage

Above **Where Were You, Robert? 2000**
Book cover for book by H.M. Enzensberger.
Published by Hamish Hamilton

"I studied Art and Design at The Cooper Union in New York in the early 80s where I discovered that I love the conjoining of language and typography. I studied with George Sadek, a Czech émigré, who had brought a weird mix of Dada and classicism to the typographic page.

I was influenced by Sadek and by the younger people working in New York who also were interested in a language-based design approach – such as M&Co and Stephen Doyle. I was also excited by the history of design, and I was deeply involved with literary theory. In my work and writing I wanted to demonstrate the relevance of writers such as Roland Barthes, Jacques Derrida and Jean Baudrillard to design.

Today, theory is a more indirect part of my work. I have internalised it; it is simply in the blood of everything I do.

I have always worked as a curator, first at The Cooper Union, running a small gallery and design collection, and then at the Cooper-Hewitt National Design Museum, also in New York City, where I have organised major exhibitions on twentieth- and twenty-first century design since 1992. I also teach design, chairing the department at Maryland Institute College of Art in Baltimore.

I am a curator, writer, and designer. Design is both my subject matter and my medium. I study a topic, and then I create the environments and print media needed to make that topic come to life for audiences.

Teaching forces you to articulate your ideas about design. It also keeps you in touch with young people – what they are thinking about, what they expect from life and society, and, above all, what they are wearing."

Ellen Lupton
curator
writer
designer

Skin: Surface and Substance in Contemporary Design 2002
The cover features a pattern design by the British design team Bullen.Pija. The book documents the fascination of merging organic forms with technological techniques, materials, and imagery in contemporary design internationally

Mark Farrow
designer Farrow Design

"I suppose I was good at art at school and wanted to go to art college to study graphics but it didn't last very long because I got a job in an advertising agency in my native Manchester.

I worked for agencies and design consultancies for a few years, and freelanced for clients such as Factory Records and the Hacienda. Music was something I cared about when growing up, and in that respect I did want to design for that industry. Peter Saville was at Factory at the time and was a big inspiration. The fusion of punk, fashion and music were a big influence at that time.

After a few years I moved to London with a folder full of work. I felt that I couldn't go any further at that stage in Manchester, and got a job with a company called XL on the strength of my work for Factory. After a year I set up a company called 3A with two other partners offering PR, interior

design and graphics. My work at the time was predominantly graphics for record labels, I loved music and record sleeves and it just seemed logical for me to work in these areas.

After a couple of years I split from my partners and formed Farrow, which became Farrow Design six years ago. I've never had any desire to grow into a great big company and I'm quite happy for it to be small. For me it's about having the right amount of people so as not to compromise the projects you work on in order to meet overheads. It's a difficult balance but I'm not interested in compromise.

Receiving awards is nice but it hasn't made any difference in terms of actually getting work. I suppose they make a difference as far as reputation is concerned but not as far as convincing a client to knock on the door.

About 40 per cent of our client base is in the music industry, as I made a conscious decision to move into other areas as so much music design now is about marketing the artist. A lot of commissioners just want the graphics to feature a picture of the artist and a bit of type. We're lucky enough now to be able to hand pick what we do in the music business. There are only a certain number of things you can do with a record sleeve before you start wondering what to do next. So we often try and go right against what's out there. With some groups, like Spiritualized, there's now a certain expectancy that we'll do something that's completely off the wall.

Broadening the client base has happened quite naturally. Last year, for example, we did a project for the Science Museum, 'The Making of the Modern World' Gallery, and the initial contact came through the person overseeing the project at the architect's who was a big fan of our

Swatch packaging for Cream album

work for Pet Shop Boys. He didn't know whether we would be interested or whether we would be capable but we met up with them and convinced them that we could do it. The aesthetic that we apply to a record sleeve is no different to the aesthetic that we would apply to a gallery the size of a football pitch.

An ideal client is somebody who lets you do what you want and thankfully we've worked with quite a few of those. There definitely has to be give and take on both sides, but I like to think that if a client chooses Farrow Design it is because of what we do and our reputation and we should be allowed to get on with it. That doesn't mean that I'm impossible to work with but I will strongly push for something I think is right, I feel that is your duty as designer. However, I can be convinced that I might be wrong, as you have to accept that you are answering a brief. We've never actually done self-motivated projects

as I find them quite difficult, and this is probably why college didn't appeal to me because you have to make a lot of things up.

We never pitch for work. Clients should be able to judge if you are capable of the job by the existing work that you show them. Also, pitches make the designer second-guess what a client wants and no designer does their best work that way.

I'm pleased with the variety of clients we work with. We could have a meeting with Kylie or Manic Street Preachers in the morning and then spend the afternoon with a roomful of curators at the Science Museum. I really like the breadth of work that we do (it keeps me interested): books, sleeves, galleries, corporate identities and packaging.

I find it tough to name influences because I get inspiration from all over the place, more so from fashion, art

and architecture than graphic design. Theory doesn't really affect the way I design as I'm quite instinctive.

With regards to the future, I'd really like to work for the cosmetics and pharmaceutical industries as I think our work would really suit those types of accounts. I'd maybe like to work with more fashion clients and I'd love to design graphics for an aquarium.

I get asked on a fairly infrequent basis if I'd like to direct music promos, I suppose people think it is a logical progression from our music work. It's not a great desire but never say never. I think I'd be more interested in designing furniture than becoming a music video director."

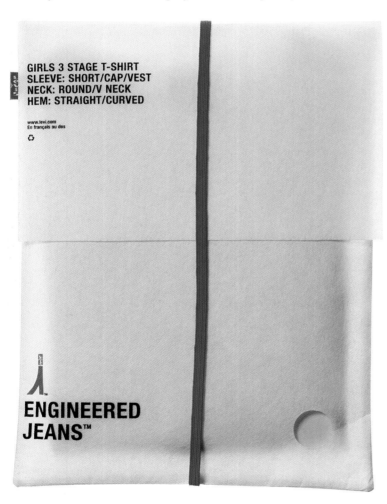

Above **Packaging for Levi's Engineered Jeans**
Right **Generic record covers for Deconstruction**
Opposite **Poster for Manic Street Preachers
single 'A Design for Life'**

A DESIGN FOR LIFE
MANIC STREET PREACHERS

A NEW SINGLE 15 04 96
TWO CDS, CASSETTE

Book design for the 1999 D&AD Annual

Gold awards 1

Silver awards 36

Silver nominations 54

Work accepted 509

Work submitted 11,107

British Design & Art Direction
Annual/CD ROM/DVD 1999

"I failed every exam at school. One bright teacher saw that I could draw and suggested I went to art school. So at the beginning of the 50s, aged 14, I enrolled at Maidstone School of Art, which saved my bacon. I was there for seven years.

After leaving art school I worked for an advertising agency in London, where I learnt how not to do it. I then worked for a packaging design company before setting up my own business when I was 25.

I got a two-day-a-week teaching position in a provincial art school and spent the rest of the week building a business. In the early 60s the design industry didn't really exist. Bank managers would throw you out as 'low life'. New business was ringing around your friends to see if they had anything.

Then in 1973, Alan Fletcher invited me to join Pentagram. My working life changed. It was like jumping forward 20 years in one stride. The most noticeable difference was that I could take holidays, which I never did in 12 years of freelance.

I have never understood the distinction between designers and business people. It's a Victorian notion propagated by crummy art teachers and bad artists. As a designer I make money for clients, even Michelangelo was an applied artist, he probably did jobs based on square metre and colour costs.

I have no idea how to describe my work, but I hope to God it's intelligent. I'm quite good at graphics but I have been doing it for 40 years – if you stand on your head for a long time you get good at it.

I mistrust trends and I'm extremely weary of them now I'm old. I am just interested in great design. This is why I have chosen Nick Finney. He is interested in the quality of materials and ideas, which will make him a long-term success."

John McConnell
director
Pentagram

Above **The Napoli Poster 1999**
One of a number of posters commissioned by the Napoli Foundation as contribution to the cultural image of the city

Above **Joyco 2000**
Joyco is a Spanish children's sweet manufacturer

Nick Finney
designer
NB:Studio

"Ever since I was a kid I've loved picture books, from Dick Bruna to Dr Seuss. Initially an aid to reading, they later became a sprawling collection of comic books and graphic novels. I think I was a fan of the medium because you could read them quickly – which is perfect for a lazy child.

At school, art was a strong subject but it didn't really grab me. I left school and worked in various dead-end jobs until one day while working in a bicycle shop I realised that I wanted to do more with my life than mending punctures. I decided to go to college and broaden my horizons.

I approached a technical college mid-term with a bunch of sketches and cartoons and they accepted me on a foundation course the same day. Following this I took a diploma in Graphic Design at Somerset College where the walls were covered with student awards, which I thought must count for something. I also thought it

wiser than going to a big name London college and blowing my student grant on the rich nightlife in the first week.

I had no definite career plans, I just wanted to move to London and work as a graphic designer as I thought this was where it all seemed to be happening. My first job was assisting the designer Howard Brown for a year, before I moved to Pentagram to work for John Rushworth, where I stayed for five years. It was a real shift from working solo with Howard, which was very quiet and craftsman-like, to Pentagram which felt like an riot of people, noise and deadlines.

Pentagram was a great place to work: creativity was championed and design heroes floated in and out with talks and slideshows. That, coupled with communal lunches and a fantastic working environment, meant that the decision to move on was a difficult one.

One night in the pub with my Pentagram colleagues Ben (Stott) and Alan (Dye) we talked about starting up our own company, as we'd all been there for some time. Having recently bought a house, Alan wisely promised to join us when we were more financially solvent. So, Ben and I moved to his spare bedroom – and started scraping a living together.

We launched in 1997 with no clients which we thought was risky even at the time. Our name came from our initials (NB) and we liked 'studio' as it sounded, well, studious. With Alan joining later the alternatives of BAN or NBA just didn't cut it, so we stuck with the original. We did a couple of freelance jobs for Pentagram that helped pay for food and pestered friends of friends until projects came in. Our first big job was for Knoll – a sales brochure for a new range of office systems furniture that was fortuitously designed by some ex-Pentagram friends.

Knoll 60th Anniversary Poster
After the popularity of an advertising campaign in *Blueprint* magazine NB:Studio were asked to produce a series of six limited edition posters. This is one from the set

The brochure was well received within Knoll and gave us the chance to experiment with the work we did afterwards. We had proved ourselves as professional designers, so from then on we were almost left to our own devices with Knoll. This is true to this day and they are one of our most cherished clients.

We don't have a company philosophy as such. If anything we believe in using the power of a good idea to solve a problem. This is our own business and we want it to be fun, we are lucky that so far it has been. We are not natural businessmen. We have never been driven by money, although we are conscious that as our reputation has grown, so have our staff, overheads, rent and headaches.

I love our studio and the fact that it's like a boy's bedroom (full of junk). We're all friends, I shouldn't be sitting here talking to you alone, Ben and Alan should be here too. There's this kind of all-for-one, one-for-all atmosphere here, which is great – if we could bottle and sell it we would be millionaires.

We find it difficult to generate work which isn't commissioned by a client. We thrive on feedback and generally the jobs themselves improve and mature with input from clients. It feels a bit pretentious if the work is purely self-initiated.

About 90 per cent of our work is print, however we recently surprised ourselves by designing an award-winning website for Knoll using the same principles as we use on all our work: ideas, simplicity and fun. I'm not wedded to any medium but I do love print. Print is tangible, it is the physical embodiment and end result of the blinking lights, crashing computer programs and late nights. With print you can't cheat time, you have deadlines, so the decision to stop tinkering is made for you.

Happiness is getting your job back from the printer and knowing that the decisions you made were right. When the Knoll 60th anniversary posters arrived from the printers, it was like unwrapping a present. We took them out of the pack and were knocked out by the stench of the silk-screen inks. When we'd recovered we noticed that the posters were actually quite striking. The client loved them. It's a great feeling when you know you've got it right and there are very few things that can compare. This is why I'm a graphic designer."

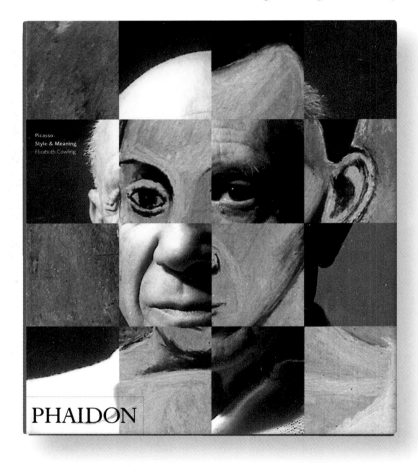

Above **Picasso: Style and Meaning**
For this book jacket for publishers Phaidon, an approach was needed to get across the biographical nature of the text. NB:Studio settled on a jigsaw puzzle portrait

Above **Gavin Martin Associates Stationery**
This stationery range for printers Gavin Martin Associates uses high quality cotton paper and fine printed patterns which produce a moire effect, giving an almost banknote-like quality

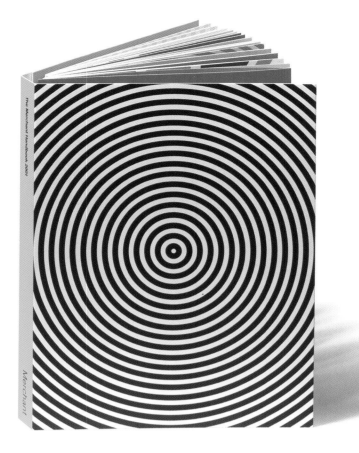

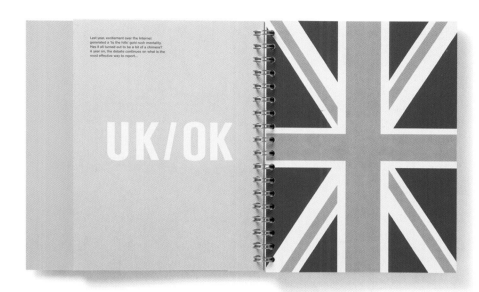

The Merchant Handbook
NB:Studio wanted the design of this book to reflect the rich variety of information that it carried and so chose a format that could take different colours, stocks, sizes, and weights to give an almost scrapbook-like feel

Below **Knoll Exhibition Posters**
Asked to do something double-quick for
an exhibition stand for Knoll furniture,
NB:Studio produced these simple giant
posters which use the concerns of the day
as a cue to the illustration

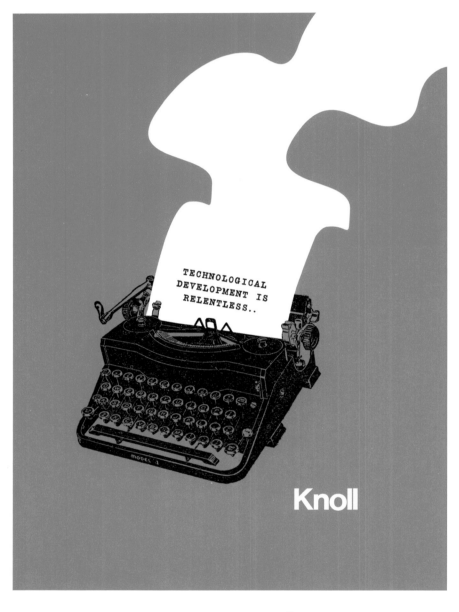

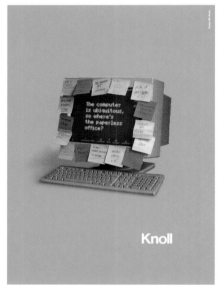

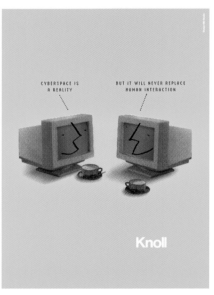

Below left **Christmas Mailer**
One of NB:Studio's first Christmas mail-outs
was this appropriated rubber stamp adorned
with the un-festive 'Humbug' message.
Recipients could have seasonal fun by
spreading the word via their mail

Below **Requiem for a Dream Film Poster**
This poster for client Momentum Pictures
echoes the film's striking cinematic sequences
and gut-wrenching narrative by splicing two
photographs to give an optical twist

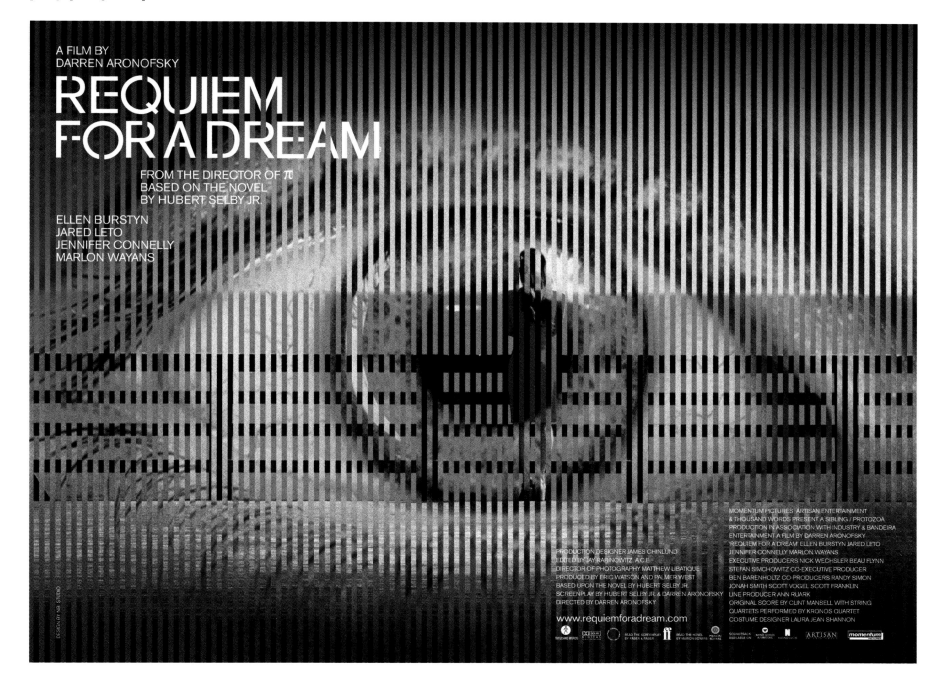

**Michael
Wolff**
founder
The
Fourth
Room

"I was born in London just a few hours after my Russian parents had arrived from St Petersburg to make a new life in England. I emerged more or less intact from a variety of English educational institutions.

After studying architecture at the Architectural Association, I took courses in building, welding, dress design and interior design at Hammersmith School of Art.

From there I joined the army where, as a Private in the Royal Army Service Corps, I continued my studies into humanity in institutions – a perfect course for what I've ended up doing, which is helping companies to be the best they can be.

I entered the world of design in the mid-50s as an architectural designer, then as a product designer and then as a graphic designer. After ten years I started my own company, Wolff Olins, in autumn 1964.

For me it lasted 20 years. Enough was enough and I left to build a new design company, Addison. In 1998 Piers Schmidt, Wendy Gordon and I founded the Fourth Room. So far that's been another exhilarating roller coaster ride. If it isn't daunting and difficult, I don't really enjoy it. Luckily I, and all my partners in The Fourth Room thrive in deep waters. We swim easily in the contradictory currents of corporate life.

I've never stuck to one view of what is good in design.

My personal goals have always remained the same: to help organisations to express themselves, in their own particular way, for the benefit of anyone they're involved with, and to do this in a way that brings value and delight to as many people as possible."

Red and Yellow Cartoon Booklet
Wolff felt that there were too many beautiful stamps and not enough funny ones. Cartoonists Larry and Jack Ziegler, Charles Barsotti, Mel Calman and Leo Callum were all friends of the designer and undertook the project. Wolff hoped that these tiny cartoon stamps would help to put big smiles on as many people's faces as possible

Fred
Flade
partner
De-construct

"I was born and grew up in Munich. After school I did a placement in an advertising agency assisting the main designer, which gave me enough insight to know that I wanted to work in communication and design. I did a marketing course and then came to the UK in 1994 to take a foundation course at Kingston. I went on to study for a BA in Visual Communication Design at Ravensbourne.

I chose to study in the UK because I felt design education in Germany was too much focused on technical aspects. Design education in the UK seemed more creative and open to the generation of original ideas. Unfortunately, recent visits to colleges have shown that things have changed a bit. A lot of the students I come across seem keen to just learn about the technology rather than creativity.

When I started college my main influences were the contemporary established designers with

international reputations such as David Carson, Neville Brody, Malcolm Garrett and Swiss designer Joseph Müller-Brockmann. Typography has always been my main focus, and at that time taking it on screen was quite a new concept. There may have been a lot of designers doing interactive design but there weren't that many who understood typography.

Understanding the role of typography in the creation of information hierarchy and visual structure is absolutely essential. I've always been interested in other disciplines [like architecture] which can inform design in terms of composition, contrast and structure. This is especially relevant to interactive design as I believe you need to have a product design approach to projects in order to ensure their effectiveness.

While at Ravensbourne I opted to study interaction design because the possibilities of the medium seemed

to be vast. At college I never found the web that appealing as it seemed very limited. I thought the future would be CD-Roms. As it turned out that medium was quite short-lived, a fact that certainly encouraged suspicion about the longevity of certain other technologies.

During the final year of college I came second in the D&AD Student Awards and won a placement with Phillips in Eindhoven for three months thanks to an RSA student design competition. When I returned I joined Deepend as a designer and then became a design director in 1999. When Deepend folded in 2001, I co-founded De-construct with ex-Deepend colleague Alex Griffin.

There are a lot of people in my age group in other small design companies whom I find tremendously inspiring. For example High Res's work is very interesting, pushing the boundaries of design for the web.

Hoover Website
This website was designed (by Flade and David Streek at Deepend) to showcase Hoover's Triple Vortex system. Technical drawings and x-ray images of the product reinforced Hoover's commitment to high levels of product engineering and added a sophisticated high-tech feel

I also find all the designers who work with me inspiring, as it's great to see the way other people approach problems.

I wouldn't say that I have developed a typical style as it really depends on what the project is about. When given a brief, I tend to isolate the core of the project and find my inspiration accordingly as inspiration has to relate to the client's culture as well as your own. For me a good designer is someone who is able to step back and communicate appropriately rather than always expressing his or her own style; you can do that in your own time on personal projects.

When we talk about brands and how to communicate their essence as designers we can enter so many different levels of discussion. It is possible to define behavioural characteristics that you can relate to a brand, which the interaction, animation and design have to reflect. That's when you uncover the emotional aspect of a brand and you inevitably build up a brand personality in your head. With a ready-established brand; the challenge lies in expressing its values, tone or meaning in an environment (eg online) that is sometimes new to it. Taking a brand into the digital space in an appropriate way is something that has always fascinated me.

Looking at how I approach a brief initially, it's important not to go straight to the computer, but to start sketching first. A designer has to distil his or her thoughts and collect material well before starting to mock up on screen. Work on screen always looks finished and if a client sees it he/she will automatically think 'That's it then', whereas a sketch has the potential to open a conversation rather than close it.

By its very nature, design for print has to go through a thorough art-working process before it goes to the printer.

You have to make sure that every little detail is perfect. Digital design is slightly different as it allows for a more evolutionary process. Aspects can be changed up to the last minute but the danger of this is that some designers can become complacent.

I judged the D&AD awards last year and was amazed at how many similarities there were between the 450 sites we looked at. It was clear that designers are running out of ideas and are just looking at the medium itself for inspiration. It makes you wonder whether technology pushes us into certain pre-produced solutions. Obviously there were some very good websites, but I think we have to ensure we do not get carried away with relying on technology, and becoming formulaic.

I believe that a designer has to be as flexible as possible and work across as many different media as they can. I do print work, websites, moving image, CD-Roms and I've also worked on projects for interactive television. In order to stay fresh you need to jump around disciplines and give yourself new challenges.

For me, the future means being able to carry on learning different things from different people; they could be a designer, an artist or just someone I meet on the bus. I don't want to become complacent and feel I've learnt everything. You have to keep an open mind. The merging of different technologies is going to happen and that is why I believe that flexibility is so important. If I had to give any advice to students it would be, instead of specialising too much in one technology which in 12 months' time might be old news, learn the basic principles of good design."

Design Museum Website June 1999
The website was launched to coincide with the Design Museum's tenth birthday. Deepend's creative solution (designed by Flade and Simon Waterfall) is based on the concept of a cube as a representation of the Museum, both in terms of structure and ethos

Team Bentley Website
A website to promote Team Bentley's return to Le Mans after an absence of 70 years. The site, a collaboration between Fred Flade and Alex Griffin, took the form of an online documentary, tracing the history of Bentley's racing career. The visual and interaction designs combine the raw energy of racing with the elegance and heritage associated with the Bentley brand

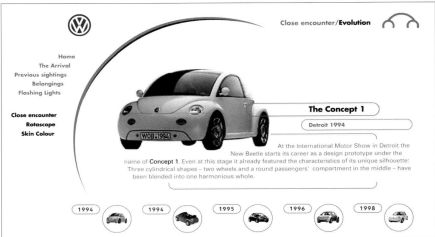

New Beetle Website 1999
Created to build anticipation prior to the launch of the new Beetle in November 1999, the website (designed by Flade and David Streek at Deepend) promotes the car as the ultimate lifestyle statement for the wired generation. Designed to reflect and affirm the cultural values of this sophisticated group with their high expectations of innovation and quality, it courts controversy by rejecting nostalgic content for a modern 'Alien Arrival' metaphor

It was summer (0.37)

(01.37)

Keep it coming.....
Keep it coming (1.58)

(01.55)

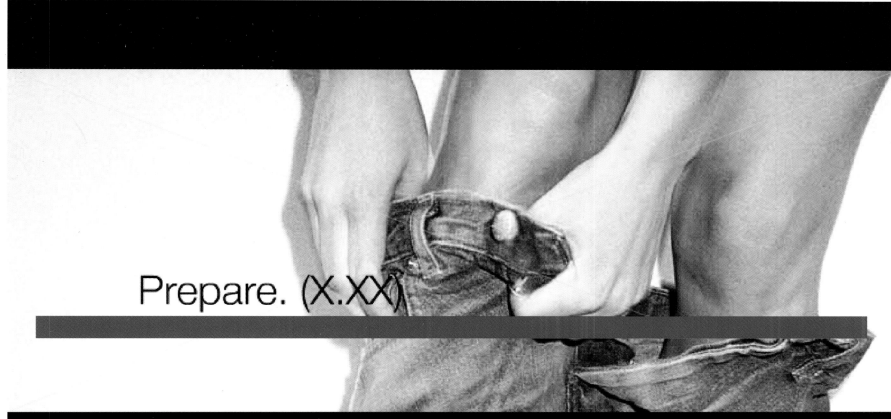

Prepare. (X.XX)

(00.46)

NEW ORDER : GET READY : FOR : Source · Perform · Listen · Watch · 01 Crystal
© 2001 London Records 90 Ltd.

WEA London Records Website
WEA London Records appointed Deepend to create a website (designed by Alex Griffin) to promote New Order's album *Get Ready*. Flash navigation, inspired by track duration times, indicates the length of time the user has spent on the site. As users progress through the site, they experience different environments complemented with specially edited audio samples from the single 'Crystal'. With the high level of interactivity offered, no two journeys are the same

Alan Fletcher
designer

"I failed to keep pace with lessons at school and took refuge in drawing. Rejecting the services or banking as career options for second-level dum-dums, I opted to study art and design at Hammersmith, the Central School of Arts and Crafts, the Royal College of Art and Yale.

After freelancing in New York, Spain, Los Angeles, Milan and Venezuela, I returned to London in 1959 to work as a design consultant to *Time* and *Life Europe* and teach at the Central School where Colin Forbes was the head of the graphic design department.

In 1962 I co-founded Fletcher Forbes & Gill, working for clients such as Pirelli, Cunard, Penguin Books, BP and Olivetti. In 1972, I co-launched Pentagram where I worked with Reuters, the V&A, Daimler Benz, Lloyd's of London and Arthur Anderson. In 1992, I left Pentagram to form my own studio.

Although my images seem familiar there is usually a sting that makes the viewer look twice. I'm not afraid to revisit the same idea, thought or technique, obsessively reworking it to achieve a better execution or a stronger effect, to give it an extra twist to deepen the meaning or just to amuse. I don't have a problem with this trait as Monet painted the face of Rouen cathedral at least 30 times and who knows how many times Hokusai drew Mount Fuji?

One quotation has echoed throughout my career: "Function is fine but solving the problem is not the problem. The real problem is to invest solutions with visual surprise and above all with wit... A smile is worth a thousand pictures."

I've nominated Vince Frost because he looked like he needed some help."

Words and pictures on how to make twinkles in the eye and colours agree in the dark. Thoughts on mindscaping, moonlighting and daydreams. Have you seen a purple cow? When less can be more than enough. The art of looking sideways. To gaze is to think. Are you left-eyed? Living out loud. Buy junk, sell antiques. The Golden Mean. Standing ideas on their heads. To look is to listen. Insights on the mind's eye. Every status has its symbol. 'Do androids dream of electric sheep?' Why feel blue? Triumphs of imagination such as the person you love is 72.8% water. Do not adjust your mind, there's a fault in reality. Teach yourself ignorance. The belly-button problem. Visual charades. What has an ox to do with the letter A? The art of looking sideways. How to turn knots into bows. When does 1 and 1 add up to 3? Why sit with your back to the view? Notes on the

PHAIDON

Above The Art Book
The idea for *The Art Book* was born out of the archives of art and design publisher Phaidon. It presents an A to Z of famous artists as an accessible introduction to the world of fine art. For instance, Leonardo Da Vinci and Roy Lichtenstein share a spread. Translated into over 20 languages *The Art Book* was on *The Times* top ten list of books for several weeks. Each letter on the front and back covers employs a different technique, medium or texture – to express the variety of painting styles demonstrated within

Above The Art of Looking Sideways
Alan Fletcher's book is a primer in visual intelligence, an exploration of the workings of the eye, the hand, the brain and the imagination. It is an inexhaustible mine of anecdotes, quotations, images, curious facts and useless information, oddities, serious science, jokes, memories – all concerned with the interplay between the verbal and the visual, and the limitless resources of the human mind. Loosely arranged in 72 'chapters', all this material is presented in an inventive series of pages that are themselves demonstrations of the expressive use of type, space, colour and imagery

Vince Frost
designer and founder Frost Design

"I opened Frost Design in November 1994. The biggest drive for me was – and still is – to come up with ideas, solve problems and create great work. I'd studied graphics at West Sussex College of Design, then worked with Howard Brown before joining Pentagram in 1989. I got very interested in gimmick-free design: the work of people like Alan Fletcher, Paul Rand, Fabien Baron and Alex Brodovitch became a big influence on me. Working at Pentagram, doing things like creating the quarterly photography publication *P-magazine* with John Rushworth, taught me how to solve problems in a mature way. I was made an associate partner in 1993.

I don't think Frost Design has a style. We have an approach. The boldness and immediacy of the work comes from a desire to create design that's as direct and accessible as possible; to communicate through design. We have an eclectic range of influences, and that helps us to create something

appropriate for every job. That need to communicate is just as relevant to other mediums. The complexity is being able to understand what the technology is capable of. The simplicity and boldness of our work means it easily translates to non-print formats.

Having said that, and having designed websites and TV graphics, I'm still always drawn back to print. I love the tactile quality, the physicality, the smell and the weight of print. My father was a printer so it's something I've always been exposed to.

My best-known print job? Probably the redesign of *The Independent's Saturday Magazine* in 1995. The publishers wanted it to become more of a lifestyle magazine, and the aim of the commission was to increase advertising revenue. It was a big learning curve for me. The whole magazine had to have a turnaround period of three days, each week.

Before then, I'd always taken as long as it took to complete jobs, but this consisted of immovable deadlines and working with a team of people geared up to meet these constraints.

The company is now four-strong. We rely purely on work that comes in: we don't advertise or approach clients or market ourselves. Maybe we should, but I'm more interested in quality than money. The big motivation for me is the fear of producing mediocre work. I'm passionate about architecture, typography, art and photography, and our clients at the moment tend to reflect that; they include the Serpentine Gallery and The Wapping Project. I'm also art director for Laurence King Publishing. In fact, we are designing a total of 15 books for several different publishers.

Another influence is advertising that's abstract, spontaneous and witty. Sometimes I feel like the playfulness of design has been taken over by

02/09/95

Independent
Magazine

Can Britain bite back?

The Independent Magazine
Photography by Giles Revell

Below **NHS Stamps 50th Anniversary Set**
To commemorate the anniversary of the NHS, Frost created this series of stamps featuring photography by Albert Watson

Left & Below **Keith Haring Exhibition Leaflet**
This literature was designed by Frost and Sonya Dyokava for an exhibition curated by The Wapping Project

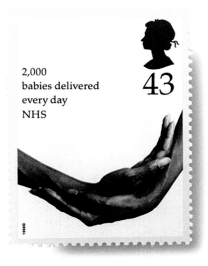

2,000 babies delivered every day NHS

43

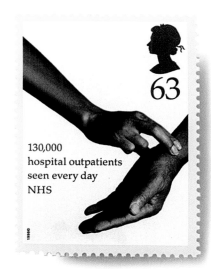

130,000 hospital outpatients seen every day NHS

63

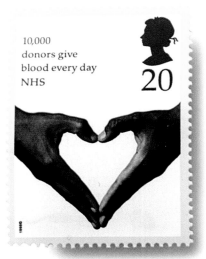

10,000 donors give blood every day NHS

20

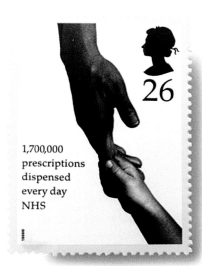

1,700,000 prescriptions dispensed every day NHS

26

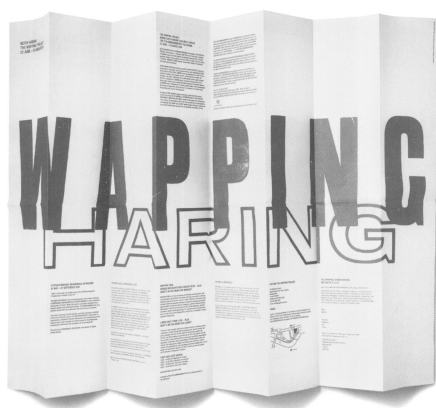

business and there are too many commercial constraints. We work quite a lot with ad agencies; our campaign (through Ogilvy & Mather) for ING Barings was nominated for a Silver Award at D&AD this year.

Future plans? I'd like to be more involved in architecture in terms of signage or identity, and I'd like to have an on-going fashion brand to work on. But I'd also like to be more involved with education. At the moment, my contribution is the occasional talk and lecture. I recently did a workshop in Durban with 40 students where we created a magazine in a day. It was great because the students had something to take home with them."

Big Magazine
Frost designed seven issues of this personal project on his kitchen table using letterpress typography and printed lithography. Spreads from the first issue are pictured

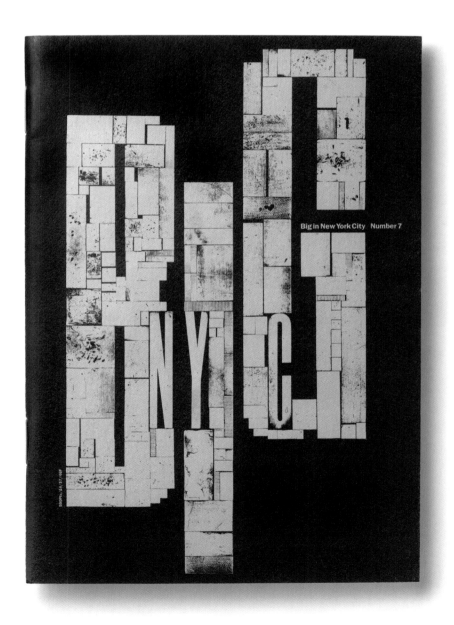

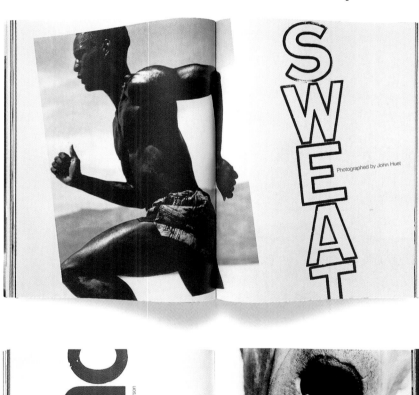

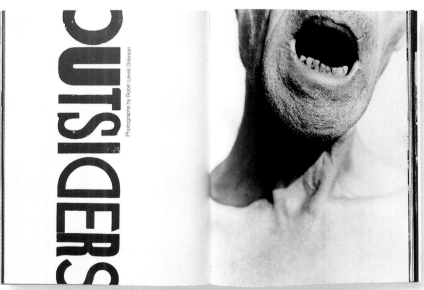

Below **D&AD Ampersand Issue 11**
Frost Design has designed British Design
& Art Direction's (D&AD) newsletter for
the past five years. This particular issue
was designed by Frost and Melanie Mues
with cover photograph by Derek Hiller

Right **Business Card for Faber**
& Faber Publishers 1998
A simple idea that was nominated
for a Silver D&AD Pencil

Below **4th Estate Catalogue 1997**
This catalogue was produced using only
wood type and hot metal. Frost claims that
it is one of the largest jobs of this type
produced on a commercial scale which
uses this old-fashioned technique

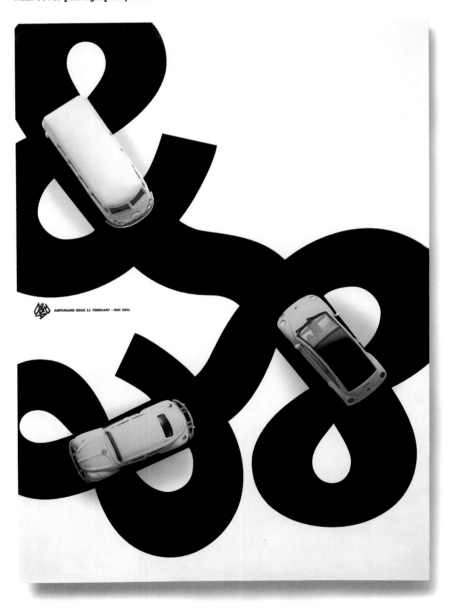

Above **4th Estate Catalogue 1999**
The re-interpretation of the publisher's
catalogue as a pack of cards

Laurence King Identity 2001
Frost created the publisher's new corporate
identity and extended the branding further
by creating this in-store promotional stand

Bernard Lodge
designer

"At the Royal College of Art in the late 50s, I had planned a career in general graphic design, but then I saw the work of Saul Bass. I got excited about combining 2-D graphic design with the dimension of movement. So, when I saw an ad for a designer post at the BBC, I jumped at it. At that time, designers were mainly employed adding typographic titles to programmes. We had to lobby producers, selling ourselves as conceptual designers till we created a demand. By the time BBC2 was launched we were a nucleus of young, fairly inexperienced designers, trying to 'write the book' on TV graphics.

Work on the 'Doctor Who' titles gave me access to electronic effects. It made me aware of an approach that was essentially televisual, not just scaled-down cinema.

In 1967 I joined Streich Fletcher Perkins, a commercials production company. I learned a lot about advertising, but creativity was limited by the agency scripts. Then colour television was launched, so two years later I was back at the BBC revelling in the possibilities that colour offered for another seven years. To give still photography some illusion of movement I became preoccupied with various image transition techniques. Trumbell's work on Kubrick's '2001' inspired me to lash up my own modest version of the slitscan effect.

Two years after going freelance, a BBC colleague Colin Cheeseman joined me to set up Lodge Cheeseman Productions. In 1979 motion control and computer graphics were seriously taking off. We became a factory, turning out commercials and animated logos, and occasionally a job in which we could take pride: the first UK commercial with fully-shaded computer graphics for Michelin, and sequences for Ridley Scott's 'Alien' and 'Bladerunner'. We closed the company in 1986.

At the Moving Picture Company I got to play with the latest electronic toys, but after five years and too many all-night edits, I drew a line. There were other things I wanted to do. In my limited spare time I'd been printmaking and painting. This led to the publication of my first children's book. I've since produced a further ten books.

The most important piece of advice for a young designer is not to be too obsessed with technique. This comes from someone who was. You really have to get inside the subject so that the graphics relate intimately to it.

Pat Gavin is so original and has such energy in his work. There are other designers that I admire where a level of 'good taste' is more apparent, but I'd rather have some of the Pat Gavin energy than cool minimalism."

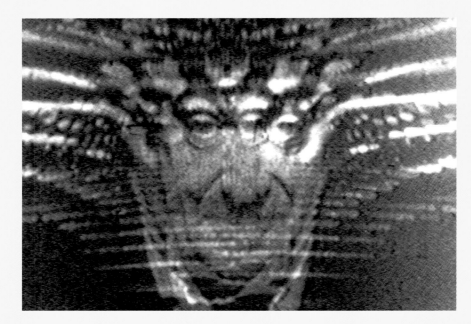

Top **Doctor Who Titles**
The second of five versions made for this long-running science-fiction series

Above **The Mind Beyond Titles**
A drama series that dealt with the paranormal

Pat Gavin
commercial artist

"I went to Hornsey College of Art in the mid-60s to study painting and found myself doing interior design. I was rubbish at it, so I went into graphics where I was lucky enough to have some very inspirational teachers such as Roger Law, Peter Fluck and Ron Jackson.

When I left college I began working as a freelance illustrator and after six months much of the work dried up, so I got a job working for Rediffusion Television as a graphic designer. I had never really thought about a career in screen graphics, as I liked the idea of being a freelance illustrator more. This was in 1967 and I spent most of my time constructing promotion cards saying 'End of Part One', but when the programme makers realised they had an illustrator in-house, they began to let me illustrate poems and stories for children's programmes. I worked on 'Magpie', which was the bad boy of children's television. I designed the entire programme's horrible late-60s graphics.

In 1969 I went to London Weekend Television where I got lucky with religious programming. Malcolm Stewart was this unconventional head of God programming and his idea for a religious programme was more akin to 'Ready Steady Go' and pop programming. So we made pop videos to illustrate songs and the first animation I did was for the Bob Dylan track 'Father of the Night'. It was little more than a bunch of illustrations in a kind of Milton Glaser/Alan Aldridge style that were jiggled under a rostrum camera to simulate movement.

At the time my other influences were Heinz Adleman and Walt Disney, but my real roots are in the fine arts, anything from Wild West paintings to Mondrian. Music, and literature by authors such as Graham Greene and Bukowski have also influenced me. I'm very interested in modern history too.

I spent years developing the idea of the animated image on television, as there wasn't any at that time because the budgets were so low. If you wanted anything like that you had to do it yourself. I did want to do film but that was impossible because of the union. If I, for example, screwed a light bulb in on a shoot I would have 60 technicians walk out on me to go and sit in the canteen for half an hour. As there were no union agreements about animation I followed that route.

My interest in music came in handy when I met Leonard Bernstein, the composer of 'West Side Story', and was invited to design and direct the overture and orchestral interludes for his opera 'Trouble in Tahiti'. I also designed the blue screen sets. This led to my generating, writing and directing a music programme about the French composer Erik Satie. I learnt to animate this one, and tutored by Gerry Hibbert I learnt quickly.

I left LWT in 1989 and up until then my most recognised work was the titles

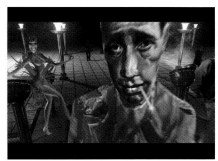

South Bank Show Titles
Title sequence No.3 (1978)
Title sequence No.6 (1983/84)
Title sequence No.10 (2001)

for the 'South Bank Show', for which I've just completed the tenth version. I think that they got so much recognition then because we had been living in a visual desert. A sequence for the 'South Bank Show' has got to look right and say the right things. So if you have John Wayne in it you've got to put in someone else who balances it editorially such as Josephine Baker; to illustrate the diversity of the programme. The titles have always had to reflect and anticipate the programme's content. I am a commercial artist so I believe it is my job to understand popular culture and reflect what's going on.

After LWT I started to direct commercials and was pleasantly surprised at how good the budgets were in comparison to television graphics. I believe this is basically because graphics are a periphery in TV. I always tell students if they want to get a reasonable budget they should go into an industry where their skills are central and the focal point of that industry.

Currently my interests are painting and digital set design. We are presently working on another Bernstein musical 'Candide' with the National Theatre where we have to extend the original stage production into a TV production using virtual sets. The current 'South Bank Show' titles have rekindled my interest in character animation, but this time using new tools.

I was an outside assessor for the Royal College of Art and Dundee University. I'm surprised at how much students now work from home, when I think that the most important thing I got from being at art school was meeting my generation and working within a climate of ideas.

I think if you decide to study art or graphics it is vital that you also take a business course. If I'd been taught about contracts and agreements I would have certainly been more secure and gone further down the road in what I wanted to do. You can't wait for the work to come to you; you have to create the situation and environment that implies an understanding of business politics to attract work. That should be compulsory in any creative environment."

Trouble in Tahiti Titles 1973
These titles were produced for Amberson
Video, New York

Poirot Titles 1989
Gavin produced this sequence for LWT's
popular series

Below **Clive Barker's A-Z of Horror Titles 1995**
The series was launched by the BBC

Above & Left **Martell Commercial 1995**
Gavin directed 'The Legend of Martell' spot
for advertising agency Ogilvy & Mather

Expert Witness Titles 1996
Gavin directed this sequence for LWT

Niklaus Troxler
graphic designer Niklaus Troxler Design

"As a boy, I loved Herbert Leupin's posters. I saw them in the streets – for Eptinger Mineral water, for Circus Knie and for the Motor Show of Geneva.

I passed the art school entrance examination in Lucerne, Switzerland, but my parents thought I should learn a 'serious' profession first. So I began an apprenticeship as a typesetter. The training took four years and I learned to love playing with type and composing letters. When the apprenticeship ended I went on to study graphic design. When I left art school I became an art director at Hollenstein Creation in Paris.

When I was 19, I started to organise jazz concerts in my native town of Willisau, so I left to open my own studio in 1973 and organise concerts. My favourite medium is the poster. It's the medium of the street. But I also design books, CD sleeves and corporate work. After a few years,

I started organising a four-day jazz festival. This summer it will be the 27th.

I never wanted my work to look like that of a typical Swiss designer, as when I trained I seemed to be surrounded by Helvetica or Akzidenz Grotesk. There was nothing spontaneous or hip, consequently I was more influenced by pop or 'street art'.

But the greatest influence has always been jazz. Whatever I need for good design, I can find it in jazz: individualism, structure, colours, contrasts, sound, shapes and form. Individuality is the most important aspect in jazz and in design.

My nominee is Alexander Gelman. He knows a lot about shapes and forms. He can reduce ideas to the max. His work is surprising as he has no particular style, but he continues to discover new ways to get fresh and spontaneous results – even if he is

solely working with type. He is a complete graphic designer. His new design for the Art Directors Club of New York is fabulous and his poster for Paper Expo will become a classic. He is not just celebrating a new wave of design but is always looking to go on to find new solutions and new surprising results."

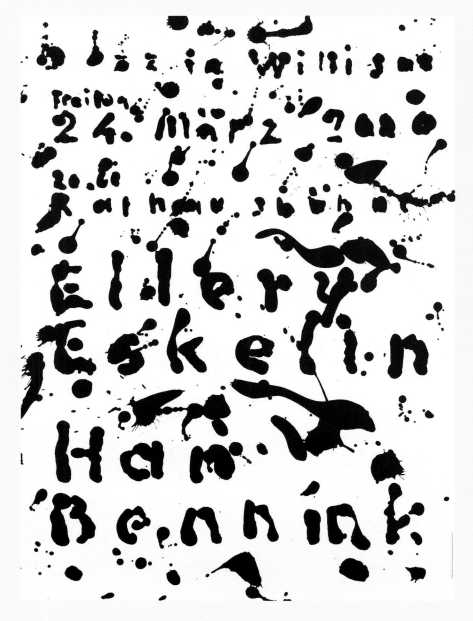

Jazz poster for a concert with Ellery Eskelin and Han Bennink March 2000
Currently Troxler's favourite piece of work, this poster was designed for a duo concert of saxophone player Ellery Eskelin and drummer Han Bennink. During the design process, Troxler played the duo's music at full volume. He started with pencil and colours, then changed to brush and ink. The poster is pared down to just the information text, but feels very spontaneous

Alexander Gelman
designer
Design
Machine

"I intended to become a painter, but while attending art college I took a design class and I was hooked.

The fine art training already frustrated me. I found it very restrictive and academic. In contrast, everything about design was attractive to me. Design was an exciting activity — challenging and stimulating. It required brains, ideas and at the same time offered the opportunity to do something useful that ordinary people deal with on an everyday basis.

However, my design teachers didn't know much about the subject, so I started learning from books, magazines and older students. I began working for newspapers and publishing houses, doing illustrations and type treatments for children's book covers. I was so busy for a couple of years that I barely graduated.

At the time I had a very strong idea of what I wanted to do. I admired a lot of

designers, but what I was doing was completely different. My effort to make a maximum impact with the minimum of means yielded results that seemed unusual, or even shocking to my clients and colleagues.

After school I continued freelancing for publishing houses and luckily got a couple of very high profile jobs for a concert series for pianist Van Cliburn and for the London Royal Philharmonic Orchestra. The visibility of these projects brought me recognition outside of the design field.

With a fat portfolio of high profile professional work, I moved to Europe and spent two years travelling around the world before settling in New York in 1993. I spent two years with Access Factory, a design boutique in downtown Manhattan.

At Access Factory, I started experimenting with interactive design and in 1994 we launched

our first website. Our commercial projects at that time included interactive kiosks for the Museum of Moving Image, user interface design for Agfa digital cameras, control panels for Epson LCD projectors, an intranet interface for IBM, and various websites and CD-Roms.

In 1997, with the aim of creating an open-structure company that actively experiments with various forms of design, I started Design Machine. At Design Machine, I collaborate with the best professionals from many different disciplines. We frequently work with graduates from the MIT Media Lab, industrial designers in Amsterdam, fashion designers in Japan, musicians and artists. Design Machine's ability to build relationships with the best and most interesting people around the world helps us win projects with intelligent and forward thinking clients.

My first book, *Subtraction: Aspects of Essential Design*, was published in

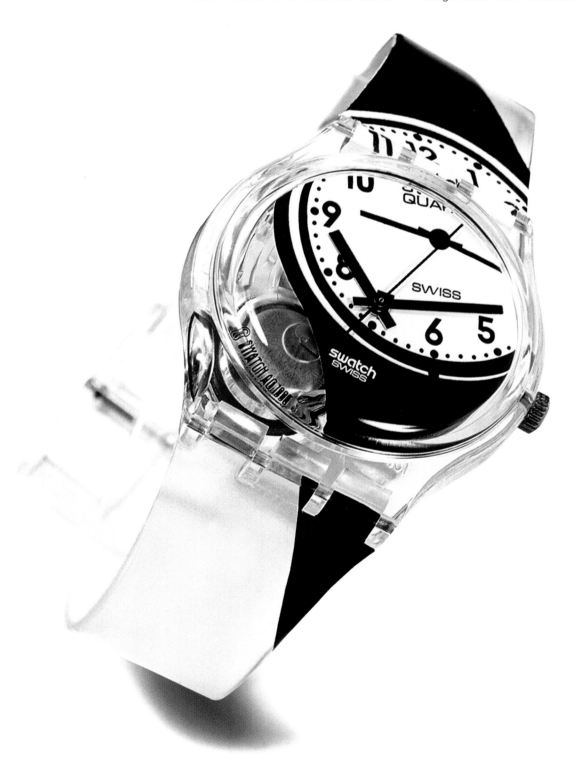

Design for Swatch Watch Collection 1997–1998
This watch adapts one of the classic Swatch designs from the early-80s. By simply sliding the image off its usual place, a totally new watch is created without adding or changing a single form. This surreal design sold out immediately and people frequently tell Gelman that there is something wrong with his watch when he wears his

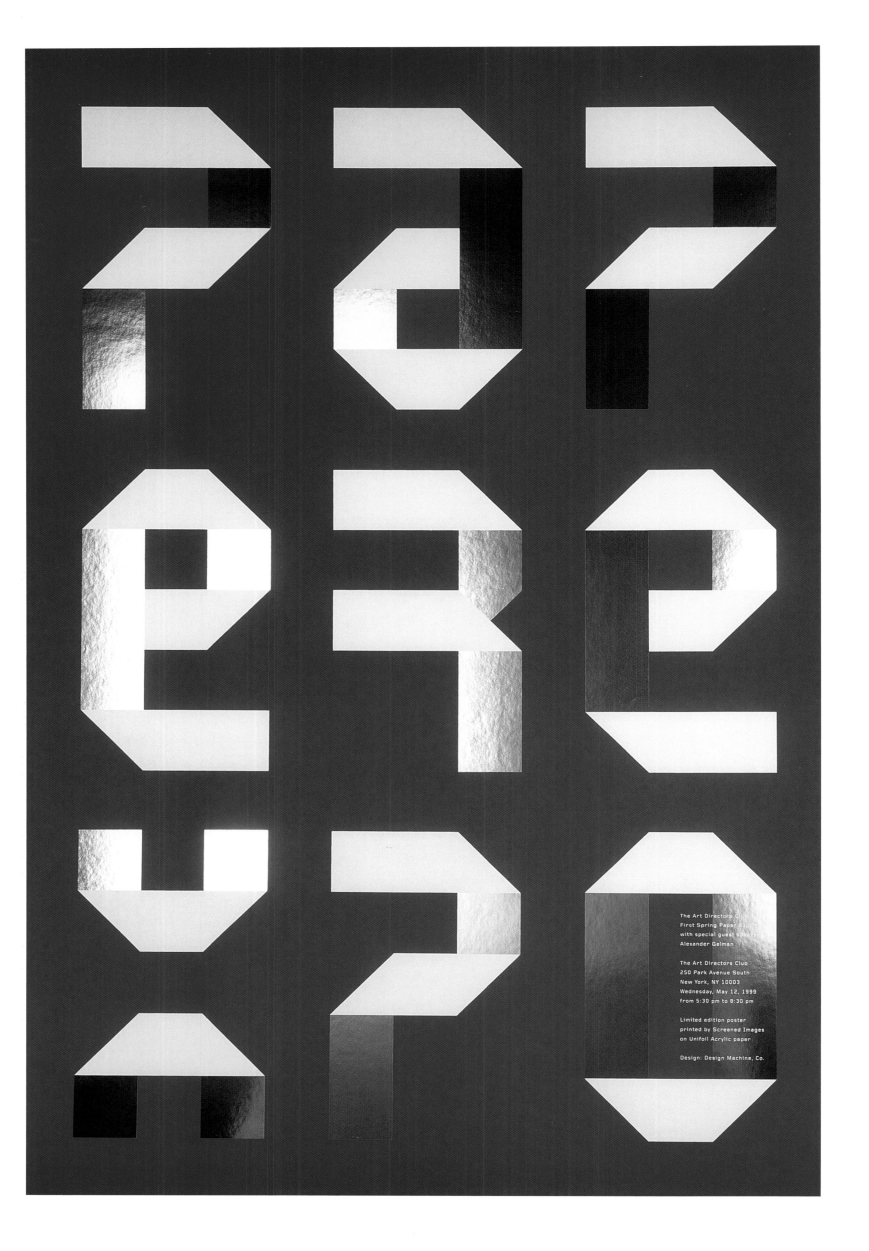

The Art Directors Club
First Spring Paper Ex...
with special guest speaker
Alexander Gelman

The Art Directors Club
250 Park Avenue South
New York, NY 10003
Wednesday, May 12, 1999
from 5:30 pm to 8:30 pm

Limited edition poster
printed by Screened Images
on Unifoil Acrylic paper

Design: Design Machine, Co.

2000. The book represents my design philosophy and explores the issue of the creative process through projects done by various designers and artists working in different media.

I teach typography and branding design at Cooper Union and work as a visiting professor at Yale University. I enjoy teaching. It helps me to articulate my thoughts and ideas better. I like opinionated people and encourage my students to have opinions about things.

In the future, I will continue consulting on a multitude of branding issues, but my dream job would be to work with a large company that embraces design (like Apple, Nike, Prada) and over a period of time co-ordinate branding, advertising, design, web and TV initiatives."

Opposite **Poster for Fall Paper Expo 2000**
The event was held at The Art Directors Club, with a silk-screened poster printed on silver paper becoming the event's logo

Below **Untitled Advertising Campaign**
This advertising campaign was for *Untitled*, **a UK catalogue of alternative stock photography. Instead of featuring images from the catalogue, the campaign focuses on the catalogue itself and its physical qualities as an object**

Below **New! 1999**
This New Year's holiday greeting from Design Machine appropriates the visual language of the American supermarket. Gelman thought a lot of designers would do the same thing that year as the idea seemed so obvious to him

ABCDEFGH
JKLMNOPQ
STUVWXYZ

a b c d e f g h
j k l m n o p q
s t u v w x y z

1 2 3 4 5 6 7 8

Opposite **T-shirts for Janou Pakter Inc.
The T-shirts were designed to reinforce
a celebrity advertising campaign for Janou
Pakter, Inc., a global creative recruitment
firm. Each shirt is distributed with a
permanent marker for writing messages
in the white rectangular speech bubble
silk-screened on the front**

ALL the virtues of the perfect w
ine glasses are paralleled in ty
pography. There is the long thin
stem, that obviates fingerprints
on the bowl. Why? Because no clo
ud must come between your eyes a
nd the fiery heart of the liquid
Are not the margins on book page
s similarly meant to obviate the
necessity of fingering the type-
page? Again: the glass is colorl
ess or, at the most only faintly
tinged in the bowl because of th

Above & right **Myrna Typeface**
**This typeface is a part of the new visual
identity program of The Art Directors Club,
New York. Outdoor signage and banners
for the Art Directors Club are shown right.
Gelman liked the idea of white banners
outside the building as the Club is in a very
bustling and dirty market district that has
multitudes of brightly coloured banners
outside of most stores**

Terry Jones
editor-in-chief and creative director i-D

"I got into graphic design by luck and chance. My mother picked up a brochure for a course in commercial art, and before I knew it, I was taken out of school and placed at the West of England College of Art in Bristol.

Then, commercial art meant packaging, but I was more interested in developing other skills. Before college the most modern artist I'd heard of was Van Gogh, but once at college I immersed myself in Pop Art. After I graduated I worked for Ivan Dodd who taught me everything there was to know about typography.

After this I went to *Good Housekeeping*, then to *Vanity Fair*, the first magazine I art directed and then I spent five years on *Vogue*. I set up *i-D* in 1980 as a fanzine because I was interested in fashion from 'the street'. I went into a business partnership with Tony Elliott (publisher of *Time Out*) in 1984 because it gave us a business structure.

I hope *i-D* continues to inspire today. Personally, I'm inspired by everything. I don't think we even thought about being avant-garde at the time, we were just interested in topics that other people weren't covering. I see every issue as an unstructured jigsaw or a movie. I would like to feel we've entered the consciousness of a lot of people and you can't escape from the fact that there are a considerable number of people who started their careers with us and are now editors, art directors or photographers doing major fashion campaigns and editorials – Nick Knight, Craig McDean, Terry Richardson, Juergen Teller. All I try to do is create a communication vehicle, with an emotion, that has and continues to attract creative people.

I think that the hardest thing for anyone coming through design school today is that there are very few people who teach the full picture and act as mentors. You can teach design with a box of matches but if you learn only on an Apple Mac you might as well be a secretary.

Laura has proved to be a great collaborator. She has a sensitivity for detail and an understanding of print which has continued the ethos of *i-D* in the 18 months that we've been working together."

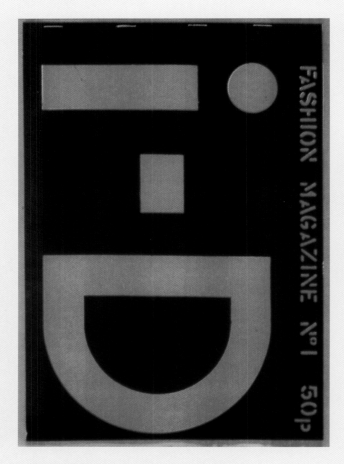
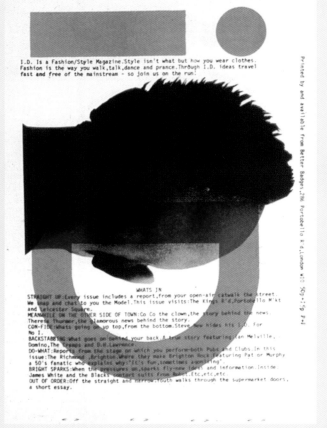

i-D Front and Back Covers of Issue One 1980
Logo designed by Terry Jones with
fanzine printing by Better Badges

**Laura
Genninger**
designer
Studio 191

Ever since I was young I've been pretty intuitive in my relationship with design. Even when I drew as a child my approach was not so much about a personal relationship with the subject, but more about how I could communicate or interpret ideas through visual form. When I was six I won my first art prize for a poster.

I studied visual arts at high school. I became quite academic at that point as we had an English department that was media studies-focused, so I was introduced to film, communication and began a relationship with literary criticism. I received an art scholarship for college, but I decided to go to SUNY (State University New York) at Binghampton to study art history combined with economics and women's studies, with 2-D design as a second major.

I started to take 2-D design classes and began to understand the discipline of graphic design. I worked on the university newspaper, which I loved and became the art director for the daily newspaper and weekly magazine there. I stayed at the Liberal Arts University for two years but I realised that I was spending more time at the newspaper than I was on my studies, so I transferred to Rhode Island School of Design and left in 1987 with a BFA in Graphic Design.

During graduation I received a scholarship to travel. I went to Holland where I met Hard Werken. I went to work with them as an intern for two months, which extended to almost a year. It was a great experience as I had been taught traditionally – the Swiss school typography – at RISD until we got Apple Macs in my last year. I was always interested in cut-and-paste, punk and street graphics. At the time Hard Werken were involved with stretching and squashing typography, using Berthold linotype set in classic compositions with an avant-garde aesthetic.

I returned to New York and freelanced for a year before returning to Holland to work for Gert Dumbar on a conference for Apple Europe. Then I got a phone call from Tibor Kalman offering a senior designer position at M&Co. It was a great experience as, at that point, M&Co was one of the few studios that worked on independent projects in New York City. Tibor was both brilliant and in his 'bad boy' phase. At the time I was working towards becoming more minimal while he was working with postmodernist theories. Some projects with Tibor included the redesign for *Art and Auction* magazine, Knoll, a fuzzy clock and bug-infested watches.

Just after M&Co I received an invitation to document an artist village south of Madras, India. Then I travelled to India (twice), Indonesia, Japan, Mexico, Iceland and Europe. I began to document using video. I used video as in still life for observation. This period has a

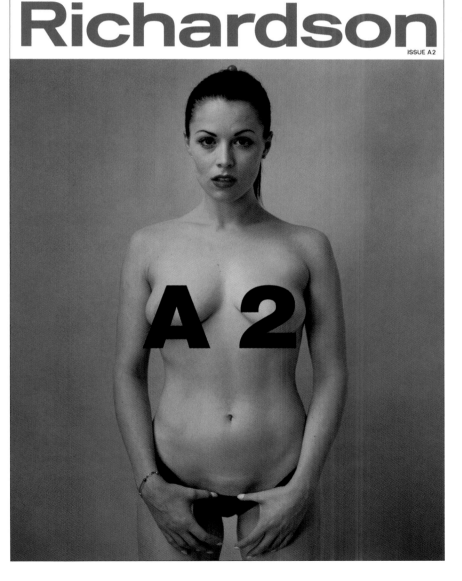

Richardson Magazine 1999
Genninger art directs and designs *Richardson*
magazine. Edited by Andrew P. Richards and
published annually, the publication considers
compulsion. *Richardson* works with
contemporary artists, film directors, writers
and fashion photographers. Shown is the
magazine's A2 cover featuring an image
of Alisha Klass taken by Glen Luchford

Dosa 2000
The art direction and design of the *Dosa Spring Summer Look Book* was intended to show the full spectrum of colour, multiplicity, and styling of the collection by showing sequential colour stories in motion in the format of a book. To reflect one of the looks, the book cover glows in the dark. Photography by David Ortega

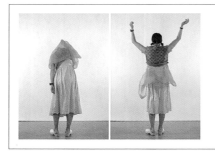

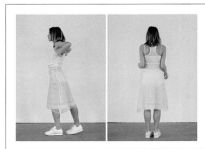

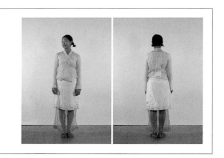

very significant influence on my design process and art direction, especially in the art direction of *index* magazine from 1997–2000.

Between travelling, I worked independently. Some projects during this time included working as consultant art director for *Details* magazine on the re-design. For a short period, I was the associate art director for *Mademoiselle* and I worked on a very large renovation project for The Museum of Natural History with Ralph Appelbaum Associates.

I set up Studio 191 in 1995. A lot of people saw me as an independent designer but I wanted to have the status and security of having a place where I could bring in artists, architects, graphic designers, fashion designers, editors, photographers, producers, craftsmen, and sound engineers to collaborate on projects. I'd had enough of being an outsider working inside big companies.

Studio 191 is a multi-disciplinary design studio. My partner David Ortega and I begin the process by opening up the definition of graphic design and setting it free. We take each project, study, explore, discuss, to try to find its essence, so that it is truly felt, so that it is understood. Studio 191 motivates solutions and the requirements of projects to places and mediums that were unexpected, to give a total realisation of the idea, system and concept. All projects and design strategies are imbued with as much information and inspiration as possible, with an integrated collaborative response as a part of the process for design projects. Design is naturally inspired by the information itself. Everything speaks to you if you listen.

I like to keep myself developed in fine arts because I like to combine all other mediums with design. I think that it is really important to continue to film, to draw and paint or to think sculpturally, because if you remain open to those things it enhances what you do in design.

Music is very influential for me. While researching a book about systems, I found 60s free-form jazz and minimal composers like Brian Eno and John Cage to be very inspirational in the process of creativity. The new wave in ambient composition, new electronica, and pop has been reflected in my working process.

I like to begin most of my work from a theoretical and intellectual standpoint, then I try to stay intuitive along the way so that the work remains fresh. I do try to strip things down to a minimal place, where important things matter, but that is merely a thread that underlines my work, it is not a style I adhere to. Really my approach depends on the client, the audience, and the feeling.

Since I have been working with *i-D*, Studio 191 consists of me and my partner. Before this we had about four individuals at Studio 191 depending on the projects. Both David and I are really personally involved in our work and enjoy being hands-on with each developing phase. We need the direct relationship to the work process, to the client/editors/publishers/designers/collaborators, and to the interesting ground inbetween, before a solution and the right visual language can be found.

I started working with *i-D* as a consulting art editor in May 2000. I travel to London every two or three weeks to design the magazine with Terry (Jones), and then work on independent projects in our studio for the two or three weeks I am back in New York. At the moment we are working on several projects including a book for an artist with a publishing company, on textile prints for a fashion company, promotional work for a fashion showroom, and on the magazine *Richardson*.

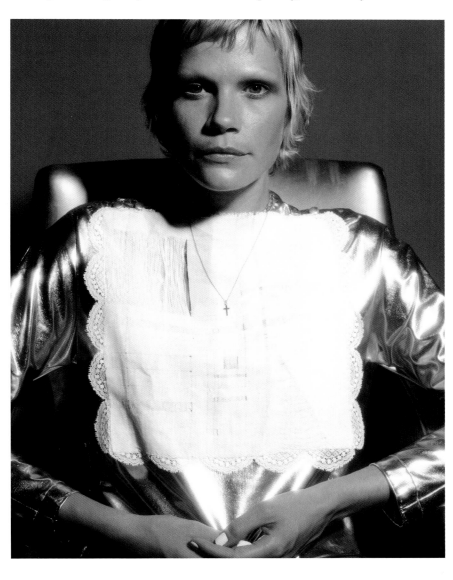

Above **Textile Design 2000**
This project stemmed from the relationship of art direction for Run Collection advertorial design and a series of books. A series of geometric textile designs, from decreasing linen fabric for collars, cuffs and a wedding dress was made for Susan Cianciolo Run 10 Collection, Fall/Winter. Photography by Cris Moor

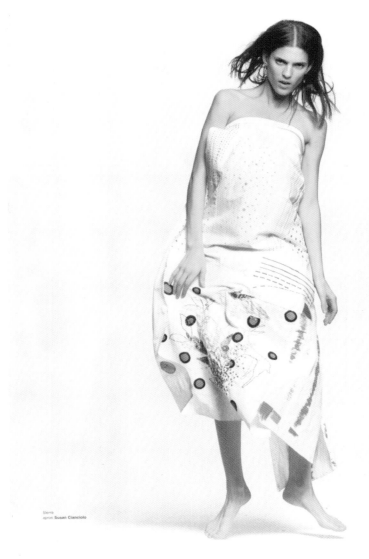

Above **Textile Design 1999**
A series of textiles from dowel relief, hand printed, and hand painted fabric for Susan Cianciolo Run 9 Collection, Spring/Summer. Photography by Thomas Schenk

I suppose I am quite good at business, but I sometimes fall into the conflict between business and being a creative person. An introduction to business at college would have helped possibly but I think, that when you're a student, it's important to explore design.

Business should be naturally incorporated; a lot of the times design decisions are in fact business decisions. Many young designers leave school and think that they can get right to it (design). What is important at the beginning is that you work alongside an experienced designer for a while to learn more about decisions in business and production. In the end it's all down to the individual project and specific circumstances involved.

Sometimes I experience conflict in young designers because they want to design without realising the complexity of the decision-making going on in your head, or the development that happens after each conversation with a client.

At the moment I'm trying to work out which area in design I should concentrate on as my work has really developed in different directions. In one way I feel very natural design editing and as an art director. But in the last five years I have been doing a lot more consulting with fashion companies and designers. In the last four years I have been developing some clothing ideas in relationship to design and 2-D application.

There are apparent sociological and ecological concerns that are important to me now that I wish to explore in design. I am in the process of discovering an appropriate format or medium.

I touch base with such diverse projects and notice that some of my favourite and biggest projects are about my relationships with people. Things are moving very fast. I just have to be very conscious about where I spend my time and focus.

I wish to contribute to design in a way that is a warm and connected aesthetic as if speaking to a friend."

Index Magazine
Genninger was art director and editorial designer of New York publication *index* magazine (1997–2000). This bi-monthly interview-style fan magazine was edited by Bob Nickas and published by Peter Halley. The publication became known for its original and personal interviews, documentary photography, and it's idiosyncratic and direct approach in design and editorial content

Far left **Cover June/July 1998**
Bianca Jagger photographed by Wolfgang Tillmans
Left **Cover November/December 1998**
Casey Affleck photographed by Terry Richardson
Below **Spread September/October 1999**
Maurizio Cattelan photographed by Anders Edström

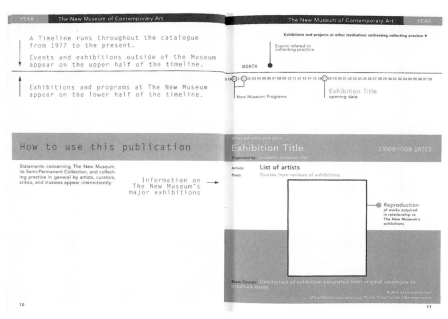

Top Book Design 1995
Genninger designed *Temporarily Possessed: The Semi-Permanent Collection for The New Museum of Contemporary Art*, New York. The book formed part of an in-house archive re-assessment and exhibition of the Semi-Permanent Collection. The organisation and design of the book came from the research of information and media on many different levels produced on and around the time of each exhibition

Above & left **Exhibition Design 1993–1995**
Genninger was responsible for the art direction and graphic design of the Fossil Halls for The American Museum of Natural History, New York with Ralph Appelbaum Associates. This constituted a renovation project that included six halls and two museum shops. The exhibition layout and design was organised by science and evolution. The layout of artifacts and text was a collaborative process between the scientist, editor, architect and designer. The visitors walk along a main path which was a graphic/architectural interpretation of the evolutionary family tree of vertebrate origins, dinosaurs and mammals of their extinct relatives. Along the main path, graphic design and graphic illustration on glass cases and panels is used to explain scientific information about the fossils. Stemming off the main path are alcoves of fossils of closely-related animals with wall graphics, primary and secondary graphic panels, and children's labels. The exhibition also included touch fossils, special media events, information computer stations and animated film

"I arrived in Britain in January 1950 from South Africa with my mother and sister, plus one small stray dog. After a school-free year spent idling my time away with my farming cousins in deepest Warwickshire, I was sent to school in London to finish my education.

Fortunately I was allowed to spend most of my time in the art department, which was run by Winnie Pasmore, sister of Victor Pasmore. On her recommendation, I went on to Chelsea School of Art, where I was awarded the Christopher Head Drawing Scholarship.

Jock Kinneir, who had just left Design Research Unit to start up his own practice, was brought in to teach illustrators graphic design. He needed an assistant to help him with a very large signing project for Gatwick Airport, and offered me the job. It was at this point that my interest in letterforms took root and I attended

Margaret Calvert
designer and teacher

evening classes in typography at the Central School of Art. Gatwick led on to more signing projects; the most significant being the design of Britain's road signs starting with the large blue motorway signs on the M1, followed by the all-purpose roads completed in 1963.

Kinneir Calvert Tuhill, which never grew above ten employees, was established in 1972. When Jock retired in 1979, I continued on my own. Our last job, as KCT, was for the Tyne & Wear Metro; the lettering was subsequently redrawn and adapted as a typeface for Monotype. It now fronts the Royal College of Art building.

I have taught Typography and Graphic Design part-time at the RCA since 1966, with a brief period as Head of Graphic Design from 1987–1991. Through teaching, I have probably learnt more from my students than they have from me.

Design is about paring down. That doesn't mean a richness of expression can't be appreciated, but communication, which is to the point, should transcend what is so often a second rate 'piece of art'.

Graphic Thought Facility's fresh thinking is particularly welcome in today's climate where, if it moves or makes a noise, it must be good. I admire the attention given to small details, and their gift for making the ordinary extraordinary – their sense of style being led by the idea."

SMALL PAINTINGS & DRAWINGS
Letchworth Museum and Art Gallery
15 July - 5 August, Mondays - Thursdays 10.00 - 17.30, Fridays Saturdays 10.00 - 18.00
An Arts Council Exhibition. Admission free. Closed Sundays

Left **Arts Council of Great Britain Poster 1972**
Poster for a travelling exhibition of 'Small Paintings and Drawings'. The image was pre-printed in letterpress, to fit both A2 and A6 formats, with the Baskerville type added at a later stage for specific galleries

Above **AGI Exhibit 2001**
Submission for a collaborative exhibition and book on the theme of a personal portrait of Paris, celebrating the 50th Anniversary of the Alliance Graphique Internationale, for its congress in September 2001

Graphic Thought Facility
co-founders
Andrew
Stevens
and
Paul
Neale

"We trained at Leeds Polytechnic (Stevens) and St Martin's (Neale) before meeting on an MA course at the Royal College of Art (1988–1990). For inspiration at the time we looked to work in old 60s *Penrose Annuals* to find some spirit of reaction to the visually complicated 'layers of meaning' graphics of the late 80s, particularly work coming out of the RCA at that time. We were chasing the directness of the 60s aesthetic but with less of a cheesy pun-based language.

We found the self-critiquing environment at college really healthy (firstly under Derek Birdsall and then Margaret Calvert) and we wanted to continue that in our work environment. Together with Nigel Robinson we shared a space after graduation and rather organically established Graphic Thought Facility in 1990 (at the beginning of the last recession).

Financially we were pretty much in the same situation as we were at college,

with our grants being replaced by the enterprise allowance and a bit of teaching. For the first five years most jobs came in on a one-off basis. I don't think that's necessarily because people were dissatisfied with what we did, just the nature of projects – start-up identities for friends or small theatre productions. Habitat was our first big client and the first with which we established a pattern of repeat work. We've enjoyed this because we've been able to develop themes from one year to the next and place jobs within an historical context of our own making.

The recession helped us in a way, because it gave us time to develop our working method as we couldn't develop in an atmosphere of having to churn jobs out. We've pointedly maintained a broad range of work including 3-D projects and exhibition design (a natural area for us to go into as our 2-D work has a strong process bias to it). Recently, for instance, we

had a company in to look at aluminium extrusions as the basis for our next job for Manchester City Art Galleries. Last year we worked for the Science Museum, and created the electro luminescent graphic systems for two galleries in the Wellcome Wing ('Digitopolis' and 'Who am I?'). Recently, we worked with the ICA on 'Stealing Beauty' – its first design show.

We've worked for very few corporate clients; this is not particularly from an ethical standpoint, it's just that whenever we have it has not been much fun. Our growth has been very gradual, there are only six of us after 11 years, because we both still want to be totally involved in the projects rather than become managers. We've been lucky with recruitment, as all the full time people who have joined us were originally our students to one degree or another.

We think much of current design education has become atrocious.

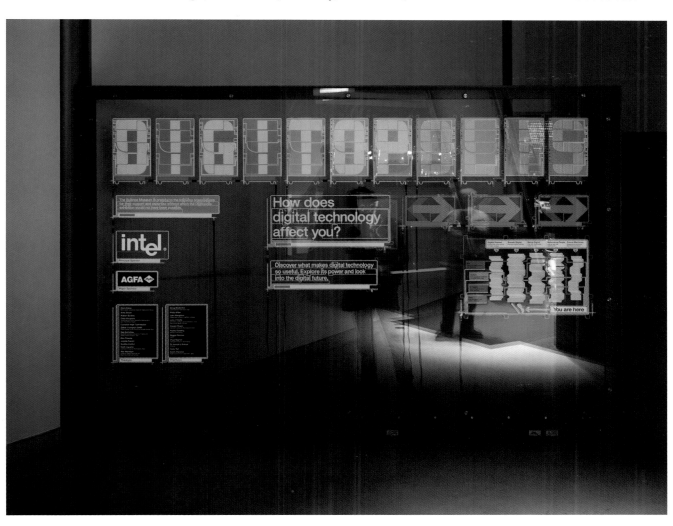

Digitopolis 2000
Exhibition graphics (Electro-luminescent signage) for the Science Museum

It's not the case that there are worse tutors now, more that larger classes are being catered for by a skeleton staff. Another worrying issue is the number of students who get places because their parents can afford to send them rather than on merit. We both got a lot out of our design education, but now it's so popular there has consequently been a significant increase in the amount of demoralised staff and students.

We're not big fans of paid-for awards. We don't enter them because it's not the way we attract our clients or justify ourselves and our work to them. Also we don't think designers should have to pay to have their work recognised."

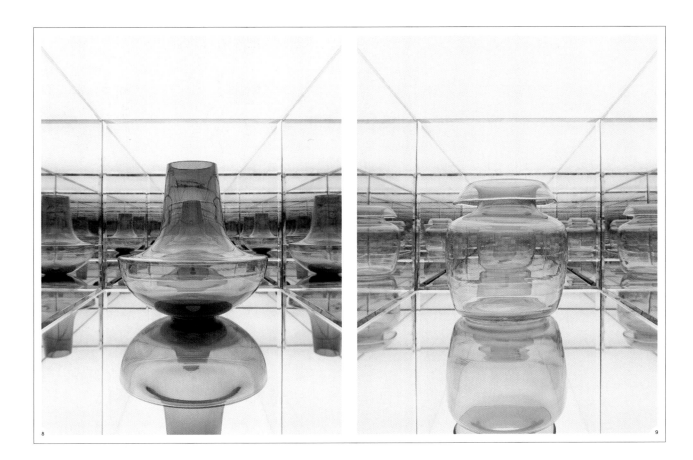

BasicDeluxe.

What is luxury?

Habitat's Autumn Winter 2001 range is more about an attitude than a collection of objects. It's a way of looking at the world, demanding luxury in the everyday and saying that mundane tasks need no longer be shabby or dull. It's about adding value to domestic tools and improving the activities that you have to do – an injection of deluxe to the everyday basics to make your life more pleasurable and functional – more luxurious.

It's an attitude that's very much in keeping with Habitat's founding principles. In other words good design and function should be beautiful – and affordable. Besides, why should certain things be the preserve of an elite or lucky few with huge spaces? By making some luxurious things in basic materials, we insist that everyone have a little bit of luxe in their lives!

Habitat is BasicDeluxe.
Tom Dixon, Head of Design

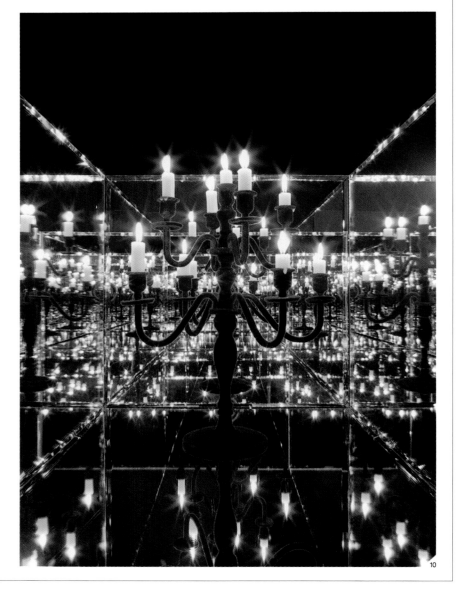

Above **BasicDeluxe Press Release 2001**
Promotion for Habitat's new collection.
Art direction and photography by GTF

Opposite **Shakespeare's Globe Theatre**
Celtic Season Poster 2001
Art direction and photography by GTF
and John Tramper

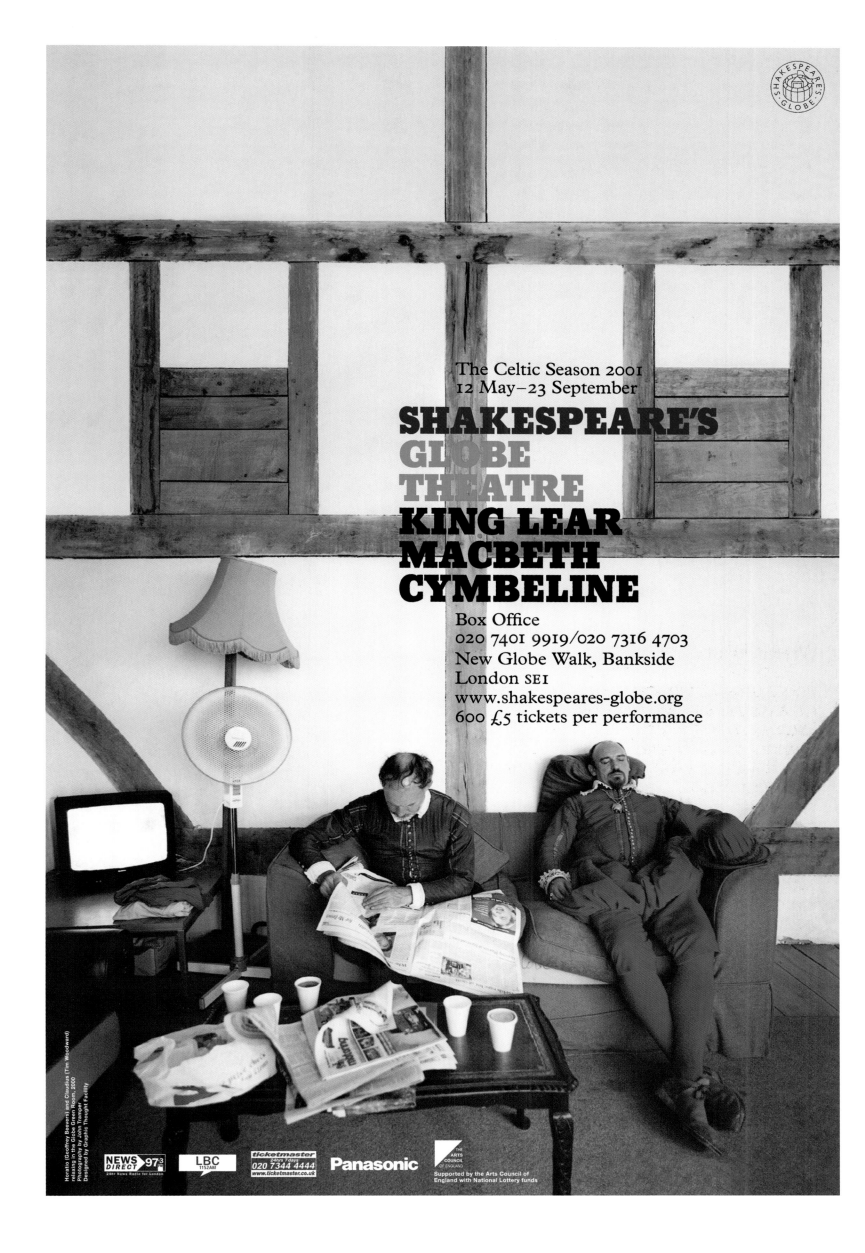

The Celtic Season 2001
12 May–23 September

SHAKESPEARE'S GLOBE THEATRE KING LEAR MACBETH CYMBELINE

Box Office
020 7401 9919/020 7316 4703
New Globe Walk, Bankside
London SE1
www.shakespeares-globe.org
600 £5 tickets per performance

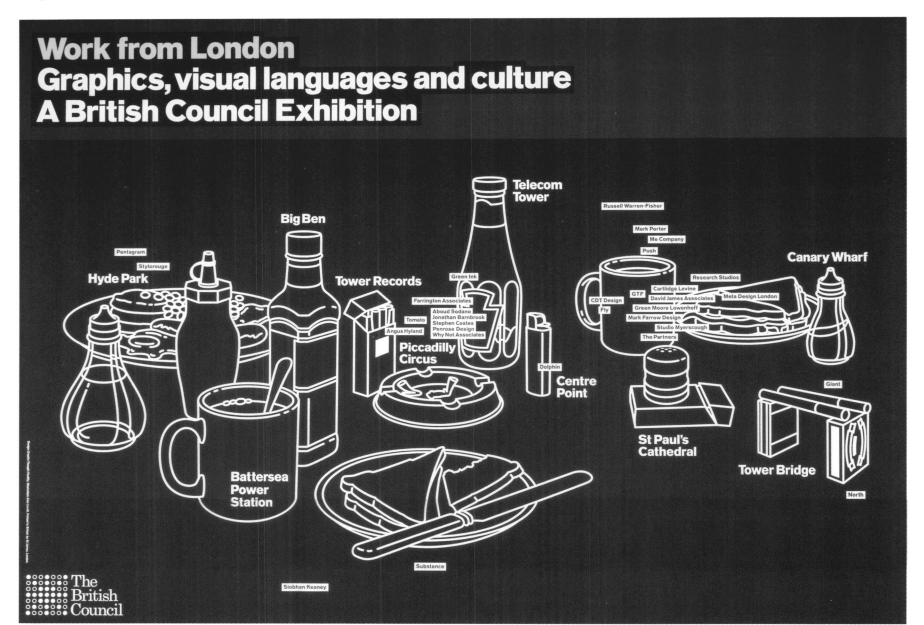

Work from London
Graphics, visual languages and culture
A British Council Exhibition

DO SOMETHINGIST
– (NOT JUST
ANYTHINGIST)

GO
GETIST
(NOT JUST ANYTHINGIST)

ULTIMATIST
–THE MAXIMUM.

MAKE HAPPEN-
IST – (NOT JUST
ANYTHINGIST)

ATTEMPTIST
–(NOT JUST
ANYTHINGIST•).

THE
ALREADYIST

MONOIST

THIS IS ONLY
THE BEGINNING
WAIT TILL THEY
SEE ME
DANCE.

THIS IS ONLY THE
BEGINNING WAIT TILL YOU
See me dance.
Everything goes blank
and I'm off. From
zero (0) to more
SPIN AROUND + AROUND
+ AROUND + AROUND
The record was being
Exhausted with
excitement.

Take Some
Action
Show them.

MAKE THEM CAN'T
BELIEVE IT.
DAZZLE THEM
GIVE THEM EVERYTHING
MORE THAN THEY
EVER EXPECTED
PLUS BOLTS FROM
THE BLUE
ALL THESE THINGS
+ MANY MORE.

GASP.

"I am the
moment I've
been waiting for.
A FEELING AND AN
INKLING AND A MOMENT
OF INTUITION, you forget
EVERYTHING ELSE LIKE
WHEN YOU GO INTO A TRANCE
AND SING "I've regrets
rien" with honesty.

GASP.
CONTINUE I'M
ENTHRALLED."

THEN AWAIT
WITH BAITED
BREATH AS TO
WHAT IS
NEXT:→

SPEECHLESS

PEOPLE SCREAM FOR.
THINGS – but there's
like a screaming
SKYSCRAPER.
THE 'WE CRAVE' mania
WE LONG FOR, WE TRY FOR, WE
YEARN FOR, WE CRY FOR.

"GIVE ME A
SIGN.
SHOW
ME, 👀

GASP

A PERMANENT
REMINDER OF:
YOU ARE READY.
TO GO OUT
INTO THE WORLD
AND DRIVE THEM
WILD WITH DESIRE

STUN

ACTION
ADVENTURE
– cover all
space with it

**Mike
Dempsey**
graphic
designer
CDT

"All three partners at CDT had worked in publishing prior to launching the company in 1979, so we had an understanding of the structure of books, a rarity with design groups at that time. Most designers then seemed more concerned with the stylistic and visual quality of their work and often overlooked the importance of words.

We believed that our publishing background would help create a point of difference. We were able to take on work with a more editorial bias and this naturally led on to more significant projects. We designed *The Independent* newspaper. Its design had a profound effect on the use of photography in editorial layout. We conceived, designed and wrote *The Royal Mail Year Book*, for which we received the D&AD Gold Award in 1985.

Ten years ago we redesigned the Parisian cultural listings magazine *Telerama*. Our approach had a

dramatic impact on both readership and advertising. More recently our work on the *RSA Journal* demonstrates that a prestigious institutional publication does not have to be dull.

At CDT we always try to present copy in a legible way so that it can be read. There has always been a movement in design that seems to disagree with this simple belief.

A further problem is that 'everyone' believes they can write, so designers tend to be given awful long-winded pieces of copy. At CDT, we always try to commission the words. I have huge admiration for advertising copywriters who manage to be economical with words and produce intelligent and structured copy, although that is fast becoming a thing of the past. Our industry has changed so much; the typesetting past has been destroyed and technology has meant that designers are now their own

typesetters. The downside is that typography has lost much of the setter's craft, a skill missing in a lot of young designers who sadly know no different.

Fernando Gutiérrez has an intuitive love of typography. He came to CDT straight from college. He blossomed with us and perfected his classical approach to graphic design. He left to work in Spain. After two years he returned to CDT as an associate. He then left us permanently to set up his own consultancy in Barcelona. It was there that he conceived and designed *Matador*, which is a beautiful example of his understated style."

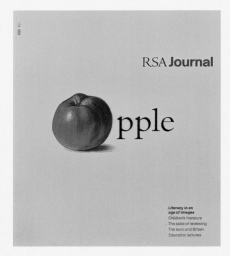

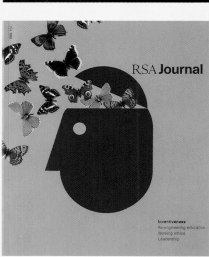

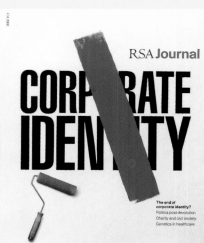

**RSA Journal 1997
Dempsey continues to art direct and produce
the title. Four of its covers are shown above**

Fernando Gutiérrez
partner
Pentagram

"I did a BA course in Graphic Design at the London College of Printing and graduated in 1986. As a child I was always drawing and what drew me to graphic design was the instantaneous element that went beyond drawing.

I started my working life as Mike Dempsey's assistant at CDT in 1987, working on annual reports, corporate identities and magazines.

My passion is for editorial design because it's a very dynamic world. You work fast to give graphic solutions and collaboratively with writers, illustrators, editors and publishers. My approach is simply to make the design look easy and logical.

I consider myself bi-cultural as I was born in Britain to Spanish parents. I moved to Spain in 1990 because I didn't know much about the country, I then returned to CDT as an associate, before going back to Spain 18 months later to set up a company in Barcelona

called Grafica as I'd always dreamt of working for myself and learning from my mistakes. By doing this, I learnt how I relate to people and more about solving problems.

I didn't have any clients but I had friends who were involved in design and one thing led to another. The big difference between design in Britain and Spain is that in Barcelona design is seen more as a craft and art form, it is very much about the normally self-taught individual working on his own. Conversely CDT was a big studio and a creative business.

While in Spain I designed a weekly colour supplement, *Tentaciones*, for the national newspaper *El Pais*. It was a 'What's On?' guide and because it was aimed at a young readership it allowed me to produce something experimental and fresh that was allowed to stand out in a grey newspaper. Communication through design is very important to me and if

it's a good product readers will follow you and want to see what you come up with the next week.

When I was at college I used to follow what Neville Brody was doing. I also admired Brodovitch, and Michael Rand's work on *The Sunday Times*. Now I look at everything from art, film, music and literature. I don't really read about what other designers do unless I am specifically interested in them. Through my job I read a lot and am used to staring at grey matter with the result that I can pick up grammatical errors very quickly.

I wanted to produce something that was the opposite of a daily newspaper and, with some friends, came up with *Matador*. More like a book, it comes out once a year and is a series of volumes from A-Z and the content is very free. Each issue has a theme spawned by a letter of the alphabet – 'C' was based on chaos and 'D' was about dreams – and we invite

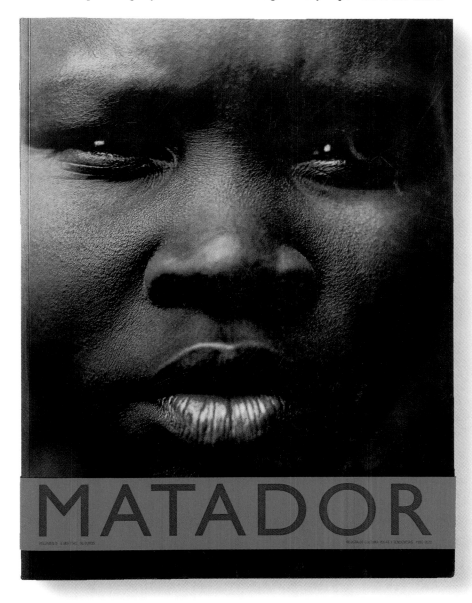

Matador
An annual magazine, published in Spain,
focusing on the arts, trends and ideas

photographers and writers to participate in the concept. It's a nice excuse for meeting up with my friends and debating things to a different level than I normally do on magazines and newspapers, I find it very relaxing and fulfilling. I started it in 1995 and it will end in 2022 when I am 60.

Matador began as a weird experiment in Madrid and now it has become very international with people like Peter Greenaway and Michael Nyman contributing. It has a print run of 6000, sells at £30 per issue and recently won a Gold Award from the Spanish Art Directors' Club.

I would have loved to have been given the chance to design *Life*. I thought it was a great magazine but I think the owners panicked and made too many changes too quickly. The problem with publishers is they get all edgy and greedy and that's when it starts to go wrong.

If I have a style it is to produce very simple design that is emotional and to take something familiar and twist it. For example I was working on the listings magazine *Tentaciones* and at the time Julia Roberts had a new film coming out and everyone was putting her on the cover. I just put her mouth on the cover and it provoked thoughts of her in a different context. Readers respond to that, but you also need writers and editors to support you. I like to do something that is different but isn't scrambling to make a lot of noise.

With the bi-monthly *Colors*, Tibor Kalman (then editor-in-chief) called me in to work with him on issue 13, his last issue. He used to switch art director every issue. I was gobsmacked that he called me as I was such a big fan of his. That last issue had no words and was totally concept-driven. It was fantastic and the experience was more like a film because it used pictures that related

one to the other. When I joined Pentagram, I became creative director of *Colors*. After Tibor, the magazine had become formulaic and my aim was to cut back on all of the sensationalism but keep the spirit. So there are no famous people, just normal people talking about their lives, and what values they share. It is a magazine about the rest of the world and I wanted to keep that great definition.

What I really like about *Colors* is that it has a lot of space. We can go into greater depth than most magazines because we are not limited by pages. It is our strong point."

Right **Colors 42**
Each issue of the magazine, which is commissioned, from the writers to the photographers, is unique, and is dedicated to a human community

Opposite **Vanidad Magazine**
Gutiérrez designed an icon logo, which contrasted with 'girlie-whirly script that existed before'. The upside-down A could be a bull's head or represent the V of the magazine's title. Following the re-design the magazine was taken more seriously and reaped increased advertising revenue

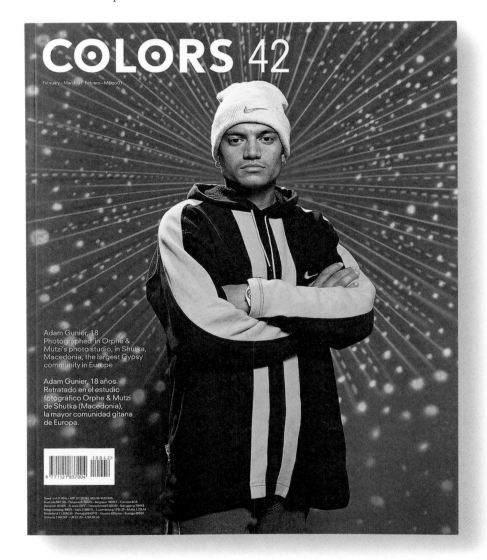

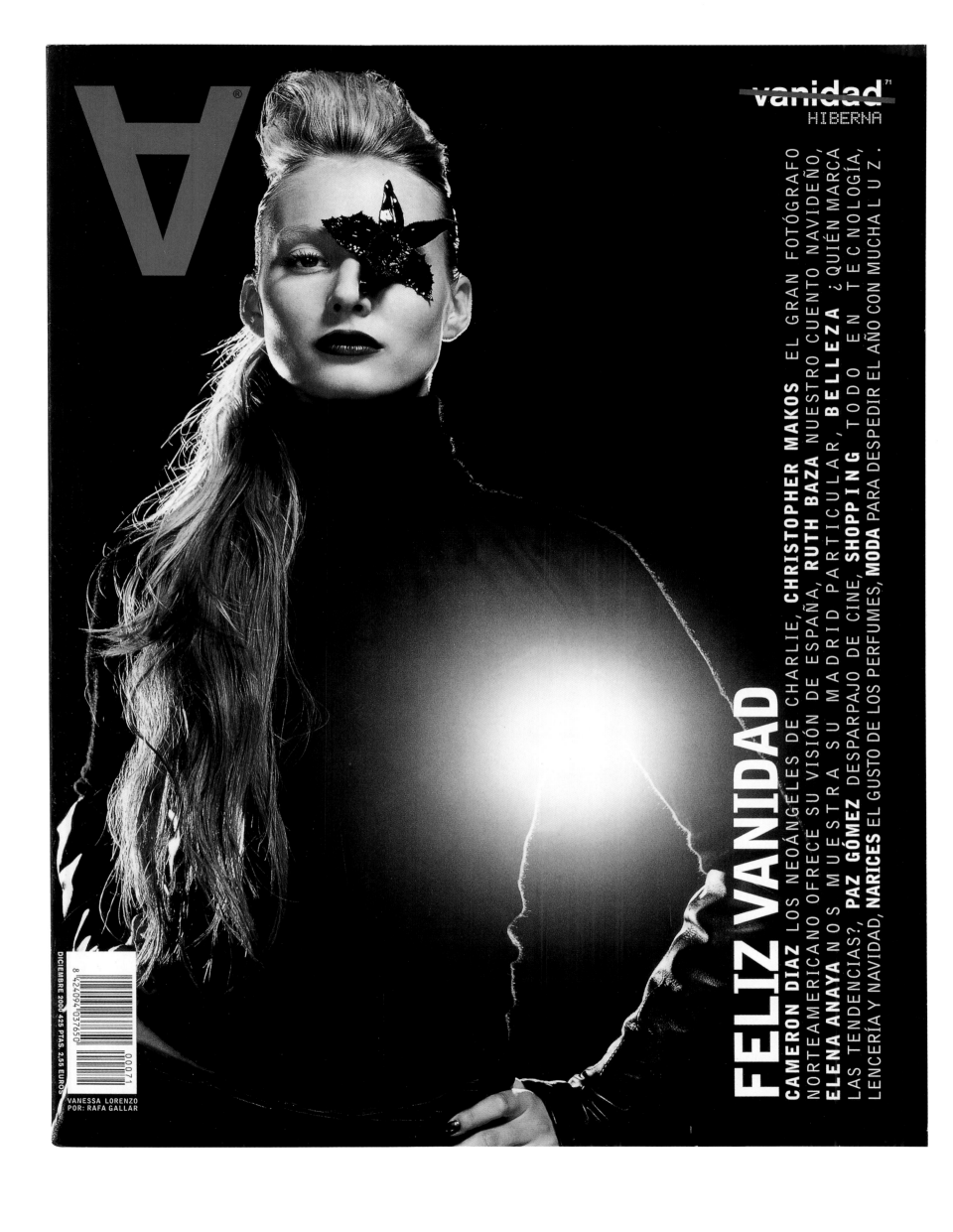

vanidad⁷¹

HIBERNA

FELIZ VANIDAD

CAMERON DIAZ LOS NEOÁNGELES DE CHARLIE, **CHRISTOPHER MAKOS** EL GRAN FOTÓGRAFO NORTEAMERICANO OFRECE SU VISIÓN DE ESPAÑA, **RUTH BAZA** NUESTRO CUENTO NAVIDEÑO, **ELENA ANAYA** NOS MUESTRA SU MADRID PARTICULAR, **BELLEZA** ¿QUIÉN MARCA LAS TENDENCIAS?, **PAZ GÓMEZ** DESPARPAJO DE CINE, **SHOPPING** TODO EN TECNOLOGÍA, LENCERÍA Y NAVIDAD, **NARICES** EL GUSTO DE LOS PERFUMES, **MODA** PARA DESPEDIR EL AÑO CON MUCHA L U Z.

DICIEMBRE 2000 425 PTAS. 2,55 EUROS

VANESSA LORENZO
POR: RAFA GALLAR

105 Fernando Gutiérrez

Below **Photo Bolsillo**
A collection of books displaying the
work of different generations of Spanish
photographers. Each book is dedicated to
the work of a specific photographer

Below **The Commercials Book**
A book illustrating 32 of the world's finest
commercials directors and their work.
The book was published by D&AD in
collaboration with RotoVision

Opposite **Fotografia Publica**
The catalogue displayed how photography
that was in print between the First and
Second World Wars was used for editorial
and international purposes

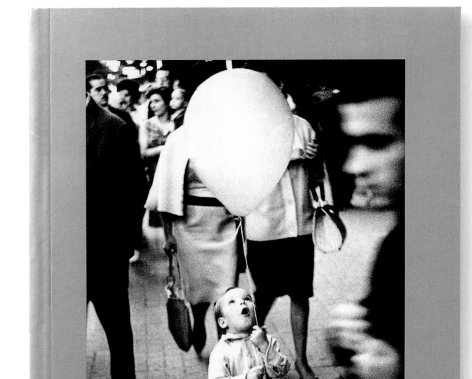

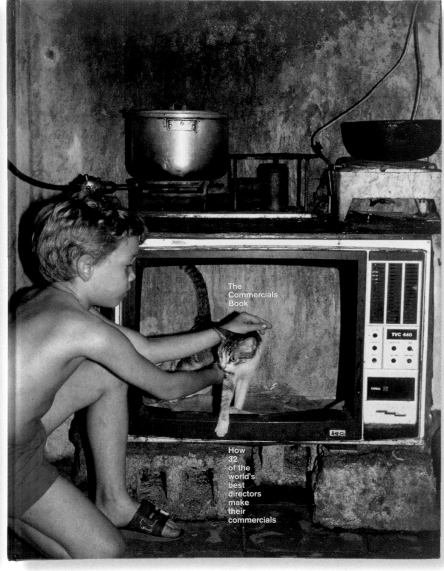

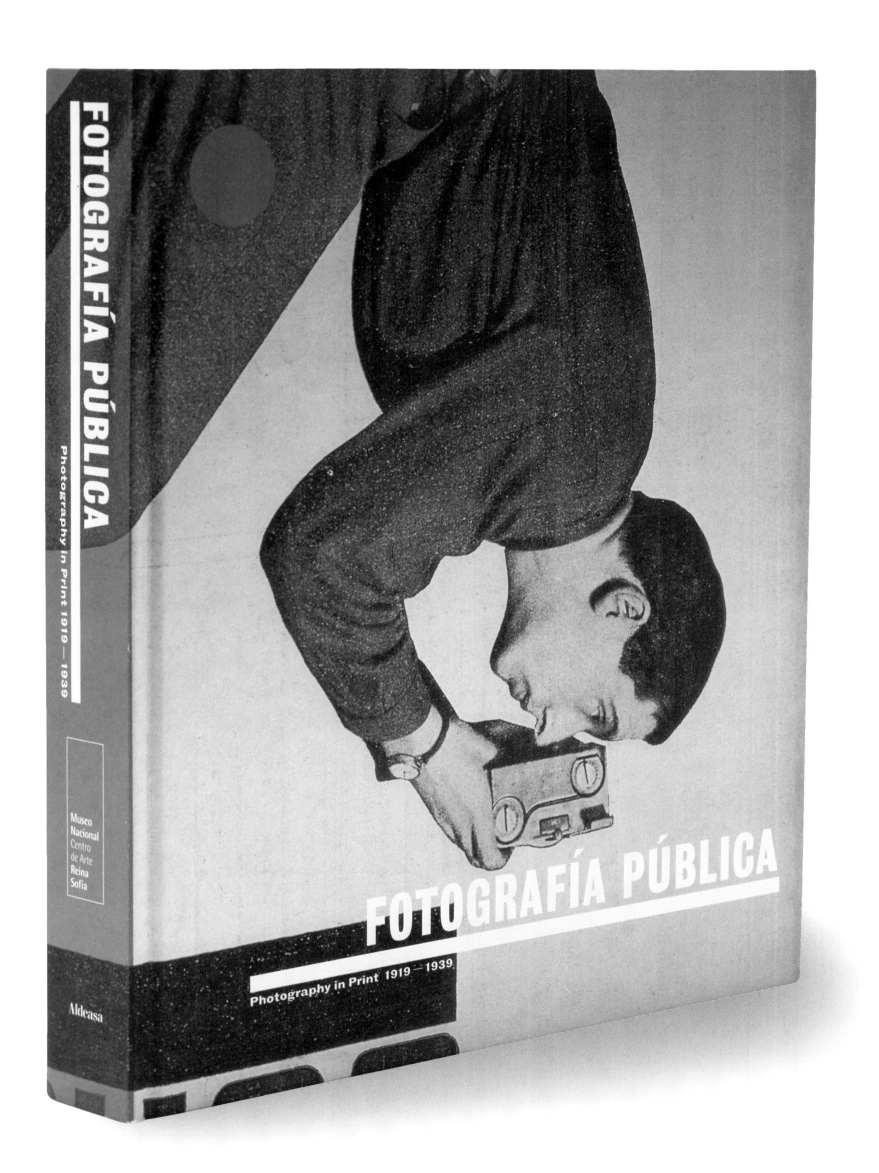

FOTOGRAFÍA PÚBLICA

Photography in Print 1919 — 1939

Museo
Nacional
Centro
de Arte
Reina
Sofía

Aldeasa

FOTOGRAFÍA PÚBLICA

Photography in Print 1919 — 1939

Jerry Kelly
designer

"I was an art major in college, as painting was my main interest. I took a calligraphy course to get a couple of credits and was hooked. After working as a calligrapher and in advertising lettering, I decided to become a book designer, so I started working at a printers' because I couldn't get a job in publishing.

My strongest early influence is the same as my strongest late influence – Hermann Zapf. I also admire fine printers such as Updike, Rogers, Morison and Mardersteig.

I've always been interested in the practical and the mechanical, and printing is a combination of both. I'm a type freak and just a beautiful letter, typographic or calligraphic, has always been of interest to me.

In 1991, I was wooed to the Stinehour Press where I stayed for nine years producing mainly art books. When the company was sold and the New York office closed, I decided to go on my own. I set up my company in 1999 with the aim to do beautiful books. I do letterheads and brochures but 80 per cent of my work is books, art catalogues and fine editions.

All my work is from word-of-mouth recommendations. I've been doing this for 20 years and have had some clients with me all this time. I work very fast – I've designed over 50 books this year – and maybe I should grow the business but my main goal is simply to design books, not to make money.

I teach a beginners' typography class at the Pratt Institute and I mainly concentrate on the history and terminology of typography. It's very information driven. There is no way I'm just going to say, 'Let's design a poster' until they know why they're using a face.

My advice to young designers is to study history and don't work in a vacuum. Learn your craft. That's why I admire Jonathan Hoefler. He has a huge respect for history and influences."

**John S. Fass & The Hammer Creek Press
Title page design in Perpetua Titling, Fournier and Rococco Ornaments. Letterpress-printed on Arches paper**

Jonathan Hoefler
co-founder
Hoefler
Type
Foundry

"I was born in New York and was motivated to become a designer through an interest in type. I really only wanted to work with typefaces. When I was a kid this came through in playing with Presstype (and loving those dictionary title pages where each letter was rendered in roman, italic, script and blackletter).

In high school I became aware of a whole body of work where typography upstaged the other elements of graphic design. *Spy* magazine was especially influential, and after I left school I became aware of Fred Woodward's work for *Rolling Stone*, which was incredibly adventurous typographically. It's due to these magazines that I have a fondness for Garamond No. 3, Metro and Alternate Gothic, and a host of wood types. I still think about new typefaces in terms of their editorial function and this is probably why most of my clients are magazines.

I recognised early on that an infatuation with typography isn't really enough to make a good graphic designer. The fact that I'm red-green colour blind suggested that art directing photo shoots might not be in my future. But I've always been fascinated by the history of design – the history of typography specifically. Research is an important part of type design and writing is an important part of running a foundry. I'd miss these aspects too much if I were a graphic designer.

I hope that I don't exhibit a personal style, as I like to think that when I'm developing a typeface, I'm creating something entirely unlike the rest of my body of work. One of my least favourite things is having one of my designs mistaken for another, but that doesn't happen very often.

When I'm commissioned to develop a new typeface, it generally means that a client has spotted something lacking in existing faces, and the opportunity to address some of these lacuna in typography is what keeps me going. And there are also things of personal importance to which I try and devote some time. There are always things that come across which I think warrant further investigation, discoveries which sometimes result in a pretty good idea for a new typeface.

I like to think that most of my influences are non-typographic. At best, they're people and things on the periphery of type. Among typographers there's William Morris, W.A. Dwiggins and Robert Granjon, but I'm more interested in trying to see if the ideas of Charles Eastlake, A.W.N. Pugin, or Erik Satie can be turned into interesting typefaces.

In many ways, designing typefaces has provided me with an excuse to spend time looking at historical typefaces. And increasingly, I'm finding that I'm influenced not so much by the look of a historical typeface, but wondering

B 33 [11] **H** Jr Heavyweight							D 53 [15] **He** Heavyweight
E/F 70 [17,18] **W** Full Welterweight	C 47 [12] **Bn** Bantamweight	F 73 [19] **Hv** Full Heavyweight	E 69 [17] **Lt** Full Lightweight	E 66 [16] **Ff** Full Flyweight	B 34 [11] **Js** Junior Sumo	G 92 [21] **Ct** Ult Cruiserweight	C 49 [13] **Li** Lightweight
A 29 [9] **L** Jr Lightweight	F 71 [18] **Mi** Full Middleweight	A 26 [8] **Jw** Junior Flyweight	B 32 [10] **Cr** Jr Cruiserweight	G 91 [20] **Me** Ult Middleweight	A 27 [8] **Ba** Jr Bantamweight	D 51 [14] **Md** Middleweight	A/B 30 [9,10] **We** Jr Welterweight
E 67 [16] **Bt** Full Bantamweight	F 72 [18] **C** Full Cruiserweight	G 93 [21] **Hi** Ult Heavyweight	A 28 [8] **Fe** Jr Featherweight	C/D 50 [13,14] **Ww** Welterweight	G 94 [21] **U** Ultimate Sumo	C 46 [12] **F** Flyweight	D 54 [15] **Su** Sumo
F 74 [19] **S** Full Sumo	E 68 [16] **Ft** Full Featherweight	D 52 [14] **Cu** Cruiserweight	G 90 [20] **Wt** Ultimate Welterwt	B 31 [10] **M** Jr Middleweight	C 48 [12] **Fw** Featherweight		

HTF Knockout Type Family 2000
Originally published in Catalogue
of Typefaces No. 4

about the thinking behind it. It's usually a theoretical underpinning that precipitates a new design, rather than merely the look of something old.

I think 'classical' is a really loaded word. What makes something 'classical'? Tower Records considers any composition for orchestra to be 'classical music'. It is a sublime moment in the history of taxonomy that the 1998 soundtrack to 'Godzilla' is deemed classical. If the work I've done has fealty to historical models, it's because the strategies employed in older designs seemed sympathetic with projects: The Proteus Project was well-served by a study of Regency typography, though it's not a historical revival, and has nothing to do with either classicism or Classicism.

Currently I think we're going through the best period for type design. There's refreshingly little standing between a good idea and a great typeface – and computers have

helped conceal the shameful secret that I've got wretched penmanship. The creation of every face is different. Faces that are explicitly based on a particular artefact start as high-resolution scans, which are used as references for new drawings. Other, more speculative things start with gestural drawings on paper, which may or may not make their way into the computer. I find that drawing with a pen is the best way of resolving structural questions, though my drawings are rarely of a quality to serve as a template for digitising.

The difference between designing type for online purposes and print has yet to be seen. Obviously you can't design a typeface for screen use that is completely indifferent to the vicissitudes of pixels, but I suspect there's more to it than that. Once we have computer screens that rival print in resolution and reflectivity, there will have evolved a style of lettering peculiar to screen fonts."

Below **Poster featuring HTF Champion Gothic 1996**
Limited edition letterpress print by Julie Holcomb Printers, San Francisco, 1996

Opposite **Title Page Muse No.1**
The Type Specimen Book of the Hoefler Type Foundry

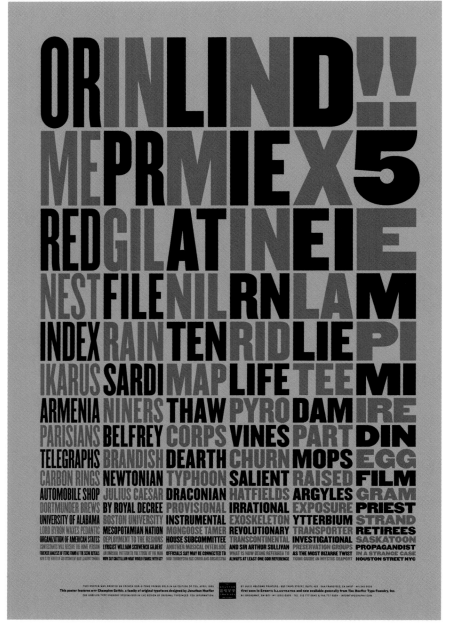

Above **Poster featuring HTF Gestalt Typeface**
Limited edition letterpress print by Julie Holcomb Printers, San Francisco, 1995

PRESENTING MUSE
NUMBER 1

A SPECIMEN BOOK OF THE TYPEFACE

DIDOT

DESIGNED AND DISTRIBUTED BY THE

HOEFLER
TYPE FOUNDRY

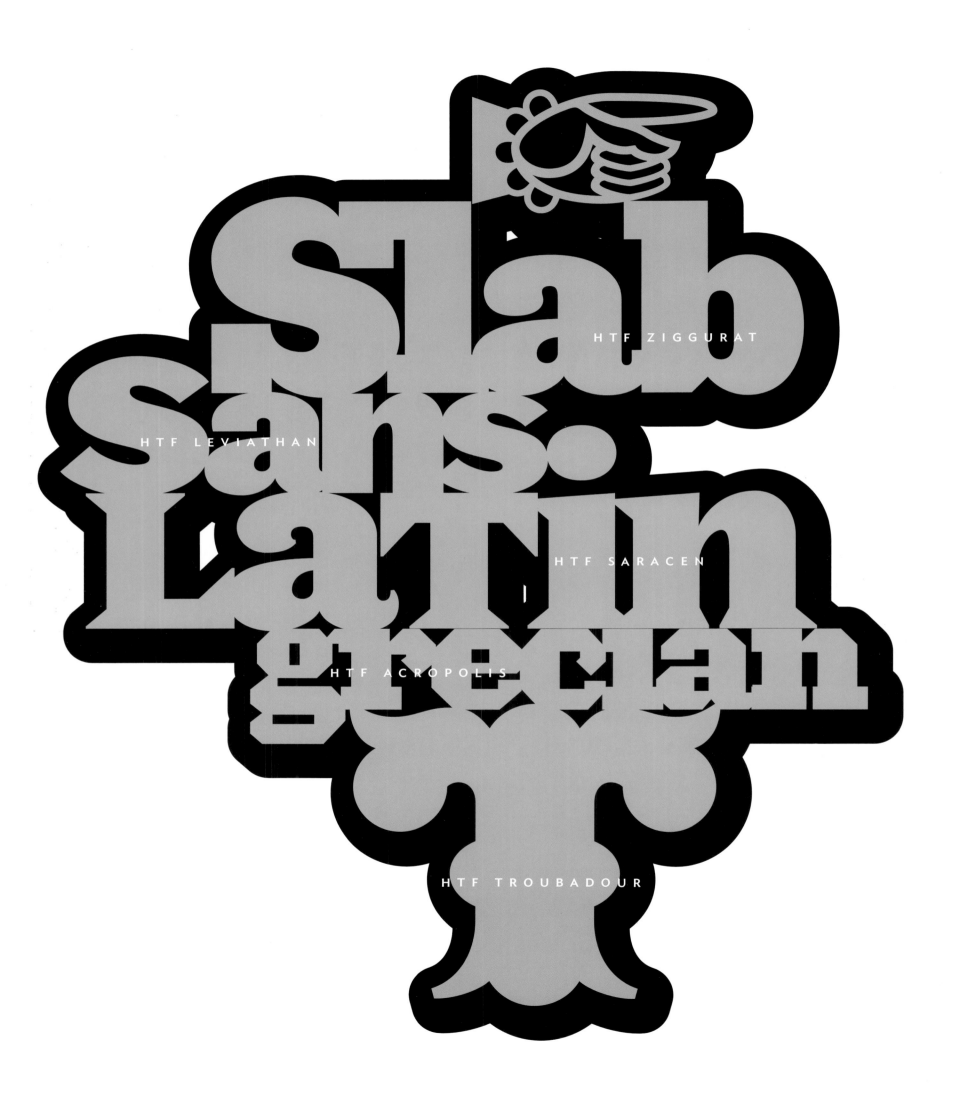

Slab

HTF ZIGGURAT

Sans.

HTF LEVIATHAN

Latin

HTF SARACEN

grecian

HTF ACROPOLIS

HTF TROUBADOUR

Opposite & below
**Composition in The Proteus Project Typefaces
HTF Ziggurat, HTF Leviathan, HTF Saracen,
HTF Acropolis and HTF Troubadour**

Above **Specimens of HTF Didot Typefaces**

HTF ZIGGURAT™ BLACK

Regiment

HTF ZIGGURAT™ BLACK ITALIC

Talkative

HTF LEVIATHAN™ BLACK

Marathon

HTF LEVIATHAN™ BLACK ITALIC

Westward

HTF ACROPOLIS™ BLACK

Delightful

HTF ACROPOLIS™ BLACK ITALIC

Giveaway

HTF SARACEN™ BLACK

Unofficial

HTF SARACEN™ BLACK ITALIC

December

"After my apprenticeship as a letterpress compositor, I realised that to become a designer, I had to move south from my native Darlington. The big change for me was meeting Anthony Froshaug. I worked as his assistant at Watford School of Art and did some teaching. I started freelancing in 1972 when there were fewer designers around. I was very lucky and made lots of connections with good people.

In 1989, when the Mac was taking over, I realised I had to step back in order to go forwards and I set up the Typography Workshop in Clerkenwell, London. I knew I had to start using type, ink and paper again in order to advance my work. My aim is not to create historical pastiche design but to push the tools and make contemporarily relevant work.

I've always had a love of libraries and books. A good place to start is with the dictionary. You can find out exactly what a key word means and this can inspire ideas or lead to new meanings and visual interpretations.

I work within the brief to create typographic images. As Alan Fletcher said: 'Artists create their own problems and designers solve other people's problems.' I'm trying to solve my own problems through the commissions I get, so that the result is beneficial to both the client and me.

As a non Mac-ed creator of typographic artwork for commercial use, I am not in total control of the final scanned piece and how my work is reproduced. So for me there has to be a lot of trust in the client and I usually have good and mutually respectful working relationships with my clients.

I've been a visiting lecturer at the Royal College of Art for 12 years and the more influence technology has on design, the more my students want to search back to find where typography came from and experiment with letterpress technology.

Letterpress is demanding work but it's very satisfying, creating with these materials and intense colours. Students and clients enjoy the process and the studio too. It's unique, surprising, smelly, physical and fun. I'm grateful for the twists of fate that led me to it.

My nominee is Angus Hyland. My favourite piece of work is the series of book jackets for the Bible because it's not what you would expect of the subject. He's chosen the photography and typography very sensitively."

Alan Kitching
typographic artist

Imagine 2000
Press advertisement for Scheufelen Paper

"After secondary school I completed a foundation course, subsequently enrolling on a BA course at the London College of Printing. This was the Media and Production Design course that was primarily concerned with information graphics design.

While at LCP, I did a work placement at a design company where I spent six months designing packaging for toiletries. The experience of rendering bunny rabbits for infants' wet wipes spurred me on towards my ultimate goal, to design record sleeves. It was this goal that inspired me to apply for a place on the MA Graphic Design course at the Royal College of Art.

At the RCA I was at a hybrid stage in my own development. I had suffered through four years of information graphics at the LCP so at the RCA I decided to opt for the paintbrush and glue pot method of working. Many of my fellow students at the RCA were interested in typography, whereas I had become more interested in images and illustration.

When I left the RCA in 1988 I maintained my interest in image-led work and became a freelance designer, specialising in book jacket design and illustration. I continued to undertake freelance work until 1992, when I established a partnership with Louise Cantrill.

In 1998 I joined Pentagram as a partner in their London offices. Pentagram gave, and continues to give me, the opportunity to increase the scope of my client base while retaining a hands-on approach to the work. Pentagram also provides me with a broader platform, enabling me to operate quickly, efficiently and effectively. I also have a large peer group here at Pentagram, which provides each partner with an indispensable network of knowledge, experience and know-how. We debate, we think, we rationalise and post-rationalise. However, design is ultimately about solving problems and designing 'things' that actually function and as far as I'm concerned, polemics can frequently get in the way. Although I don't subscribe to any specific school or theory, I do adhere to a certain set of loosely defined values, which, at a push, could be described as Modernist.

Designing corporate identity commands a more rational, theoretical approach than other types of graphic design. The design of book jackets, record/CD covers and posters can be a more intuitive process; those particular markets can't always be rationalised and provide more space in which to be creative. Identity, on the other hand, has to communicate both authority and accessibility, often across a plethora of commercial and corporate operations. Although research can lead to creatively inspired solutions, the core of an identity always has to be rational.

The Pocket Canons
Extracts from the King James Bible in pocket-book form. Each of the 22 volumes has an introduction written by popular figures of contemporary culture such as Steven Rose (Genesis), Louis de Bernières (Job), Will Self (Revelations) and Doris Lessing (Ecclesiastes).

To broaden market appeal and make these well-known pieces of text more relevant to a contemporary audience, Pentagram decided to approach the project as though they were designing covers for modern fiction.

In order to lend the series a modern tone, a striking language of black and white photography was employed and combined with a strong graphic grid and a clear sans serif typeface. The tonal balance and typography holds the whole series together

Angus Hyland
partner
Pentagram

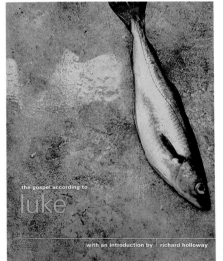

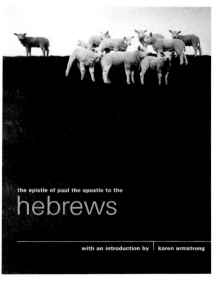

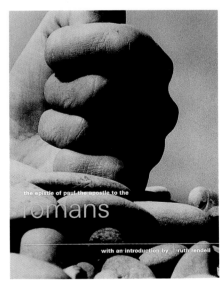

The project of mine that has gained the most recognition was my redesign of the Bible: a set of twelve Pocket Canons for the Scottish publishers Canongate Books. The project involved a radical overhaul of the Bible's packaging and, effectively, its positioning as a brand within a competitive international marketplace. The 'brand' had to appeal to a contemporary market, so the Pocket Canons had to be aimed at the kind of market who wouldn't usually buy the Bible.

If the monochromatic images employed for the Pocket Canons had been used for contemporary literature, they might not have attracted quite so much attention. However, it seemed to be the ideal solution to this particular problem: to present the Bible to a young, contemporary market.

Problem solved."

Opposite **Crafts Council Poster**
'No Picnic' was an exhibition of 'Objects and Attitudes of 10 Contemporary Designers'. An alternative to the traditional Royal Academy Summer Show, the exhibition concentrated on the conceptual side of crafts. The promotional material, poster and catalogue were all given an overtly modern tone. The catalogue employs a minimal colour scheme of metallic silver, grey, black and white with a range of modern typefaces and close-cropped photography; all these devices accentuate the cutting-edge nature of the work in the show

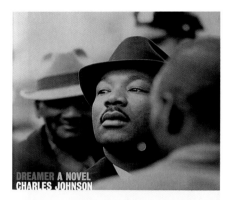

Above **Dreamer Book Cover**
Charles Johnson's *Dreamer* is a novel based on the final months of the life of civil rights activist Martin Luther King.

The cover features a photograph of King taken shortly before his death. A hole has been punched in the dust-jacket, revealing the blood red colour of the hardback cover beneath. It is a chilling image which anticipates King's impending assassination – the hole appearing just under his chin, a simple but very striking device

Above **Misadventures Book Cover**
Sylvia Smith's *Misadventures* has been described as the antithesis to books such as *Bridget Jones's Diary*, concerning itself with themes such as isolation and anonymity and referring to the general mundanity of day-to-day life

The cover design shows the figure of the central character as a mere outline, a generic female pictogram suggesting anonymity. This overriding theme of the book has been subverted by applying a red floral dress to the pictogram, evoking the underlying notion of individuality

Above **Nikkei Design Covers**
Nikkei Design is Japan's leading design magazine, a technical publication that puts stress on the relationship between design and business. Hyland designed the covers for seventeen consecutive issues between

October 1998 and February 2000. The brief asked that each cover should reflect the general theme of that particular issue. The issue shown above, October 1998, was concerned with the design of alcoholic beverage packaging in Japan

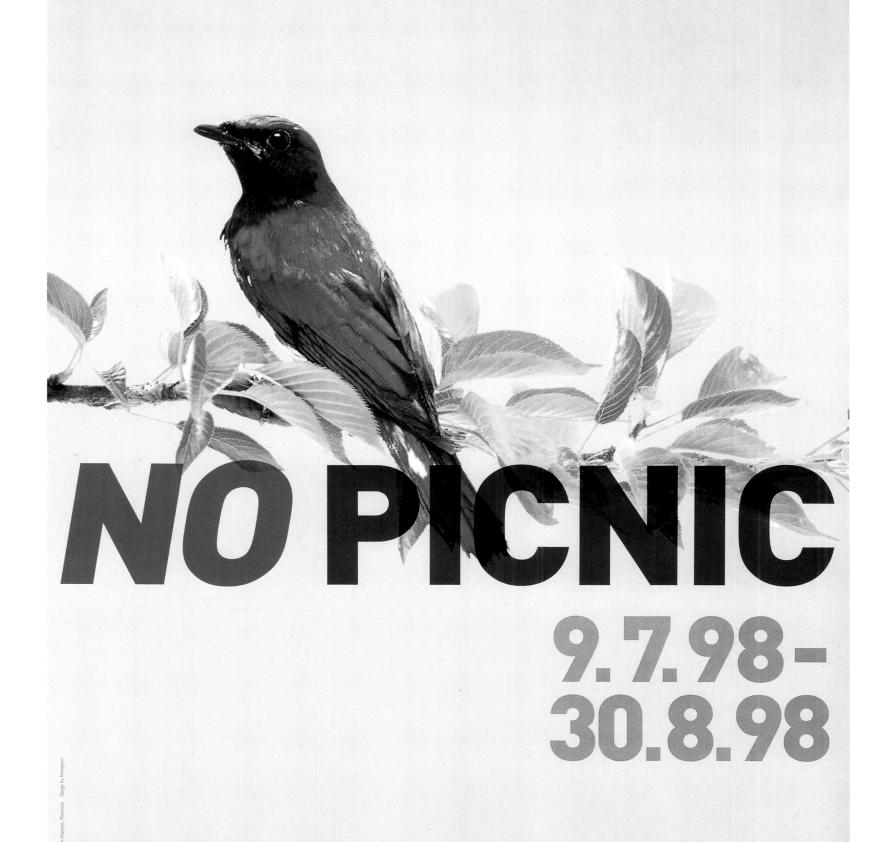

Crafts Council Gallery,
44a Pentonville Road,
Islington, London N1 9BY
Tel 0171 278 7700
5 minutes from
Angel tube

Free entry.
Tues to Sat 11- 6,
Sun 2- 6, Closed Mon
& Disabled Access

NO PICNIC

9. 7. 98- 30. 8. 98

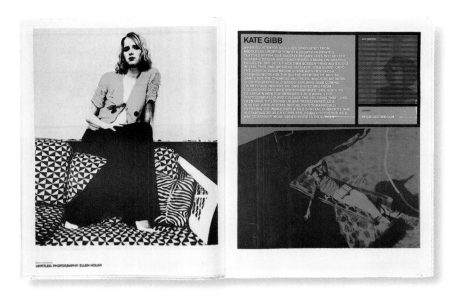

Left & below left **Picture This Exhibition**
An exhibition arranged and sponsored by The British Council, 'Picture This' was concerned with London's contemporary illustration scene and featured the work of 17 graphic artists. The exhibition was co-curated with Roanne Bell.

Hyland designed a catalogue to accompany the exhibition, the format of which resembles a tabloid-size newspaper or supplement. This refers to both the contemporaneity of the work in the exhibition and the current vogue for cutting-edge illustration in editorial design and advertising

Below **Home Sweet Home Poster**
Hyland was commissioned to design the promotional poster for this travelling exhibition organised by The British Council. Featuring examples of furniture, product and household design by contemporary British designers, the exhibition travelled to venues in Stockholm and Copenhagen.

The main title of the exhibition and the cross-stitch typography of the poster refer to the traditional role of hands-on craft in design for the home. The poster incorporates a grid that displays the silhouettes of work by participating designers, to communicate in very simple terms the content of the exhibition. It was important for the poster to be flexible: key information, referring to relevant venues and dates, was printed on a 'spoiler' at the foot of the poster in order to maintain an overall sense of clarity

Above **Walk 2000 Poster**
Hyland designed this poster for an annual
event that takes place during autumn in the
Notting Hill area. The main focus of the event
is a pedestrian tour of ateliers, shops and
galleries in the general locale.

The pedestrian nature of the event is
suggested by the *trompe l'oeil* image of a
pavement (a photograph screen-printed
with hand-separated colours), whilst a wet
footprint and autumn leaf refer to the season.
All relevant information on participating
venues and their locations can be found
on an apparently discarded note, lying on
the pavement. This note is actually a
photocopied fragment of the London A-Z
with handwritten details, an effective
device which reiterates the central themes
of the event

Right **20th Century Type: Remix Book**
The book presents classic and lesser-known
typefaces from each of the featured periods
and places them within their historical
context, considering specific examples and
practitioners. The cover design is a 'remix'
of a Wim Crouwel poster, created for the
Stadelijk Museum in Amsterdam and
featured in the chapter on the 60s

Debra Zuckerman
strategic
design
consultant
Zuckerman
Tighe

"Initially I wanted to be a journalist. I completed a BA History degree in the States, also taking the equivalent of an art foundation course. I wasn't thinking about a profession in graphic design, but the explosion of new imagery then was electrifying. In my third year I studied at UCL in the UK and took evening classes in printmaking at Chelsea School of Art. A year later, I enrolled on LCP's Typographic Design course. I liked the stress on good ideas and rigorous design craft. But it would have been too narrow an education without the history degree.

After my first client commissioned a series of book covers, I joined Mitchell Beazley as assistant to the creative director. The company was at the cutting edge of international visual book publishing. Working there gave me an understanding of conceptual and presentation skills, company politics and team management. Next I freelanced for Michael Rand at *The*

Sunday Times. Editorial design introduced me to two pleasures: collaborating with writers and editors and commissioning illustrators and photographers. I believe design always needs a good marriage between words and images.

I joined Wolff Olins as a designer on the 3i identity team. I admired the unique creative environment and enjoyed the formation of strategy, working with consultants and clients. From 1986–1990, I was art director of *Business* magazine – appointed by David Hillman, the launch designer. I made my own mark on the design, created a dynamic art department and won awards for art direction. I've had good rapport with cultural institutions, starting with Tate. In 1993, I designed *Tate: The Art Magazine* for its launch and art-directed seven issues. That project led to brochure designs for Tate communication and development departments.

I co-launched Zuckerman Tighe in 1995 with Michael Tighe (former art director on *The World of Interiors*) who worked with me on *Tate*. We work collaboratively or independently on projects for magazine, book, cultural or corporate clients, including The Art Fund, *Management Today*, and the Corporation of London.

Currently I plan to take on clients and projects with an emphasis on strategic thinking. I want to contribute to the front-end ideas and management that allow good creative solutions to occur.

I've nominated Michael Johnson, whose work is inventive, witty and intelligent. I respect that he attracts large clients with a small company. I like his presentation of the work – which has deceptive simplicity."

Top **Management Today**
Zuckerman Tighe's redesign of *Management Today* in 1999 was integral to a full editorial relaunch. In 2000 she designed *Section e*, the quarterly e-business supplement. According to client Rufus Olins, this was 'its most radical makeover in 33 years... subscriptions rose by 92 per cent. People are talking about the magazine again.'

Above **Tate's Biennial Report**
Redesigning the Tate's Biennial Report transformed a dull, neglected project. Zuckerman Tighe made one book into two: dividing the report from the facts and figures, packaging both in a plastic slipcase. The work is a reflection of good rapport with a dynamic client

Michael Johnson
principal
Johnson
Banks

"I studied Design and Marketing at Lancaster University in the early 80s and got my first job at Wolff Olins as a 'a suit with a magic marker'. I got disillusioned with consulting and decided to try my luck as a designer. I freelanced in Tokyo, Australia and London in both advertising and design. I moved back to London and worked at Sedley Place and Smith & Milton before setting up Johnson Banks in 1992. I had a total of eight jobs in eight years, which included three firings. I tend to say what I think so it's fair to say people like me or they don't – there are no greys on that scale.

Great designers tend to be terrible businessmen. I think that a judicious mix of the two is a useful compromise. It took several years for me to find my feet but the background in marketing as well as design has now become very useful – a lot of designers who take the traditional course through design school don't have the first idea about business. As for Johnson Banks I am determined that it will remain small. If having all those jobs taught me one thing, it was that small really can be beautiful, and the perfect size for a design team is a creative director helped by a handful of great designers. We currently stand at seven people and a dog, but as a unit continue to happily confound received wisdom by working with big clients. We keep the bank manager happy with blue-chip projects for the likes of Carlton and the Yellow Pages whilst cultivating cultural clients such as the Science Museum and the V&A. We work for the British Government and related bodies such as the Design Council and the British Council.

We hover around the top of the creativity charts by dint of award winning at D&AD (four yellow pencils and four nominations), *Design Week* Awards (seven consecutive winners), Design Effectiveness Awards (two so far), a New York Art Directors Gold and two Millennium Products. But awards aren't everything, are they?

We used to be based in print design, but we have now broadened into brand identity, exhibitions, signage, animation, web design and film direction. We still don't do packaging design. We did try it once but it was a disaster. We like to communicate, not confuse.

We're lucky that 95 per cent of our clients come by referral so they tend to know us, are interested in design and what it can do. Luckily they usually know that they will get the best out of us if they prod us in a direction then leave us alone. Consequently, we have very few who mess with what we do and it's rare that our work needs a 'big sell'– it either works or it doesn't. Irrefutable logic is so much harder to refute.

We have been known to fire clients who don't subscribe to our views. We also turn down quite a lot of work if we don't think it's going anywhere interesting.

When I was at college Neville Brody was everything. After I started working

Above **Canna Kendall Corporate Identity Johnson Banks devised a corporate identity for headhunters Canna Kendall that showed how they put the right people and companies together. Famous 'pairs' are featured on the reverse of all stationery elements**

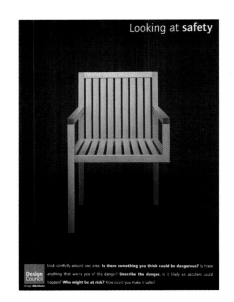

Below **The Design Council Design Decisions Education Campaign**
The initiative aimed to encourage pupils to think about basic design concepts such as 'storage', 'safety' and 'materials'. By illustrating the campaign with impossible images, Johnson Banks prompted children into investigating the ideas in more detail

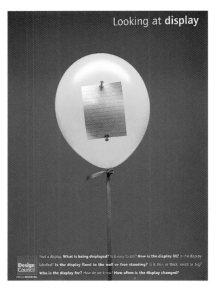

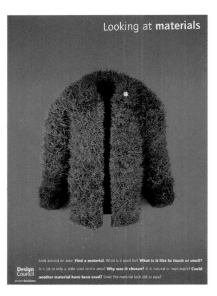

for other people, I either read or bought every book on graphic design I could lay my hands on. Consequently, everyone was my hero. Now I tend to be less interested in graphics per se and more interested in all forms of art, design, advertising, film and architecture. From a graphics point of view, Tom Roope and Fred Flade's work always intrigues me. While I'm sure they hate my work, I think that Farrow Design and North have done some of the strongest work in the 90s. Overseas, Stefan Sagmeister's body of work is already quite astonishing. And it was a great shame to lose Tibor Kalman; his work was constantly clever and different. I also admire Cahan & Associates for, in my view, completely turning print design upside-down in the last few years.

Next to my bed there's always a huge pile of magazines, books and journals – anything from old copies of *Typographica* magazine to *The Economist* or a book on Daniel Libeskind. I've turned into a sort of culture and information magpie. People often talk about me using words and pictures together and I do use these elements together constantly rather than treat words as the grey bits between pictures. Clearly our work is conceptual and ideas-based, but 'witty' design has become a bit associated with a different time. I'm keen on twisting wit, ideas, concepts and humour into a 21st-century cocktail, not merely endlessly re-hashing the same old 60s concepts.

Politics has a considerable effect on the way we work. We've spent the last few years working for Number 10, the British Council, the Design Council and the DFEE. We briefly worked for the Labour Party prior to them coming to power, and we were once referred to as the Government's favourite designers. We couldn't do it for any other party and I'd actually like to do more activist work if I could.

Mine tends to be a very narrow-minded consultancy as we'd like to do more, maybe all, cultural and political work, but we couldn't run a company on cultural work alone. Well, we could, but it would probably have to be even smaller.

The design industry has become increasingly professional while I've been working within it. Over the last ten years it has adjusted to the wholesale adoption of computers, while over the next decade we will see the impact of the web on our day-to-day lives. The blurring of the boundaries between graphics, animation, film, sound design and multi-media will, I think, be the most interesting area of the next few years.

From an education point of view, I would like to get more design into the curriculum and grab every chance to do schools-based work. The only reason I'm a designer is because my woodwork teacher would send me down on school trips to the Design Council's old building in London's Haymarket when I was 15. I would travel back up north with my head full of all the design I had just seen and all the ideas I had soaked up. I think it probably changed my life."

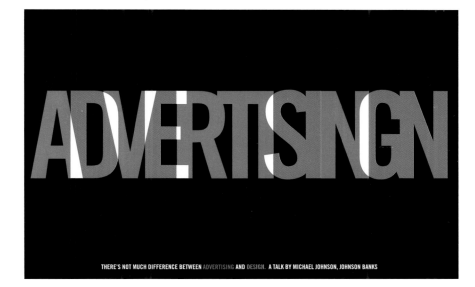

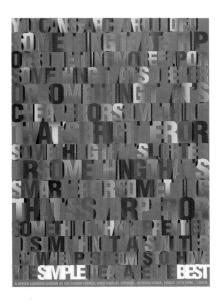

Lecture Posters
The poster above is a play on the two words to show that there is not much difference between the two disciplines

Opposite **V&A Fundraising Brochure**
A 'twisted' brochure which explained Daniel
Libeskind's radical proposal for extending
the museum. After months of work Johnson
Banks realised that the concept didn't work
in 2D, and that it made much more sense to
send a model of the 24-0plane continuous
spiral. The brochure was put on the inside
of a collapsible container that deconstructed
to reveal the model

Opposite right **William Morris Symbol**
This symbol challenged the usual attempt
to sum up his work using wallpaper or
'The Strawberry Thief'. When asked to
re-present Morris in a more contemporary
light, Johnson Banks noticed that all of his
work drew upon nature in some form. The
lead image for the exhibition took a real
acanthus leaf and morphed it into a piece
of Morris's acanthus wallpaper

Below **The British Council Britain Posters**
A worldwide set designed to illustrate the fact
that Britain is changing. The poster below
sums up centuries of British art by chopping a
Stubbs horse painting in half and sticking it
onto one of Damien Hirst's formaldehyde sheep

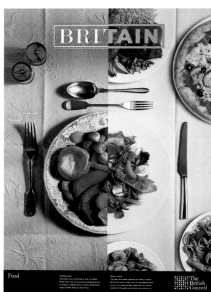

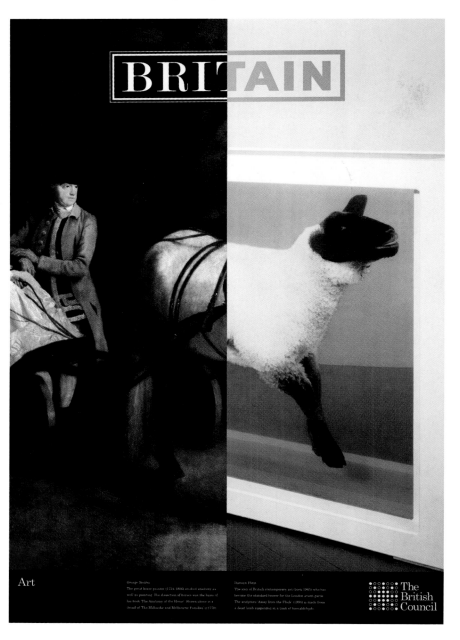

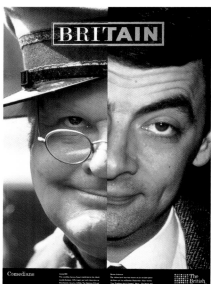

Above **Symbol for Parc de La Villette
film festival**
For years Parisians have flocked to the Parc
de La Villette for the outdoor film festival
which runs for ten weeks during the summer.
It's free if you sit on the grass or you can hire
a deck chair for a few francs. To symbolise the
event Johnson Banks replaced the cloth of the
deckchair with film. The symbol can be used
at any angle on posters and leaflets, and has
also been turned into a 'sting' at the beginning
of each film

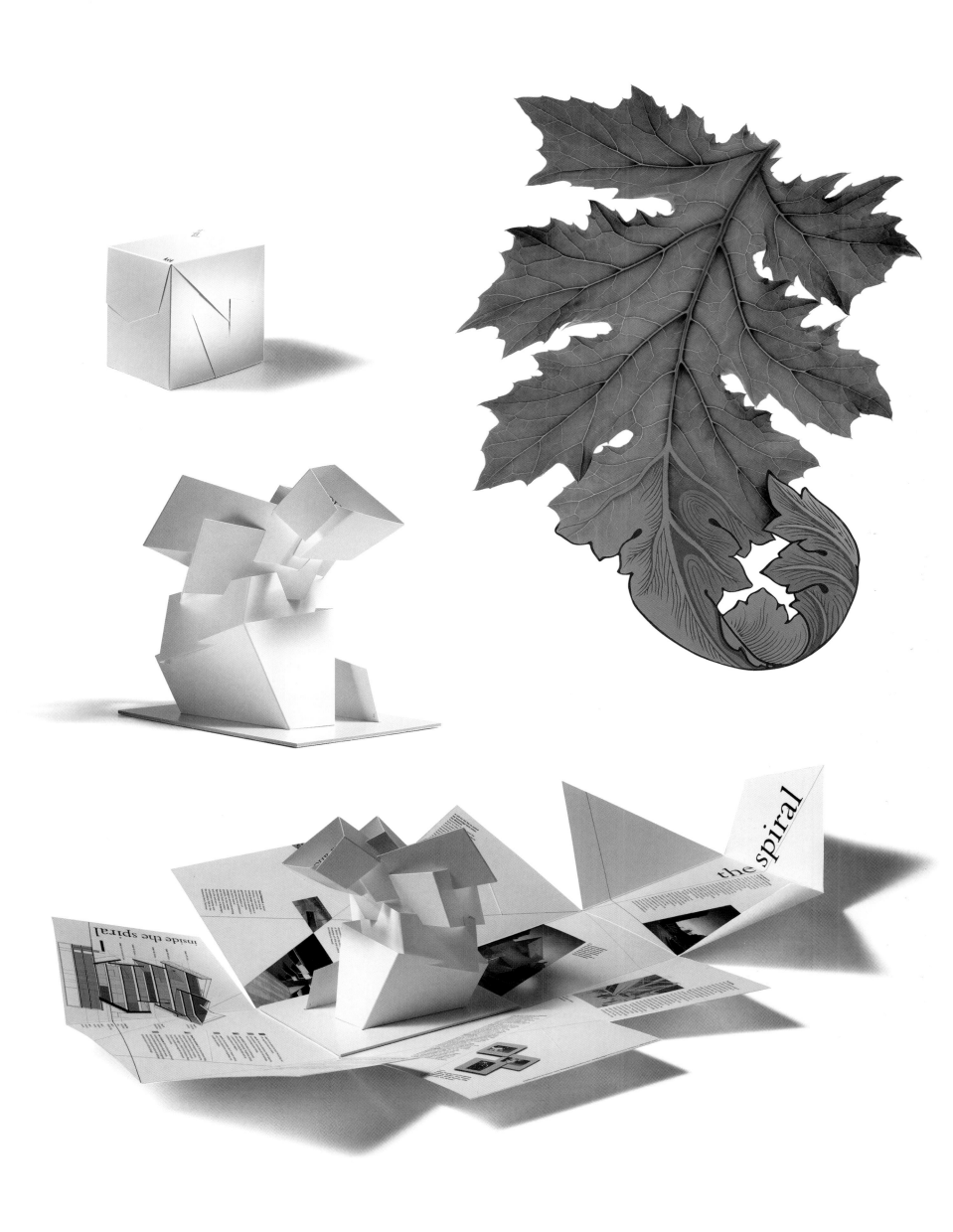

Professor Erik Spiekermann
information and type designer

"I studied History of Art at the University of Berlin. Afterwards I had a little print shop in London where I set type, which is how I became interested in design. After the shop burnt down, I became a designer and taught at the London College of Printing. In 1979, I started MetaDesign and moved back to Berlin.

I left MetaDesign last year, as I didn't agree with the policy that my partners were pursuing, which led to the firm suffering. The business people had taken over and the company's main focus was no longer design. We actually earned more money when we put design first.

Designing is an intellectual activity although that doesn't mean you have to approach it intellectually. I used to work a lot with Neville Brody and I wouldn't call him an intellectual. He's intelligent, well-read, well-travelled and an amazing art director. But he doesn't analyse. While I take things apart and put them back together again, he has great ideas and visualises them.

Teaching keeps me in check, as young people can spot if you're not authentic. I also give lectures; we designers are a vain lot and need applause. I learn by teaching, as I never trained properly. Also lecture organisers need a Kraut with a sense of humour who speaks English.

Colleges seem to want their graduates to instantly get jobs with lots of money, whereas I expect graduates to leave with an open mind. That was the problem with the dot.com hysteria: graduates were instantly paid huge salaries. It had a negative effect on the business – they all read stupid American magazines and believed that they were entrepreneurs because they owned a Powerbook. My advice to young designers is to ask questions, travel and get on people's nerves. LettError combine amazing technical ability with a childish humour. A lot of people who have technical expertise tend to be the grey over-coated, nerdy guys, but Just and Erik are creative wizards, great designers and still great programmers."

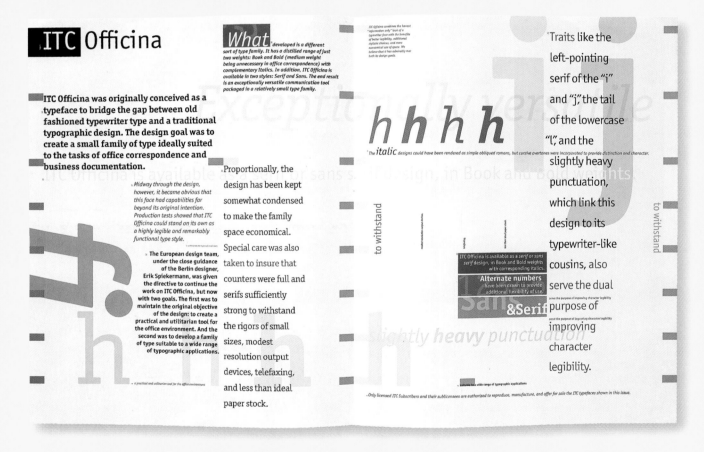

ITC Officina 1988
ITC Officina was supposed to replace Courier and Letter Gothic as the typeface for correspondence printed on laser printers. While working on the face, however MetaDesign soon realised that it could hold its own as a proper typeface. Its cool look and honest, no-nonsense shapes have made ITC Officina one of the most popular fonts around since it was released in 1990. There are sans and serif versions, and weights range from book to black

LettError
co-founders
Erik
van Blokland
and
Just
van Rossum

"We launched LettError in 1989. We publish and license a series typefaces, develop tools, illustration and animation work, graphic and typographic design for any and all media. Our clients vary considerably, while a lot of different people buy our fonts we're not strictly a font foundry. A small group of people buy our font tools. Our graphic design clients include the Dutch Mail, MTV, Apple, various publishers, foundations and non-profit organisations. In 2000, our work was awarded the Charles Nypels Award for innovative typographic design. Last year marked the development of the LettError Shop, taking type design and typography online.

We both studied typographic and graphic design at the Royal Academy for Fine & Applied Arts in The Hague, Netherlands. After graduation we worked at a couple of firms and decided that we should be working for ourselves. Font sales picked up unexpectedly (FF Hands, FF Trixie, FF Instant Types etc). Now LettError is mostly visible as a popular website and the Typoman & Crocodile digital puppet show.

Graphic and typographic design, with detours into illustration and animation, is where LettError is at its best. Like any other design company we find experiments important, but we also like to draw conclusions from them and learn. Building software as part of the design process means that a lot of typographic experience is written down in code. The tools we build for one project are the basis for the next generation of tools and the next job. Not necessarily recycling — the tools reflect a way of working, not a specific graphic style or aesthetic.

Apart from growing up in families where creative work paid for things, we have no formal training in business. That's probably keeping us from launching a multi-national design firm with 200 people, but it also keeps the work enjoyable. All you need is a good accountant for the rest.

Currently we have no plans for expansion. Rather we have opted for automation and software development. This makes it possible to take on small to medium size jobs without having to employ people. It's flexible and efficient without the corporate hassle. Licensing design, mainly our typefaces, to other companies is our answer to expansion for the short term.

We make an effort to solve the riddle through design, as the problem that the client puts forward might not be the one that needs solving. We like clients who have a sense of humour and allow us to do our job.

LettError distinguishes itself from other design firms in a couple of disciplines. We offer type design next to regular typographic and graphic design. Custom type design can solve a lot of

LettError Website
Logotype and screen design for
LetterSetter.com

problems. For instance, a custom type family can provide a cost-effective solution to complex font-licensing and deployment issues. The design can offer a clear and different typographic voice for a corporate identity. LettError has developed corporate typefaces for large companies.

When it comes to programming, we have a lot of experience in automating parts of the design and production processes. Custom (graphic) applications can solve complex production issues, for instance by producing illustrations, layouts, websites or any other piece of structured design matter following specific design parameters. This way we can take on much bigger jobs than most firms our size.

Computers are the tools of choice, but we think the software is the main influence for designers. That's why we make an effort to develop our own when existing tools can't cut it.

Creativity should drive the software, not the other way round, as is usually the case. Everything said and done, sometime the best solutions are hand-drawn, scanned and outlined without much modification and sent into the big world. Computers and software are great tools, but we can't write a program to make an aesthetic decision. But they can do just about everything else.

In short, LettError believe that life's too short for tedium. Type should be readable, illustrations should be fresh (never stocked), websites have to be clear and navigable (why bother otherwise?), and repetitive work should be automated."

Above **Python Software Foundation Logo Python Software is an open source programming language. Also shown is an illustration for the Python installer for Windows**

Left **Illustration for an article about PDAs**

Opposite **Type Design**
This design was initially developed as an on-air typeface for MTV. It was reworked and extended with italics

Joints for Model Aeroplane.
In constructing *model* or *toy aeroplanes* the strips are used are so slender that it is difficult to join them at the brads without splitting them. If glue is used, there is a danger of breaking two or more ribs, should it be necessary to *remove* a broken or defective rib. *An empty 22-gauge long cartridge can be formed into an elbow that will connect the framework accurately,* give **more strength** than glue or brads and allow a broken section to be removed without spoiling the other part of the framework.

PULLING *WIRE* THROUGH CURVED ELECTRIC FIXTURES

INDOOR **BASEBALL** GAME
'BASEBALL DIAMOND ON A BOARD'
An indoor game of *baseball* may played on a board 15 ft. long and 13 ft. wide.

HOW TO MAKE
A RADIUM *Photograph:*
The radium rays, like the X-rays, affect the photographic plate, as is well known, but it would naturally be supposed that the enormous cost of radium would prevent the making of such a photograph by the amateur.

GALVANOMETER

IT IS A FACT however that a radium photograph can be made at home at practically no cost at all, **provided the amateur has enough patience to gather the necessary material,** which is nothing else but *broken incandescent gas mantles.*

python powered

Cleaning **clothes** by boiling them:
1. A labor *SAVING* method in dish washing for a summer day is as follows: 2. Construct a wood *FRAME,* cover it with galvanised wire mesh. 3. Hose it down.

GEAR CUTTING MACHINE

LTR NewCritter Regular
abcdefghijklmnopqrstuvwxyz
ABCDEFGHIJKLMNOPQRSTUVWXYZ
çœæøÇŒÆØ fiflß
åäáàâãÅÄÁÀÂÃ ëéèêËÉÈÊ
ïíìîÏÍÌÎI öóòôõÖÓÒÔÕ
üúùûÜÚÙÛ ÿŸñçç
0123456789 ([{}])
‹‹‹«›››» ""„‚'""'"" \|//-_-—.,:;…?!¿¡
®©℗ •™ºª†‡µe #%‰°±-+÷=≠ $ƒ¢£¥€

LTR NewCritter Bold
abcdefghijklmnopqrstuvwxyz
ABCDEFGHIJKLMNOPQRSTUVWXYZ
çœæøÇŒÆØ fiflß
åäáàâãÅÄÁÀÂÃ ëéèêËÉÈÊ
ïíìîÏÍÌÎI öóòôõÖÓÒÔÕ
üúùûÜÚÙÛ ÿŸñçç
0123456789 ([{}])
‹‹‹«›››» ""„‚'""'"" \|//-_-—.,:;…?!¿¡
®©℗ •™ºª†‡µe #%‰°±-+÷=≠ $ƒ¢£¥€

LTR NewCritter Italic
abcdefghijklmnopqrstuvwxyz
ABCDEFGHIJKLMNOPQRSTUVWXYZ
çœæøÇŒÆØ fiflß
åäáàâãÅÄÁÀÂÃ ëéèêËÉÈÊ
ïíìîÏÍÌÎI öóòôõÖÓÒÔÕ
üúùûÜÚÙÛ ÿŸñçç
0123456789 ([{}])
‹‹‹«›››» ""„‚'""'"" \|//-_-—.,:;…?!¿¡
®©℗ •™ºª†‡µe #%‰°±-+÷=≠ $ƒ¢£¥€

LTR NewCritter BoldItalic
abcdefghijklmnopqrstuvwxyz
ABCDEFGHIJKLMNOPQRSTUVWXYZ
çœæøÇŒÆØ fiflß
åäáàâãÅÄÁÀÂÃ ëéèêËÉÈÊ
ïíìîÏÍÌÎI öóòôõÖÓÒÔÕ
üúùûÜÚÙÛ ÿŸñçç
0123456789 ([{}])
‹‹‹«›››» ""„‚'""'"" \|//-_-—.,:;…?!¿¡
®©℗ •™ºª†‡µe #%‰°±-+÷=≠ $ƒ¢£¥€

LettError Federal
Showing of LTR Federal, pomp and circumstance in typography. Four levels of detail (6, 9, 12 and 18 lines on the Cap height), several angles and hundreds of combinations. Comes with LTR LayerPlayer to make sense of it all

Screendump of LayerPlayer
LayerPlayer is an application developed by
LettError to build complex layered graphics
with LTR Federal

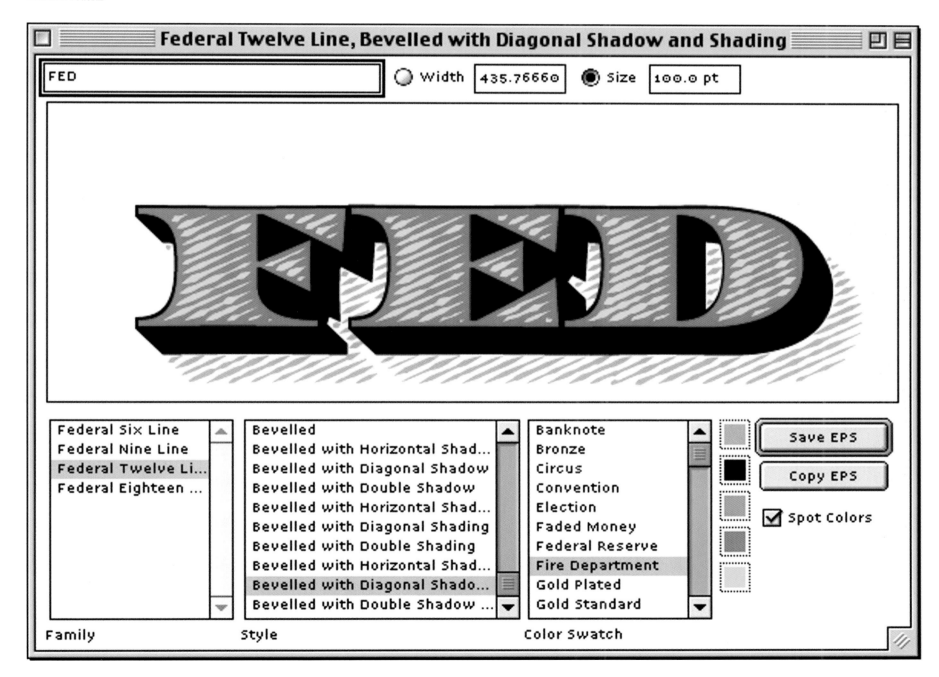

Federal Twelve Line, Bevelled with Diagonal Shadow and Shading

FED

○ Width 435.76660 ◉ Size 100.0 pt

Family	Style	Color Swatch
Federal Six Line	Bevelled	Banknote
Federal Nine Line	Bevelled with Horizontal Shad...	Bronze
Federal Twelve Li...	Bevelled with Diagonal Shadow	Circus
Federal Eighteen ...	Bevelled with Double Shadow	Convention
	Bevelled with Horizontal Shad...	Election
	Bevelled with Diagonal Shading	Faded Money
	Bevelled with Double Shading	Federal Reserve
	Bevelled with Horizontal Shad...	Fire Department
	Bevelled with Diagonal Shado...	Gold Plated
	Bevelled with Double Shadow ...	Gold Standard

Save EPS

Copy EPS

☑ Spot Colors

**Aziz
Cami**
managing
partner
The
Partners

"In 1983, we launched The Partners, comprising five designers who knew each other really well. We had all shared a studio for 18 months prior to launching the company. As designers we had a breadth of experience and an intrinsic creative integrity to share.

I don't believe that creativity comes from an artistic background – it comes from asking really probing questions and identifying the unique not generic problems. The best design comes from asking why and then challenging conventions. As we don't see design as a personal expression, we are able to facilitate many different problems and offer solutions. We do use wit, it's a basic communication tool that engages the mind as well as the heart. Also, we've always been interested in the literary component of design, whereas many designers see words as an afterthought. We never wanted to be fashionable, so we haven't gone out of style.

There is another myth that you can't do big and small jobs. At our size, we now have to seek out the small projects. These projects give us a change of pace; they are very tangible and give small businesses a pay back very quickly.

We sold to Young & Rubicam in July 2000, which was bought by WPP. This allowed us to raise the bar and attack some other fundamentals, such as the notion that you can't be creative and make money. We have had significant growth but retain our core values from 1983. That's important to us.

I've nominated Atelier Works because, as a business, I recognise some basic values that we both share. The company uses intrinsic business understanding and complimentary craft skills to produce great work. They are modest, quiet people. They work for clients in lots of different areas: this and their enthusiasm will push them forward.

The piece of work that most inspires me is the 'Sex Life of the Alphabet' poster, which is a great idea and fantastically designed. I always feel that if you can take something out of a piece of design and it still functions, then it doesn't work. This design is totally pared-down; all the elements rely on each other."

Above **Hewlett Packard Annual Report 1983**
The Partners tackled the design conundrum –
why annual reports are invariably interesting
at the front and then boring at the back.
Its report for Hewlett Packard was the first
to use illustators and photographers to make
graphs more engaging

Left **Warner Bros. 1996**
A hoarding to cover Warner Bros.' New York
flagship store during its revamp. It received
awards on both sides of the Atlantic

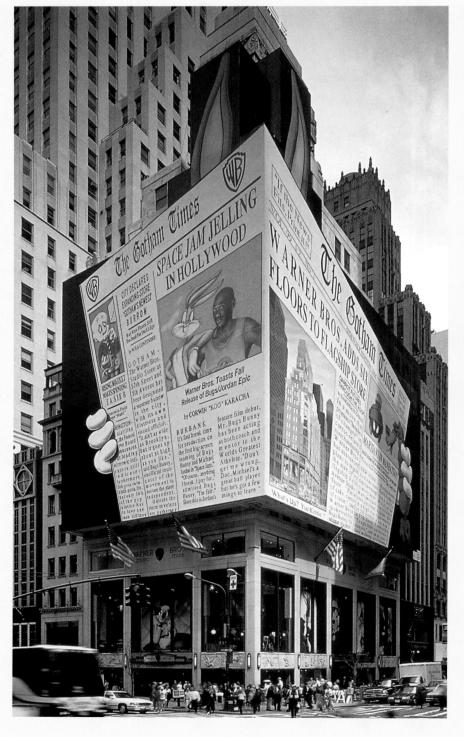

**Quentin
Newark**
co-founder
Atelier
Works

"I left college with a first in Graphic Design and thought the world lay at my feet. My first job consisted of choosing the colour for the little cotton head and tail bands that furnish the spines of novels at Faber & Faber. In 1984, I went to Pentagram, working with John McConnell to produce Faber covers, designing one a day for 18 months.

I'm now a quarter of Atelier Works, a graphic design collective founded ten years ago. Recent projects include the Labour Party's manifesto, wine bottles for the Royal Society of Arts, re-branding RIBA, all design work for Volkswagen UK, and an exhibition in the then Foreign Secretary Robin Cook's office for the Design Council. We don't differentiate between big or small clients as they both present problems that can be exciting to tackle.

We like to think our work is not cosmetic and we orientate it towards longevity – museums, commercial companies with huge audiences and government organisations need a graphic approach that is cooler, confident, durable and less desperate to impress.

Politics have an effect on the way we work, but we don't produce overt political work. We work with charities and other groups that are trying to move things on. When we left a meeting with Tony Blair recently, he smiled and said, 'Our future is in your hands'. A lot to ask of typography.

I see Atelier Works as a family, a creative workshop with a convinced, common approach and ambition that allows the work to be done individually or collaboratively. We are only ten people, and people tend to stay here a long time.

We will never sell. Selling yourself is always about doing more or bigger business – money essentially. Expansion almost always means that the principal designers have to become managers: meetings, reading and writing reports, financial projections, overseeing and never doing. It is very rarely about better design.

The designer I am most touched, affected and moved by is Alan Fletcher as his work has evolved to be so personal, fresh and unmannered. He draws, paints, collects, collages, builds diverting papier-mâché animals and has compiled and designed a vast book about creativity and imagination. He doesn't issue press releases nor does he plan to merge with a network. There is a vigour and energy about youth, but design is a very sophisticated activity and mature designers do it better.

I find a lot of aspects of the design industry depressing. I don't like design to be seen as an art or world-changing experience because it isn't. I hate the obsession with the new thing. All these exciting and ambitious positions see design as magical,

Sex life of the alphabet

A talk by Quentin Newark
of Atelier Works for TypoCircle

at Ammirati Puris Lintas
25 Soho Square London W1
on 27 April at 7.30pm
tickets from patrick.baglee@r-t-s.co.uk

and at Copthorne Hotel
Quayside Newcastle-upon-Tyne
on 6 May at 7.15pm
tickets from Gillian Smith 01482 325503

**TypoCircle Poster
Type made sexy in a poster to publicise a
lecture on the 'Sex Life of an Alphabet'**

which it isn't. The most depressing view of design is when someone in a suit says, 'clients need to understand what we do', like we ought to be perceived and comprehended like accountancy. The whole point about design is that it isn't a formula (like accountancy mostly is). It's an attitude and a very varied and complicated set of responses.

Sadly, the faculties to help designers deal more effectively with these sets of responses do not have a main role in design education. It would appear that the moment you show the slightest inclination towards visual skills at school, you're cut off from the need to read or contextualise. I want to understand why it is so different in graphic design and why it isn't necessary for a designer to understand the politics, ethics and history of their own profession. Designers don't read, they glance, and the roots of this are two-fold: partly due

to design being perceived as non-intellectual and partly to do with the non-literary way that we develop visual skills. If designers read more, the way they designed would be more conscious of being read. What designers considered important would change, instead of 'design as content', we would be much more interested in making the content into content worth reading."

Opposite top **The Labour Party Manifesto**
The manifesto for the 2001 election in all
its variants; English, Scottish, Welsh and
Welsh language

Opposite bottom **Department for Education
& Employment**
The 'Learning Journey': seven million
booklets, one for every parent in Britain,
which through a rich mixture of text,
photographs and illustrations, explain the
National Curriculum

Below **Bull Signs Calendar**
A catalogue of bewilderingly contradictory
signs for a calendar

Sign seen near Swanage

June 2000

T	F	S	S	M	T	W	T	F	S	S	M	T	W
1	2	3	4	5	6	7	8	9	10	11	12	13	14
15	16	17	18	19	20	21	22	23	24	25	26	27	28
29	30												

Bull Signs Bayhorne Lane Gatwick Surrey RH6 9EU **T** 01293 821313 **F** 01293 821414

Sign seen in County Wicklow

October 2000

S	M	T	W	T	F	S	S	M	T	W	T	F	S
1	2	3	4	5	6	7	8	9	10	11	12	13	14
15	16	17	18	19	20	21	22	23	24	25	26	27	28
29	30	31											

Bull Signs Bayhorne Lane Gatwick Surrey RH6 9EU **T** 01293 821313 **F** 01293 821414

Sign seen in Butchart Gardens, British Columbia

May 2000

M	T	W	T	F	S	S	M	T	W	T	F	S	S
1	2	3	4	5	6	7	8	9	10	11	12	13	14
15	16	17	18	19	20	21	22	23	24	25	26	27	28
29	30	31											

Bull Signs Bayhorne Lane Gatwick Surrey RH6 9EU **T** 01293 821313 **F** 01293 821414

Sign seen on Vancouver Island, Canada

July 2000

S	S	M	T	W	T	F	S	S	M	T	W	T	F
1	2	3	4	5	6	7	8	9	10	11	12	13	14
15	16	17	18	19	20	21	22	23	24	25	26	27	28
29	30	31											

Bull Signs Bayhorne Lane Gatwick Surrey RH6 9EU **T** 01293 821313 **F** 01293 821414

Sign seen in Streatham

December 2000

F	S	S	M	T	W	T	F	S	S	M	T	W	T
1	2	3	4	5	6	7	8	9	10	11	12	13	14
15	16	17	18	19	20	21	22	23	24	25	26	27	28
29	30	31											

Bull Signs Bayhorne Lane Gatwick Surrey RH6 9EU **T** 01293 821313 **F** 01293 821414

Sign seen near Winkfield, Berkshire

August 2000

T	W	T	F	S	S	M	T	W	T	S	S	M	T
1	2	3	4	5	6	7	8	9	10	11	12	13	14
15	16	17	18	19	20	21	22	23	24	25	26	27	28
29	30	31											

Bull Signs Bayhorne Lane Gatwick Surrey RH6 9EU **T** 01293 821313 **F** 01293 821414

Opposite top **The Orange Studio Identity**
Identity for a new venture for the
telecommunications whirlwind;
The Orange Studio, a business/café/
internet/conference centre

Opposite bottom **Royal Society of Arts
Wine Label**
This shows exactly what you want from
a bottle of wine – a glass

Below left **The Mennonites**
Itinerant farm workers and religious
zealots, the Mennonites, live on the fringes
of American society. The only books they
allow themselves are Bibles. This moving
essay of words and pictures by Larry Towell,
made over a ten years, has photographs on
artpaper interspersed with prose on thin
paper sections

Below right **Royal Society of Arts Annual
Report 2000**
This uses different typefaces designed by
the RSA's own Royal Designers for Industry

Milton Glaser
founder
Milton
Glaser
Inc.

"As a child I was always drawing comic strips. As an adult I wanted to do something that combined drawing, telling a story and type.

I began working for a packaging designer in 1950. In the 50s, design was thought of as a combination of beauty and purpose. Nobody talked about marketing and branding – the latter was something you did on a cattle farm. The implicit notion was that aesthetics could be effective in selling a product.

Style used to be something that could be identified by its visual characteristics, now style is a mode of thought. I can't lose my appetite for creating imagery and playing the form, although the basic work I do is communication, which involves moving a message from a client to a public. Style is only part of this activity. Frequently the role of style is essentially to signal that something is 'hot'.

The kiss of death for a designer's career is success at an earlier moment. Some of this comes down to how a designer identifies his or herself in relationship to fashion. For example, when you're 70 you look ridiculous if you wear what is deemed hot. Therefore consider how you might change and evolve your own personal style in relationship to the current zeitgeist.

My favourite piece of work is usually my latest but I enormously enjoyed illustrating Dante's *Purgatory* because of the complexity of the subject. I hadn't done mono prints for years.

I have a tremendous appetite for things visual, whether they are Chinese watercolours or Islamic paintings. Humankind's patrimony is the visual history of the world. Modernism is just one manifestation of that history so there is no reason for getting stuck in a single ideology. I prefer selecting from a larger menu.

I've nominated Christoph Niemann because he solves visual problems elegantly. His work is clear and articulate at a time when much work is over-burdened and complex. He doesn't feel that he has to have a favourite food."

Illustration for Dante's Purgatory 1999 (Canto XXX) was published by Nuages. Glaser believes this is the first portrayal of Beatrice as an erotic vision rather than a kind of literary abstraction

Christoph Niemann
designer
art director

"I never wanted to do illustration to put a message out there, it was just for the fun of drawing. It was only when I studied graphic design that I got in touch with the whole idea of communicating an idea with illustration.

I studied in Stuttgart at the Academy of Fine Arts under Heinz Edelmann – he was a very good although harsh teacher. But, from him, I learnt to see my work as separate, distanced from myself and was able to criticise it. In 1995 I went to America as an intern with Paul Davis and, the following year, I was an intern with Paula Scher at Pentagram. I fell into the whole graphic design culture and the New York community and decided to stay a year to test it out. And I'm still here.

From an illustrator's point of view you think that the art director plays God and decides upon your fate, but now that I've worked as an art director at the *New York Times*, I realise that there is a huge amount of pressure

and there aren't that many good illustrators who can work to deadline. So as an art director you're really happy when you find somebody that you can rely on and once you have somebody you share him or her with other art directors.

For example, *Rolling Stone* work with a lot of really established illustrators but gave me a full-page commission in 1995 when I was still a student. They successfully use a combination of established and new people all the time. In fact I can track down 95 per cent of my commissions back to my work for *The Times* and *Rolling Stone*. You get repeat business after your work has been in titles of that calibre because people think you must be good if you're commissioned by them.

I think I have a split personality, half illustrator and half art director. Naturally the art director treats the illustrator like a bad dictator, but the hierarchy is perfectly set up to solve

problems. I try not to get carried away with the fun of making a skillful drawing and just do what is required to support the idea, but sometimes you need a nice drawing to hide a weak idea. There's a certain ironic twist in what I do, a little device that helps my ideas to work.

For me the art director is the cook and the illustrator is the ingredient, so 95 per cent of an art director's job is choosing the right ingredient. Also you need an art director who is articulate enough to sell your ideas to the editor.

The vast majority of my work is editorial. I like tight deadlines and I love news; I'm a bad, bad news junkie. I read all commentary and get outraged quite easily. Whilst other designers will go into a library to research I have to start immediately with a piece of blank paper and draw on the information on an issue I already have in my head such as globalisation. I prefer print to the web

Above **Print Magazine Cover 1999**
'Young Visual Artists' issue.
Art direction by Andrew Kner

Top **Lovebook 2001**
From *Love* the latest issue of *100%*,
the third issue of a publication series
by Nicholas Blechman and Niemann

Above **Globalisation Illustration 1999**
Cover illustration for the *New York Times*
***Book Review* section. Art direction by**
Steven Heller

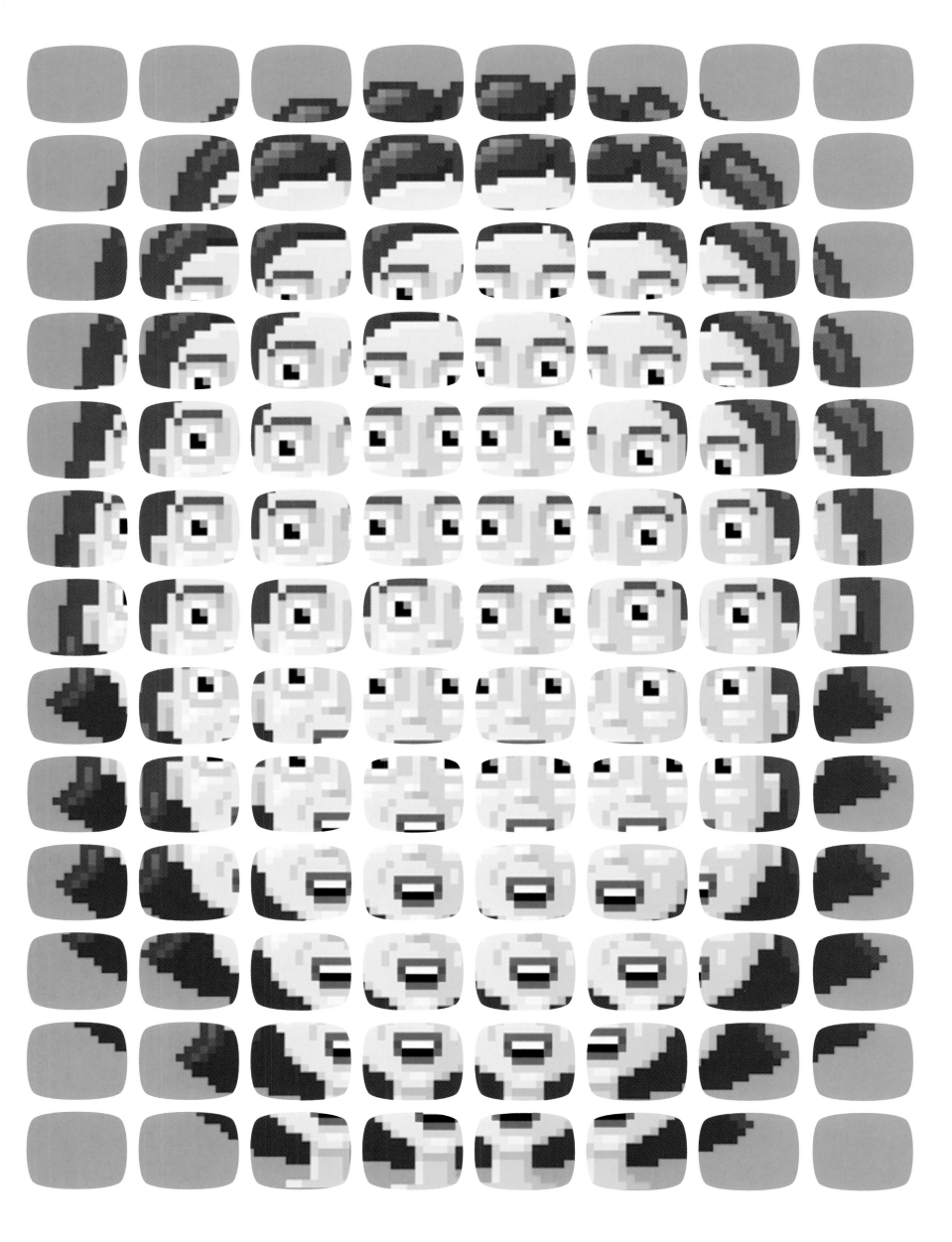

because in print you have to draw something that will appeal to millions of people, whereas the web targets a much smaller, specialised audience.

Right now I'm doing the kind of work that I enjoy. Maybe five years down the line it might change. But then again, what is wrong with sticking to the work you like? I have no idea about the next couple of years. I've just got married and I think I'd rather scale down to concentrate more on quality rather than quantity. I would love to take a lot of time and just rediscover new and old things – possibly do some animation? But I like working on my own and I don't know how great a team player I am. The great thing about my work is that I can produce without having to be dependent on anyone else.

I'm a co-teacher at the School of Visual Arts with Nicholas Blechman. Teaching as part of a team is actually a lot more fun than teaching by

yourself, because then you don't want to be too harsh or too bad. But when you have two people you can play good cop/bad cop.

I have won awards but I don't care too much about it. Of course it's nice that your work is appreciated. My dream project was always a cover for *The New Yorker*, but luckily I've just had one. One of the best moments was during the Lewinsky crisis and I did an illustration for *The Times* on the day the Starr Report came out, so everybody bought the paper. It was great to walk through Washington Square and see everybody sitting there reading it. They probably didn't pay any attention to the illustration, but I liked being part of the official record that day. And I aspire to more jobs like that."

Opposite **Web Camera Illustration 2000**
Article on web cameras for *Time Digital*.
Art direction by Sharon Okamoto

Right **Book Review Illustration 1998**
New York Times **Book Review,**
Summer Reading **Issue. Art direction**
by Steven Heller

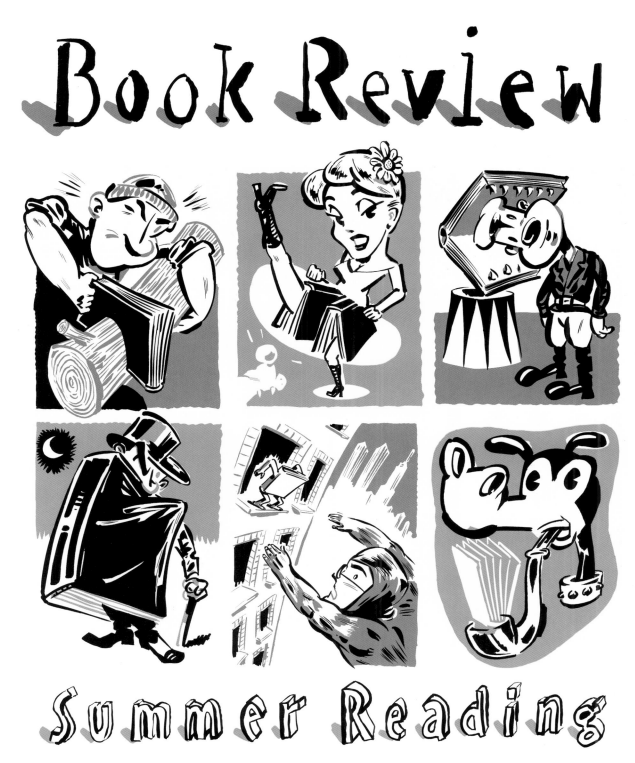

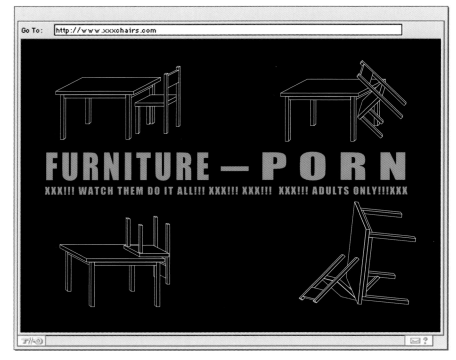

Below **Parsons Catalogue 1999**
Continuing Education Catalogue for
Parsons School of Design, New York.
Art direction by Janet Levy

Above **Mohawk Paper Promotion**
Designed by Pentagram. The theme was
'The Ten Least Visited Websites'

Opposite **Icons Illustration 1998**
The Good Portrait was published by Maro
Publishers, Augsburg, Germany

DAS GUTE PORTRAIT

SHAKESPEARE

MUHAMMED ALI

PELE

CYRANO DE BERGERAC

ATLAS

THE THREE WISE MEN

CHURCHILL

NIXON

BATMAN

NAPOLEON

E.T.

PYRRHUS

NERO

JOHN W. BOBBIT

ARCHIMEDES

HOROWITZ

JUDAS

MICHELANGELO

IKARUS

OBLOMOV

REINHOLD MESSNER

JESUS

BOCUSE

POSEIDON

HITCHCOCK

KING ARTHUR

CAIN

ABEL

ROMEO

JULIET

STEVIE WONDER

BEETHOVEN

THE MARATHON MAN

EVE

PAMELA ANDERSON

KATE MOSS

SIEGFRIED

AND ROY

BASELITZ

GIACOMETTI

MUNCH

PICASSO

MALEWITSCH

TOULOUSE-LAUTREC

ARCIMBOLDO

CHRISTO

ASTERIX

OBELIX

IDEFIX

JAQUES COUSTEAU

NARCISUSS

MOSES

SHERLOCK HOLMES

RENE MAGRITTE

BRUCE LEE

PONTIUS PILATE

GODOT

ST. MARTIN

ARIADNE

DIOGENES

SYSIPHOS

MURPHY

**Vaughan
Oliver**
graphic
designer
v23

"At college I tended to answer the illustration briefs. I really wanted to be an illustrator, as I wanted to work in a commercial design field that offered an opportunity for personal expression. And I didn't see much evidence of personal expression in graphic design at the time.

I didn't have much luck getting illustration work so I got a job in a design consultancy in 1980. A year later I moved to Michael Peters & Partners where I was the token studio rebel. I rarely got any work through but I learned a lot about the process of design and it turned me onto typography. I was always into music and art, when it came to record sleeves I admired the element of design and imagination in work by Roger Dean and Hypnosis. While at Michael Peters I met Ivo Watts-Russell, who was setting up 4AD, a new record label that was producing music I liked. I started freelancing for 4AD and then joined full time in 1983 as its first employee.

In 1988, I went freelance before setting up v23 with Chris Bigg (whom I have been working with since 1985) in 1998. Now I know what it is like to have my own business, I'm full of admiration for anyone who can hang on to his or her design philosophy while running a company. It was much easier when I was on a retainer and all my time was for creative. We want to keep v23 small and personal, as our ambitions lie more in the creative area of design rather than studio management. It's nice when the cheque comes in but I'm not after big clients.

I have a design research post at the University of Northumbria that includes a few days of contact teaching every couple of months. My brief is to produce a unique piece of graphic communication that is driven by an idea to assimilate traditional modern methodologies in a project that will develop from book design to websites."

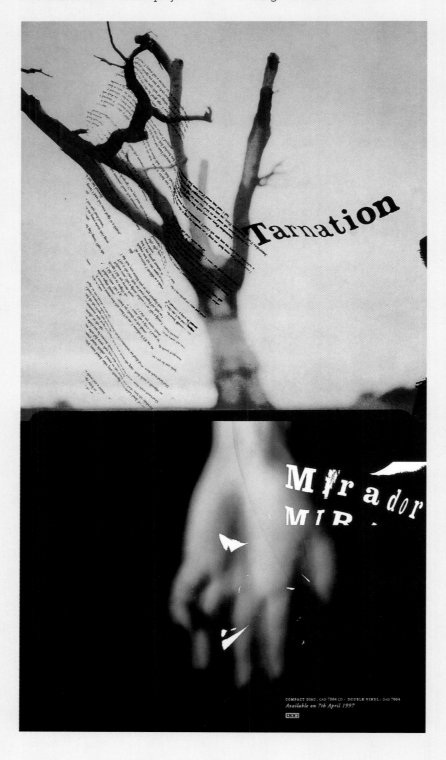

Tarnation Mirador Poster 1997
These songs by San Francisco band, Tarnation, expressed half-remembered moments and half-remembered places. Consequently Oliver wanted to evoke a melancholic dream moment in the design. Photographer Michele Turriani distorted the landscape with his lens while Chris Bigg distorted the typography in the darkroom

**Adrian
Philpott**
designer

"If there is a style to my work it is because it's thought-based. There's often a story or a narrative that can be unearthed and all the aspects connect. I absorb media and environments to get an element of realism that always has a very human quality about it. Technology doesn't drive the ideas, but can fulfil them. And this is my approach to all media – where the concept behind the idea drives the media I choose.

I permanently aspire to be able to draw simple lines, and use the arm, the whole body to draw a curve. I relate to the conceptualist movement, for example Baldessari. Events and the experience of theatre influence my work – Fluxus being a prime example of what makes me tick. I'm also influenced by artists such as Yves Klein who broke boundaries within art and the media to express himself. His art wasn't limited by the tools presented him. I admire Cornelia Parker, for the way she captures

energy – evoking time and memory. I approached creativity with these ideas in mind even before I found these artists. Discovering these artists after I had already begun on my own way reinforced my directions, and strengthened my commitment to this way of thinking, this way of working – putting the physical into visual art – and getting my hands dirty.

I am always mindful of tailoring art for a commercial need, without losing the art itself. To become a designer I had to learn to draw, to cultivate skills within the visual arts.

After some time in Canada drawing, taking photographs and a flirtation with glass blowing, I chose St Martin's to take up a formal graphic design course. I knew that St Martin's students were encouraged to produce very eclectic work – a crucial element for me.

At the end of three years I stepped out of St Martin's with no idea what I was

going to do, I just moved from St Martin's into Tomato in 1993. This was a big learning curve: working with Tomato's Graham Wood and Simon Taylor I was given the opportunity to indulge in processes to create, amongst other things, typography for a 60-second cinema commercial for Kiss 100. I produced big pieces of typographic artwork that were then taken out into a stadium and filmed.

I freelanced at Tomato for about eight weeks and then moved to v23.

Working with Vaughan Oliver and Chris Bigg of v23, then based at 4AD, was a passionate experience as I really felt close to the work we were producing. From within a collaborative team Vaughan encouraged me to 'do my own thing'.

At this time I also collaborated with photographer/director Brian Baderman on the Winter 1993 Diesel catalogue and with director John England for ad

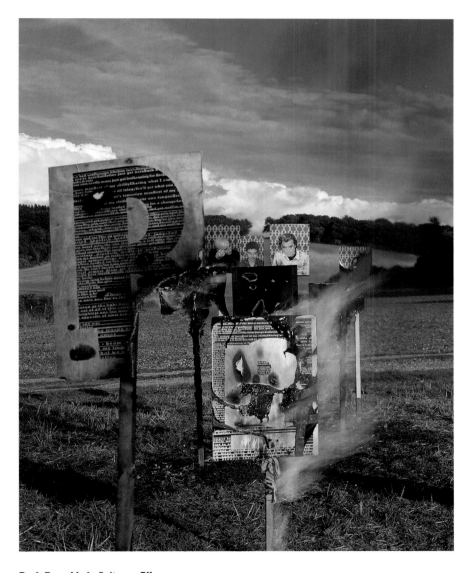

**Bush Razorblade Suitcase Album
and CD Cover 1996**
**The concept for the photography was
inspired by a series of Philpott's personal
projects, some of which were produced
during his time at the RCA. The original
work explored typography and space beyond
the realm of a work-a-day design studio and
the interface of an Apple Macintosh**

agencies such as HHCL + Partners before going to the RCA to study for an MA in Graphic Design.

Primarily I have always wanted to construct a career path for myself. Sole trading over the last few years has enabled me to choose jobs and allowed the time for private projects, while the experience of working with design studios made me realise it was highly beneficial to have more than one creative mind to produce work.

The dynamic created through collaborations transcend media disciplinary boundaries. In this environment the premeditated clashes with the intuitive. This produces a diverse palette that I can draw from to meet and combine with the client's culture.

This crossover with the client culture is crucial to me: I will always question the relevance of the medium before using it, to ensure client fulfilment.

In this questioning I will involve them and encourage their interaction. I feel uncomfortable producing design that has no value other than its own aesthetic quality. I endeavour to design with ideas that are in reaction to their needs: professionalism with creative integrity.

A strong desire of mine is to keep expanding my creative toolkit and this passion fuels my motivation. I am lucky as I find inspiration can come from challenging, cross-examining and taking risks. I trust new work to take me further."

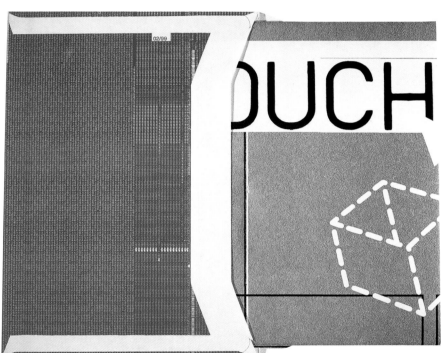

Left **Tornado Productions 1999–2000**
Brand design, development and website art direction for a digital media production company. A comprehensive branding tool kit was developed enabling maximum flexibility and control of the client's image across all digital media

Above & opposite **Tinderbox 1997–1998**
Re-branding for a film and video production company in London. The identity playfully explores the theme of boxes and places a focus on the box as the catalyst for creativity – 'the jack-in-the-box'. The logo was created from video footage of a box exploding. The direct mailer consisted of an inside-out envelope with Tinderbox logotype pattern and fold out broadsheet with the announcement: 'A Touch Warmer'

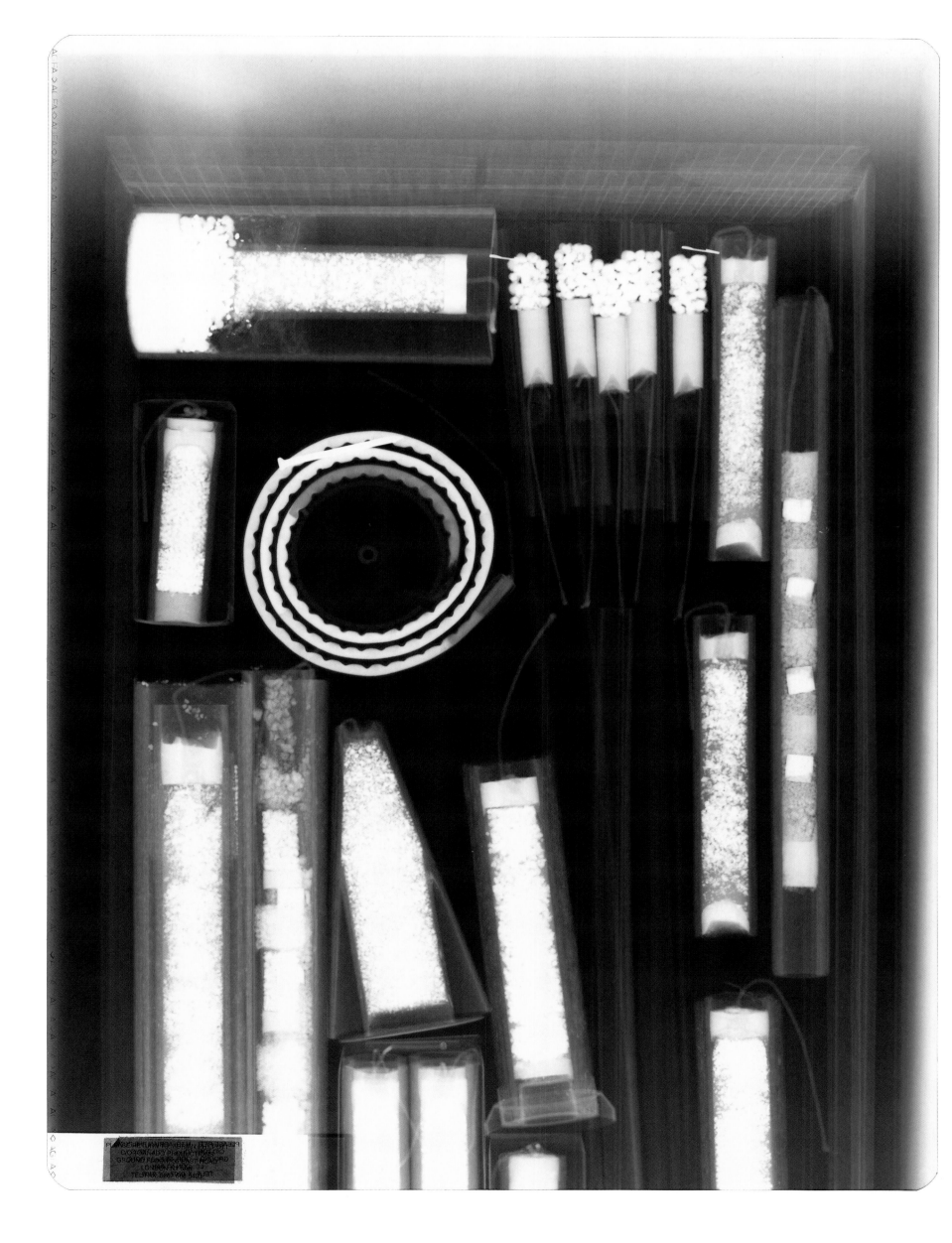

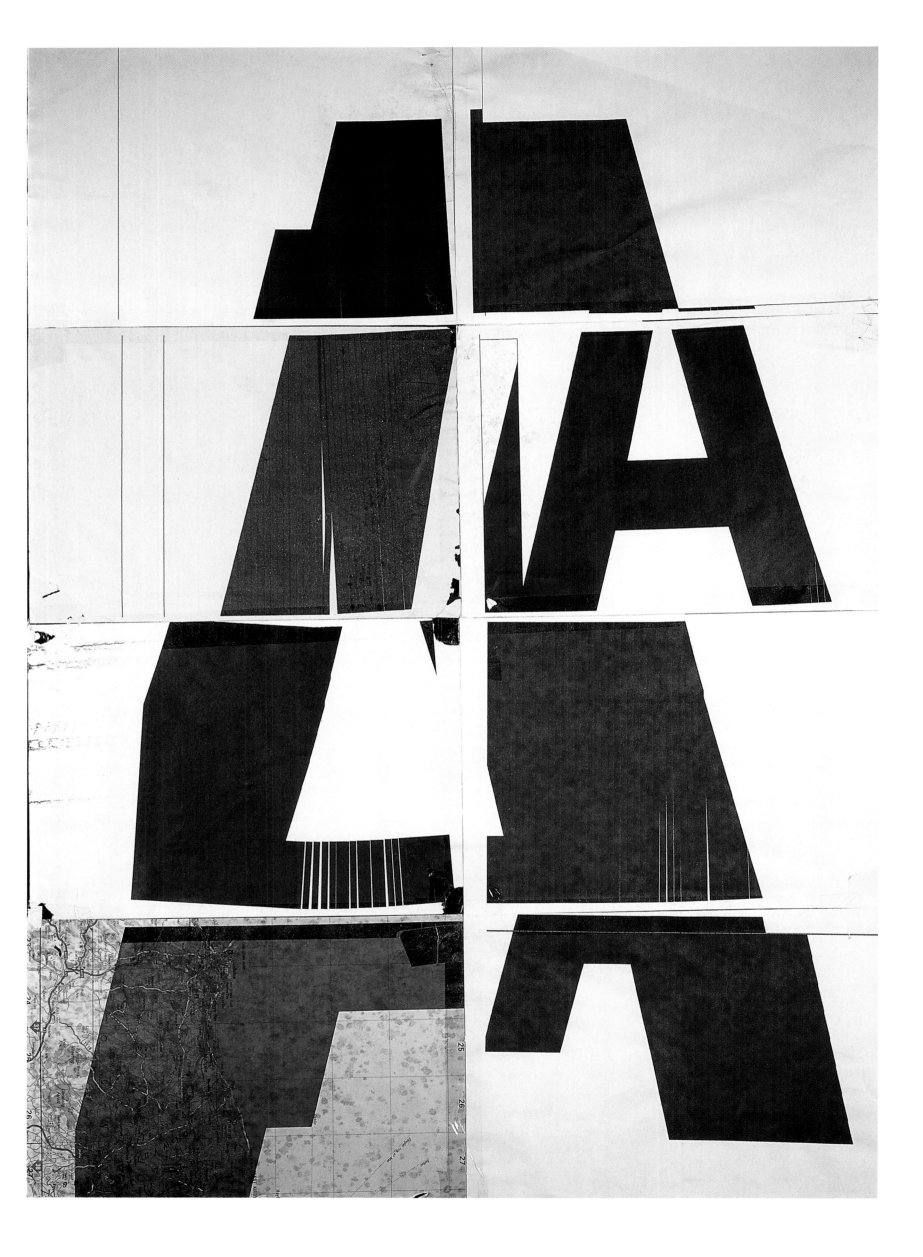

Above **At the Races Branding 2001**
Produced for Tornado Productions, this brand
development was for attheraces plc (formally
Go Racing), a cross-platform media company
that owns the rights to televise horseracing
from 49 of the UK's 59 tracks. The attheraces
consortium comprises Channel 4 Television,
BSkyB and Arena Leisure

Opposite & below **Lancia Commercial 1997**
**Typographic installations were constructed
on an airport runway in Milan**

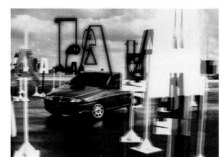

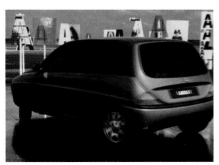
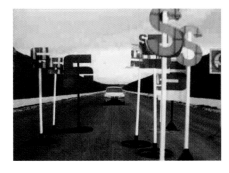
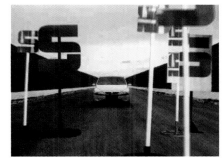
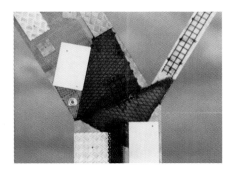

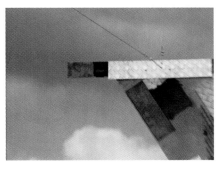
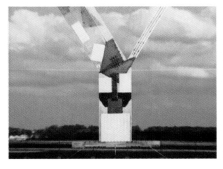

"I was cursed for being good at both mathematics and art. But my dad said that I would never make any money from drawing pictures, so I studied Computer Science and Electrical Engineering at MIT. Then I came across Paul Rand's book *Thoughts on Design*, which showed me that design was a philosophy. Consequently, I completed an MFA and PhD at the Art and Design Institute at Tsukuba University in Japan.

I returned to the US in 1995 to become a Professor at Media Lab as I felt that the relationship between computers and design still had to be reconciled. My mission has always been to work with the people I call 'Mutants of Society' – people who don't really fit into either the design or computing pods. I provide an area for them to improve their skills and then release them into the wild.

I think the most common problem is that most designers have accepted that technology is here but it has lead to frustration. I work as a sort of pragmatist looking for theories that existed before, but I am also curious about the kind of things that may be more relevant to the digital age.

Consequently my influences are really hard to quantify. If anything, it would be materials and how they fit into our world: the gentle fabric of information technology, as opposed to a human being.

I receive many enquiries regarding my programme from many a designer. 'What should I study?' they often ask. I reply that a core understanding of computer programming and computer graphics skills is critical. The usual reply is an emphatic, 'Yes. I will get back to you soon.' I never hear from them again. When I told Casey, he said, 'Yes. I have quit my job and am taking courses at a local college in the areas you have suggested.' Less than a year later Casey brought by his notebook computer and showed me some incredibly delicate work that he had designed and programmed.

Since then Casey has diversified his skills, combining electronics circuitry and motor control with his cunning capability in computer graphics and visual communication design. Casey's work represents a return to mastery of the basics while challenging conventions of the separation between design and art."

John Maeda
associate director MIT Media Laboratory

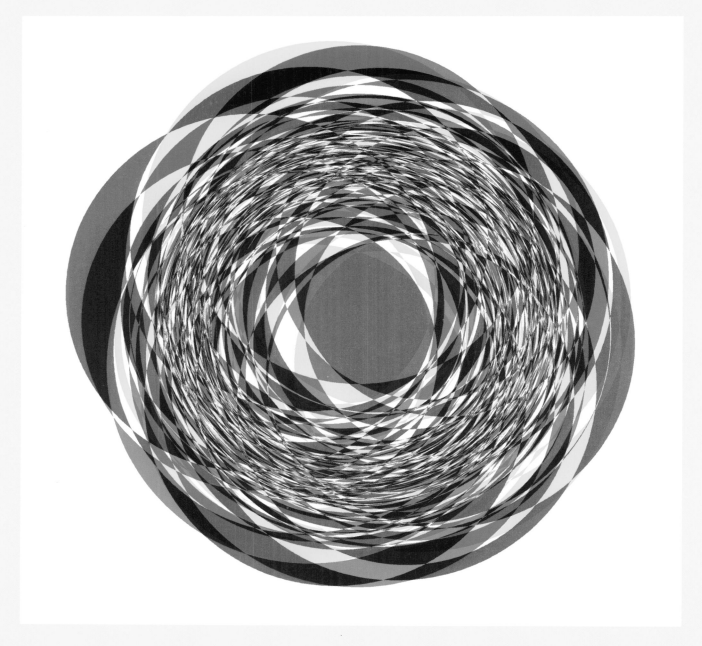

Illustration for Maeda@Media 2001
For the 'Four Colours' chapter of Maeda's book *Maeda@Media*, Maeda created a series of illustrations in the spirit of Bradbury Thompson. One of them in particular struck Maeda as something that embodied the interests he held at the time – namely the quest for complexity that lies in the space of simplicity. Maeda has since moved on, but when he looks back at this illustration he is reminded of the essence of values that he once held dear, and at the same time feels extraordinarily anxious to find the next conceptual step forward

Casey Reas
associate
professor
Interaction
Design
Institute
Ivrea
Italy

"When I was younger I was able to draw so I became interested in making visual works. I grew up amongst the corn in a small town in Ohio, so I didn't really know what design was. I wanted to be an illustrator, but happened into a design program at the University of Cincinnati and there I fell in love with visual communication and visual systems design.

Initially I was studying to be a book designer and the printed page was my first passion in life. At that time some of my influences were *Èmigre*, Paul Rand, Wolfgang Weingart, April Greiman, and Armin Hoffman. Now I've started to look at influences largely outside of the design community such as the robotics and artificial intelligence communities. Twentieth-century art has also been a strong influence on me.

While at university I became interested in the emerging multimedia industry. When I graduated I started working at Two Twelve Associates in New York creating financial planning software. There I became more interested in information design and the internet. After briefly returning to print at Design/Writing/Research, I went to i/o360° in 1997.

At the time it was still undetermined as to whether websites would be useful to businesses or not. It was a very open field and no one knew what would happen. The excitement triggered by the sense of the unknown attracted me to this area. Although I had studied to be a print designer, it was the idea of visual systems that had interested me. I saw the possibility of dynamic interactive information systems on the web as a way of pushing forward this interest.

When it comes to my work, my creative process involves thinking about general system design versus a specific design, and thinking about how the different types of information flowing into a system will change the form.

In January 1999, after eight years of using the computer as a tool, I began to think more about it as a medium. In an effort to imagine new forms and interactions I felt I needed to develop a deeper understanding of the medium of computation and began programming as a method of working with the material more directly. Through writing programs, I was able to think about form as a dynamic system. The first experiments I created were curious cousins of my previous work, but over time they gradually evolved into a new aesthetic.

I joined the Aesthetics & Computation Group at the MIT Media Lab in 1999 as a research assistant to investigate and design exploratory software. I wrote programs, and explored the potential of the medium, and I hope this work will expand the realm of

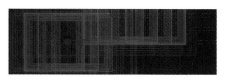

Dakadaka
Typing can be thought of as a percussive spatial action, a play of tiny thoughts scattered onto a tightly organised grid – a kind of speech that is spoken through the fingers with flashing rhythms and continuous gestures. Dakadaka is an interactive java applet that explores the process of typing by combining positional typographic systems with an abstract dynamic display. Dakadaka was built in collaboration with Golan Levin

what is possible to create as a designer and generate new ways for design to progress.

My work shifted from experiments in interface and information design to work in computational kinetic sculpture. The common thread in this work was the study of dynamic reactive systems that receive and process input as a means of generating and altering visual compositions. The systems I built were computer programs written in C and Java that ran on both high-end computers and microprocessors. I began creating purely digital screen-based compositions using a mouse and keyboard as input and over time I began creating physical sculptures, which use sensors such as cameras, microphones, and sonar to receive data from the environment.

I left MIT in summer 2001 to take a teaching position at the Interaction Design Institute Ivrea in Italy. I'm interested in teaching a design program that takes traditional design skills and applies them to a different way of thinking, basically a program for educating hybrid designer/engineers. I hope the infusion of concepts from a larger context will encourage students to challenge conventions. There is a huge community of designers who are looking to program and therefore design in a different way. I don't think there's an education system set up for that now.

Too often schools concentrate on just teaching the tools and not teaching the concepts behind them. In general I think courses are too vocational and superficial – often stuck in the mid-90s concept of multimedia. The lack of emphasis on concept, looking at why and how people interact with designed objects, systems and environments is damaging to innovation. I am currently working on an educational environment for programming interaction with Ben Fry, a former colleague at MIT. This is the next generation of the concept introduced by John Maeda's 'Design By Numbers' system.

I think there's enormous potential for design to have a powerful effect on the future of our culture, but I don't often feel that potential is recognised. I think that, in general, visual design isn't a very strong discipline and is perceived as a support structure, which realises other people's ideas. By developing more theory and by designers becoming more outspoken and engaged with major issues in our culture, I think it will begin to be a stronger discipline and begin to have more effect."

Cells
Cells of colour navigate through an abstract architecture to create an active ecology. As the user-defined architecture changes, the autonomous geometries redirect their movements and therefore the entire composition

Egg Machine
**Egg Machine is an interactive audiovisual
system. Intentional operation requires
decoding the visual grammar of the system
and manipulating the relationships between
visual elements**

Plane Modulator
Plane Modulator is a dynamic system for analysing and experiencing the relationships between time and space. Manipulating the location, phase, and transparency of multiple instances of the same moving object creates new kinematic forms

Above **Reactive006**
Reactive006 is a collection of 32 studies exploring basic properties of the medium of computation. Each study expresses a single idea. The themes addressed include movement, visual relationship, interaction, recursion, modulation, iteration, and space

Left **Reactive Boxes**
As a precursor to developing larger computational sculptures, Reas devised a series of three studies to explore various ways of interacting with sculptural systems and to explore different types of sensors and motors. The first study is physically reactive and touching one of two sensors mounted on its surface triggers its motion. The second study has a remote interaction via a screen-based interface. Sending a stimulus triggers a solenoid and the temporal difference between stimuli is calculated to modulate the speed of a DC motor, which turns a series of wires. The third study has an ambient reaction and uses the sound and light levels in the room to generate motion

"I went to the Tyler School of Art to study painting but I wasn't good at it. So I majored in illustration and moved to New York to become an illustrator, but I wasn't very good at that either.

I went to work at CBS Records, where I eventually became art director for the East Coast from 1975 to 1982. I produced 150 covers a year in that position. In the 70s most were image-driven. My best became unusual in their day because they were type-driven. I designed a series of covers for about 30 individual jazz artists called *The Best of Jazz*. The covers were printed on paper bag stock and had bold wood typography printed on angles. The work received a lot of attention. First it was called New Wave. Then it was called postmodern.

In 1984 I co-founded Koppel & Scher with my partner and friend Terry Koppel – a publication designer. We received immediate recognition for a self-promotional piece called 'Great

Beginnings' that utilised period-oriented typography. We also designed the identity for Manhattan Records, styled after Piet Mondrian's painting 'Broadway Boogie Woogie'. We were soon criticised by some of the design press for our rampant 'historicism'. The greatest offence was a parody advertising campaign we did for Swatch Watch that imitated Herbert Matter's Swiss Air posters.

The recession in 1990 ended Koppel & Scher. In 1991 I was invited to join Pentagram. This has been terrific because it has allowed me to operate within a structure that has a collective power base and support system. So, I have been able to work on much larger projects than I was capable of doing in my small business. Because of the intelligence and interests of my partners I've been able to expand the disciplines in which I work. My favourite projects of the past ten years have been designing the identities of the Public Theater and Ballet Tech.

Lately many of my projects are environmental in nature.

My advice to young designers is to push the limits and not to worry about money. Don't follow trends because they will leave you behind. And never be afraid to expand the type of projects you work on. It broadens you.

Stefan Sagmeister approaches his work in a way that comes totally from his own head. He is informed and influenced by what goes on around him, but he applies it in a unique manner that is only suited to the particular project at hand. He can be simple and elegant, obsessive and over-the-top, funny, challenging or provocative. But he is never boring. I believe that all designers have an obligation to be interesting."

Paula Scher
partner
Pentagram

Above **Environmental Graphics for The Lucent Technologies Center for Arts Education, New Jersey Performing Arts Center (NJPAC), Newark, NJ, 2001**

Right **Bring in Da Noise, Bring in Da Funk Poster for the Broadway production by The Public Theater, New York, NY, 1996**

Stefan Sagmeister
designer
Sagmeister
Inc

"I was born in the resort town of Bregenz in Austria and had no real knowledge of design until I was 16 and started writing for a student magazine. I soon discovered that I liked doing the layouts much more than writing.

The magazine also organised quite a number of concerts and I designed the posters; by that time I knew I wanted to study graphic design. I went to a private design school for 12 months after applying unsuccessfully to the University of Applied Arts in Vienna, but I was accepted by the University the following year.

My sister went out with a German rock musician and as part of his wooing ritual he got me to design an album cover. He was also an actor and introduced me to a theatre – the Schauspielhaus – and this turned into a very fruitful relationship. So while a student I worked with the design group Gruppe Gut on the theatre's posters. At the time the Schauspielhaus was the most important modern theatre in Vienna and the posters were all over the city.

Consequently, when I finished school there was practically no school work in my portfolio, just the posters. I never had to say that I had recently graduated because people thought I had been working for years. At the time my main influences were German poster designers like Gunter Rambov and the English design group Hypnosis.

After graduation I won a scholarship to Pratt Institute in New York. The scholarship was excellent, not only did they pay for my schooling, but also for housing and flights, so I had two freebie years in New York. I did freelance outside of school, but not from a financial aspect, I just wanted to learn more.

I extended the time in New York for as long as I could, three and a half years, and then I had to return to Austria to do my civil service. I really missed design but worked at night.

Then I went to live with a friend in Hong Kong and started to look for work. I went from being a civil servant in the suburbs of Vienna to being a creative director at Leo Burnett Hong Kong within a week.

Two weeks into my job in 1990, Leo Burnett asked me to open an annexed design studio, which turned out to be very much my own gig. But after two years I decided to leave Hong Kong as the culture was so money orientated. It became clear that I had to get out because it was affecting my personality. I was turning into a super yuppie.

The design company was too big for me. I went into the studio at 6am to design because by 9am I was too busy doing managerial stuff until 7pm. I didn't want to spend 90 per cent of my time doing admin.

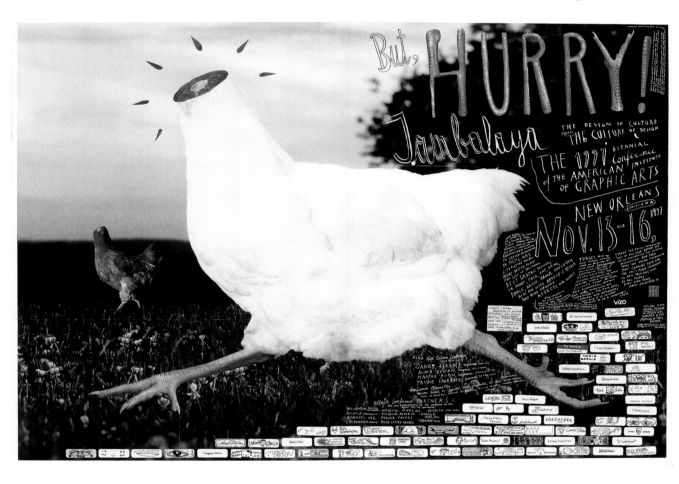

AIGA New Orleans, Jambalaya Alaya Poster
As it reads in tiny squiggly type on the top corner of this poster for the National conference of the American Institute of Graphic Arts: 'Why a headless chicken? Is it a metaphor for the profession? Should we stop running around like one and sign up for this very interesting conference? Is it a Voodoo symbol? Anti-technology? Will a mixture of telephone scribbles and turn of the century Art Brut really be the hot new style replacing wood veneer, itsy-bitsy type in boxes and round corners? Wasn't New Simplicity supposed to come first? Euro-Techno?'

I opened up a little place up in New York in October 1993. Aside from me there is one designer and one intern. We started with the idea of working mainly for the music industry, but this took longer than we'd hoped. In the beginning we had to take on some non-music clients, but our main clients would become Warner Brothers, HBO, Capital Music, Sony and TOTO.

I have no plans for growth and I made a couple of deliberate moves that would not allow me to get bigger, such as buying a space that was beautiful but small. Since 1993, apart from last year, the economy has been booming here in New York. There were many possibilities to grow into a much bigger place.

Due to the Hong Kong experience, I am determined to be the manager of all aspects of the company. I know that growth would not allow me to give my all. While I may be able to delegate management responsibilities, I have to

be totally involved and responsible for the client contact.

In most cases clients have tons of choices of whom they go to and our clients choose us on account of the portfolio. In presentations we usually offer only one direction.

Theory doesn't affect my work significantly, as I'm not in the habit of reading French de-constructuralists. I read and go to galleries quite a bit. I'm completely in love with contemporary art. Contrary to practically everyone I know, my favourite period of modern art is 1995 – 2001.

I used to be purely ideas-orientated but discovered quickly that there are problems with idea-based design. One of the dangers is that you just deliver one-liners and the work doesn't stand up to repeat viewing. One-liners are OK for a single poster but not so effective if it's a book or a CD cover that people keep.

I teach at the School of Visual Arts and Parson. I prefer teaching mature students because then it's much more of a discussion rather than me preaching which can become quite boring for myself. I specifically like graduate programmes as it offers a forum to discuss things from the ground up and, once in a while, it makes issues clear for me as well.

As to future ambitions, I'd love to re-design the Coca-Cola can because it's so ugly at the moment. Two things I would never do are a corporate identity for George W and carve a poster in my chest again. That did hurt."

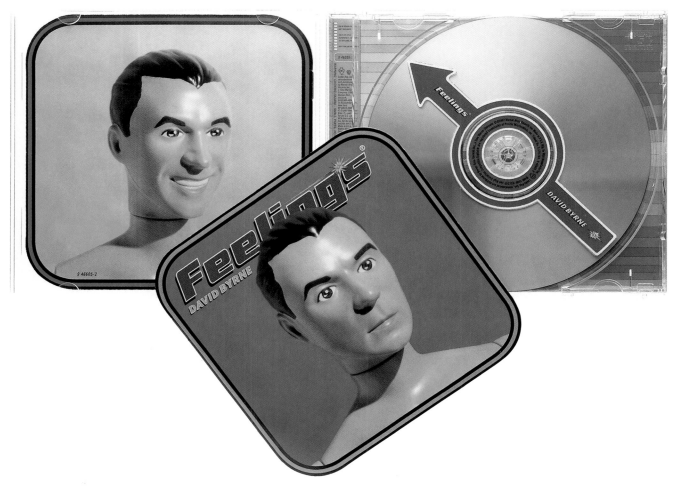

Left **David Byrne Feelings CD**
This round-cornered *Feelings* CD packaging features happy, angry, sad and content David Byrne dolls. The packaging includes a sophisticated, colour-coded 'David Byrne Mood Computer' (printed on and under the CD disc) that allows the listener to determine his or her current feelings. The type has been constructed as a model and then photographed

Below & opposite **Sagmeister: Made You Look**
The book features all the work that Sagmeister Inc. has ever designed. The paperback is encased in a red transparent slip case

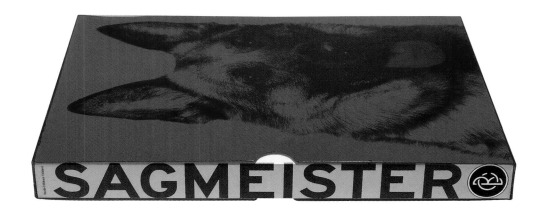

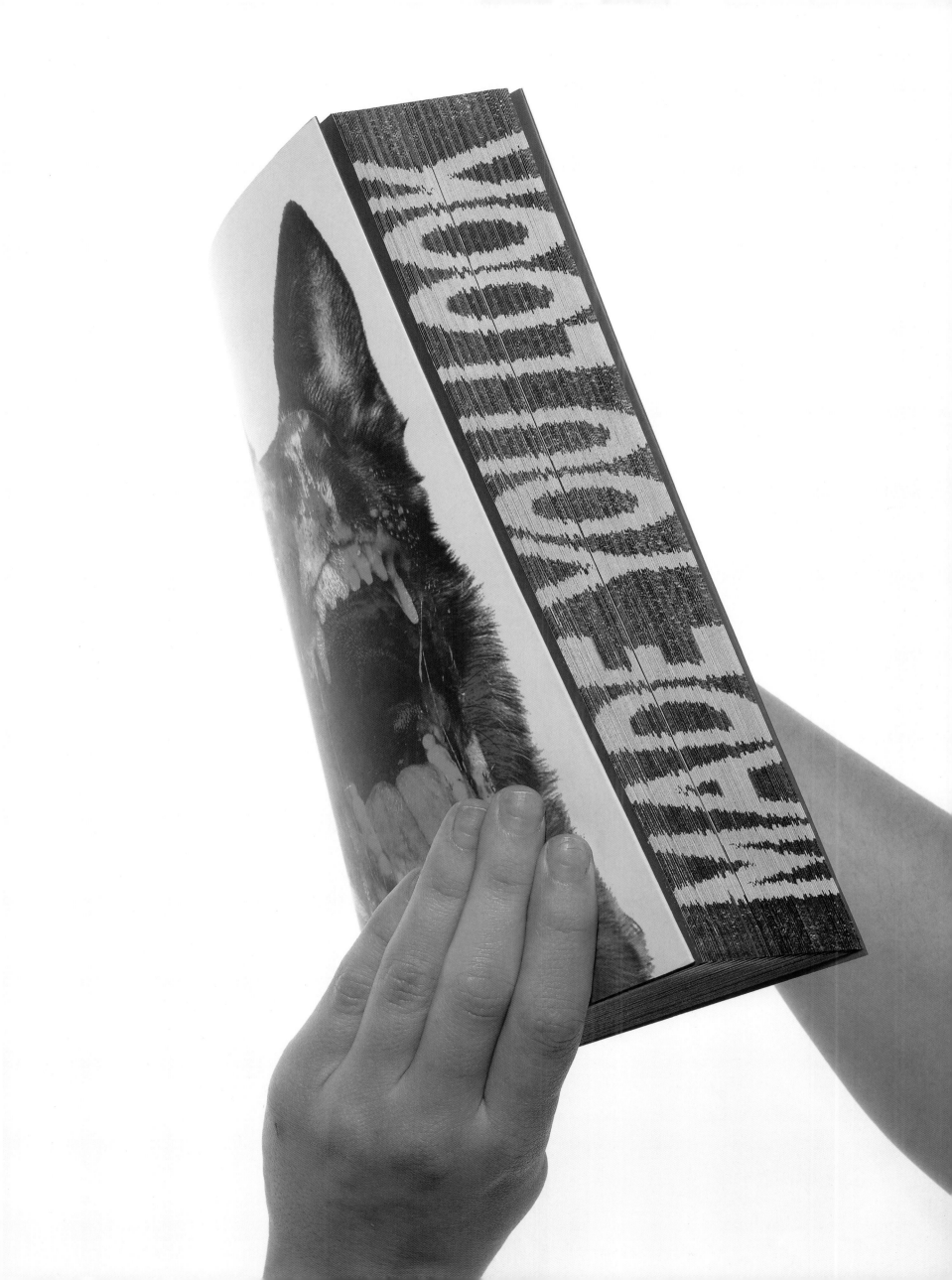

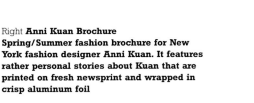

Right **Anni Kuan Brochure**
Spring/Summer fashion brochure for New
York fashion designer Anni Kuan. It features
rather personal stories about Kuan that are
printed on fresh newsprint and wrapped in
crisp aluminum foil

Below **Pat Metheny Group Imaginary Day CD**
All type on the *Imaginary Day* cover has been
replaced by code. The images connect to the
songs and mood of the album, and can be
decoded by using the diagram printed on the
actual CD

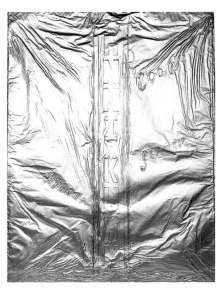

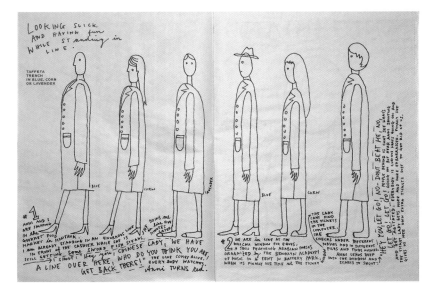

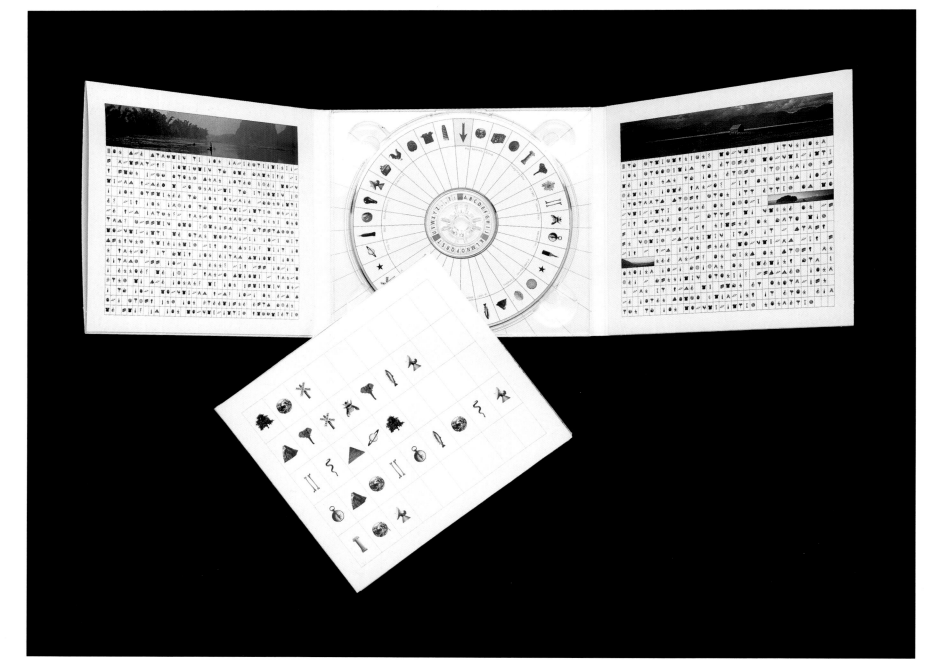

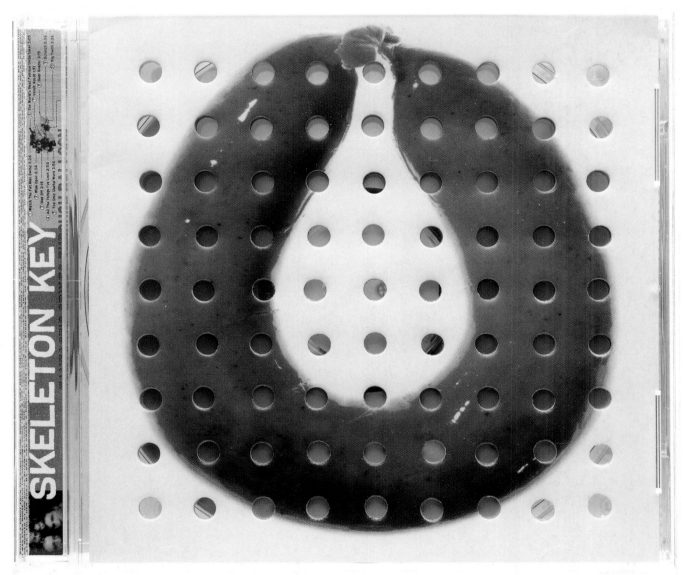

Above & left **Skeleton Key Fantastic Spikes Through Balloon CD**
True to the album title *Fantastic Spikes Through Balloon*, Sagmeister Inc. photographed all the balloon-like objects they could think of – sausage, fart cushion and blowfish – and punched a lot of holes through them. As the band did not want its audience to read the lyrics while listening to the music, the words to the songs are printed flipped so they are only readable when seen reflected in the mirror of the CD

"I enjoyed drawing as a child and my mother encouraged me to take it seriously and enrol at the Faculty of Design at the Tokyo National University of Fine Arts. I chose design so that I could learn about various creative disciplines.

I am a very proud designer. I want the client to be happy with what I do and, if possible, create work that will become noted in the history of design. However, no matter how high the fee is, I refuse work in which I'm not allowed to show my personality and realise my dream as a designer.

I admire the humour of Raymond Savinyack, the creative philosophy of Paul Rand, the sense of play of Bruno Munari and the visual spice of M C Escher. The best visual communication is simple, but I tend to inject a visual trick into my work. I see visual communication as a living culture so I observe the world around me and rely on my own sensibilities.

My advice to young designers is to cultivate their individual ability and not to imitate. In these times I think it is more important than ever that students and young people overcome the established system. To design is to think; a computer creates nothing, it is only a tool.

My nominee is Koichi Sato."

Shigeo Fukuda
designer
Fukuda
Design
Studio

Exhibition Poster 1991
Fukuda c'est fou (France)

Koichi Sato

designer
Koichi
Sato
Design
Studio

"I graduated from Tokyo National University of Fine Arts and Music and worked for Shiseido, a major cosmetic company in Japan, for two years, opening my own studio in 1971. I worked alone without assistants for a while, and then hired one or two young designers to help me. At present I have only one assistant.

My aim as a designer is to revitalise traditional Japanese aesthetics so that these elements will sympathetically work with contemporary and future environments. Of course it makes me happy to receive high design fees – the higher the better – but I have never thought of my work as a business concern.

For a long time I've believed that the concept of graphic design is much like the concept of electricity. Both inhabit a world of images, gravity-free, non-material, super-objective, and are very 20th-century. So when I think of the future of graphic design I always imagine what our future relationship with electricity will be like.

Design is like a tiny flower on the roadside. If you look at it closely you realise it is well made, but it is there naturally and casually. When I was about ten years old my mother taught me that if you look intensely at your own shadow on the ground and then look at the sky, you are able to see your own silhouette floating in the blue. I was so amazed and excited when I learnt this. The powerful feelings of gravity-free, mysterious, weightlessness were a great inspiration to me. This wonderful memory suddenly came back to me last year. I'd forgotten about it for a long time.

As for style, perhaps people think I'm unique or different because I use airbrush, but as a general rule I don't really trust what other people say about my work. I don't think my standard of creativity is much different from other designers; I always try to appeal to everybody's heart. I am flattered when clients are happy and people love the work. I always consider my clients as friends. Friends trust me and I try hard to create the best I can for them. In fact my dream design project is always the next engagement.

I'm not very involved with the graphic design industry; I only know a handful of hard-working genuine graphic designers. Twentieth-century design is collapsing as a major system clash occurs, as the world itself collapses. A creative step is inevitable when we move into the next new era, the New World of design. But I'm not worried about our future because I know that many young designers around me are fighting and working hard to orient our collective creativity into the new century.

In order to build a new generation of good designers the current so-called

Anniversary Poster 1996
This poster was produced for the 70th
birthday of a flower arranging school

art education at school in Japan
urgently requires major reform.
The Eurocentric idea of fine arts is a
harmful one if we are to accommodate
art to every kid. We must begin by
making school kids confident in their
own inborn abilities."

Overleaf left **Poster 1997**
To celebrate the 100th anniversary
of Japanese emigration to Mexico

Overleaf right **Europalia Poster 1989**
Designed to publicise the event

Below **New Music Media Poster 1974**
To publicise a music concert

Below right **IdcN Poster 1996**
To promote the establishment
of a new design centre

Opposite **Soup Bubbles Flew to the**
Universe Poster 1989
To advertise a theatrical performance

シャボン玉とんだ
宇宙までとんだ

原作・作曲＝筒井広志 脚本・演出＝横山由和 出演＝土居裕子・佐藤伸行・他

designed by Koichi Sato
1989

音楽座 下北沢・本多劇場

6月1日困—11日日 お問い合わせ
音楽座0427-22-1189・ヒューマンデザイン0427-22-7331

日本人メキシコ移住100年
CENTENARIO DE LA INMIGRACIÓN JAPONESA EN MÉXICO, 1897-1997

EUROPALIA 1989 JAPAN

Printed by Dai Nippon Printing Co., Ltd. JAPAN.

"Malcolm Garrett and I went to the same school where we were encouraged to study graphic design by our young progressive art teacher, Peter Hancock. Pop Art and music were my biggest influences as a teenager – bands were at the epicentre of my cultural universe, particularly Roxy Music and Kraftwerk.

When Malcolm joined me at Manchester Polytechnic from Reading University in 1975 he brought his reading list, which included *Pioneers of Modern Typography* – a huge influence on both of us. We felt the need to move on from the 'visual pun' graphic culture of the 60s and early 70s – we proposed a form of design that would communicate through cultural reference, association and mood.

My first projects were posters for a club, The Factory, founded by Tony Wilson. We subsequently released a Factory record featuring Joy Division, Cabaret Voltaire and The Durutti Column. The release was a success and we were inundated with demo-tapes; I found myself a founding partner and creative director of a record company. In 1979 Factory released *Unknown Pleasures*, Joy Division's first album. Hailed as a seminal product it brought recognition to Factory Records and consequently myself.

I set up my own studio in 1983 working primarily with record companies. My first client outside of the music industry was Whitechapel Art Gallery director Nick Serota, for whom we designed a new gallery identity in 1985. Fashion clients followed, particularly Yohji Yamamoto for whom we produced campaigns and catalogues throughout the late 80s.

In 1990, on the brink of insolvency, I joined Pentagram as a partner and I finally learnt how a design 'business' is run. I found it difficult – particularly time management. Also, I was too young; a Pentagram partner needs the support of a client's chief executives and ten years ago that was too soon for me. Today, the decision-makers are of my own generation and I now have fans on the executive boards of corporations. At present I am consultant to Givenchy, Selfridges and CNN – whilst still working with New Order, Pulp and Suede.

I was impressed with Frauke's work, especially its significant understanding of material and context. She appreciates how the values and codes inherent in materials can be used to communicate effectively and with great economy. Her choice of 'found' resources – transposed from their original context and creatively repositioned – displays innovation with a remarkable and contemporary lightness of touch."

**Peter
Saville**
designer

American Pioneers Poster 1999
Designed by Paul Hetherington, Peter
Saville and Howard Wakefield

Frauke Stegmann
designer

"I went to school in Namibia and did my BA in Graphic Design at the Hochschule fuer Gestaltung in Mainz (Germany), after which, I completed my MA at the Royal College of Art in London. I spent a very long time studying which was absolutely wonderful because it is a space in which you can develop within your field. The experience at the Royal College of Art was very important for my work. It somehow brought everything together. I had the privilege of studying with a group of people who shared similar visions and ideals of what we wanted graphic design to be.

My big influence in terms of appreciating form is my mother. When we were on the road in Namibia, my mother would always tell us to look at the endless stretches of overwhelmingly unspoilt nature. I could never sleep on trips in the car because I was scared to miss out on the beautiful landscape. Subconsciously I am constantly in

a process of identifying and challenging conventional design.

I like finding a language within the field of graphic design that reflects my personal experience of what I want design to be. The bird is a recurring subject in my work. In my stationery a golden bird is embossed on pink paper: the bird is romance, yet I want it to function no more and no less than a letterhead.

In the case of the poster I designed for David Carson, the bird is a representation of both an objective and romantic nature. Nature can be viewed as objective – that's without feeling. It is only our projection of ourselves onto nature that makes us perceive that nature has feeling or is subjective. Mystery often lies in what is unknown or unfamiliar to us; the element of mystery can be linked to the nature of romance. I wanted to create something for the David Carson talk that would compliment the work

he does, away from urban graphics. I kept the objective description of the bird, emphasising that the bird comes from a rational nature, while the glitter (applied to the poster) represents the realm of romance.

The bird in the invitation poster for Eley Kishimoto is a seagull that is part of a pattern on a fabric in their collection. The seagull is photocopied with the invitation text on a small sheet of paper that is attached to the poster showing screen-printed shapes. The poster is a representation of a land and seascape.

I have a lot of screen prints of family photographs. A second theme in my work is the representation of such images through different mediums to create a type of 'fantasy' within memory. I want to get underneath the surface of these pictures, to try to make romantic recreations of my youth – I had the most fantastic childhood with my parents and sisters in Namibia. Part of this theme of working with

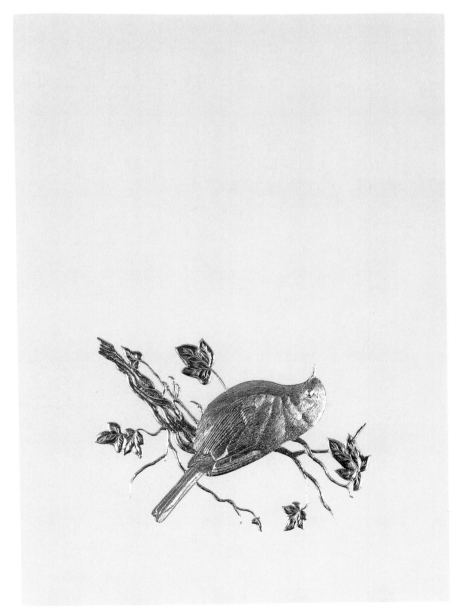

Left **Frauke Stegmann Letterhead/Stationery Gold blockfoil bird on pink paper**

Above **This is the place where Stegmann normally works. This image is a still life of Kajsa. Photograph by Sue Parkhill and Anders Kjaergaard**

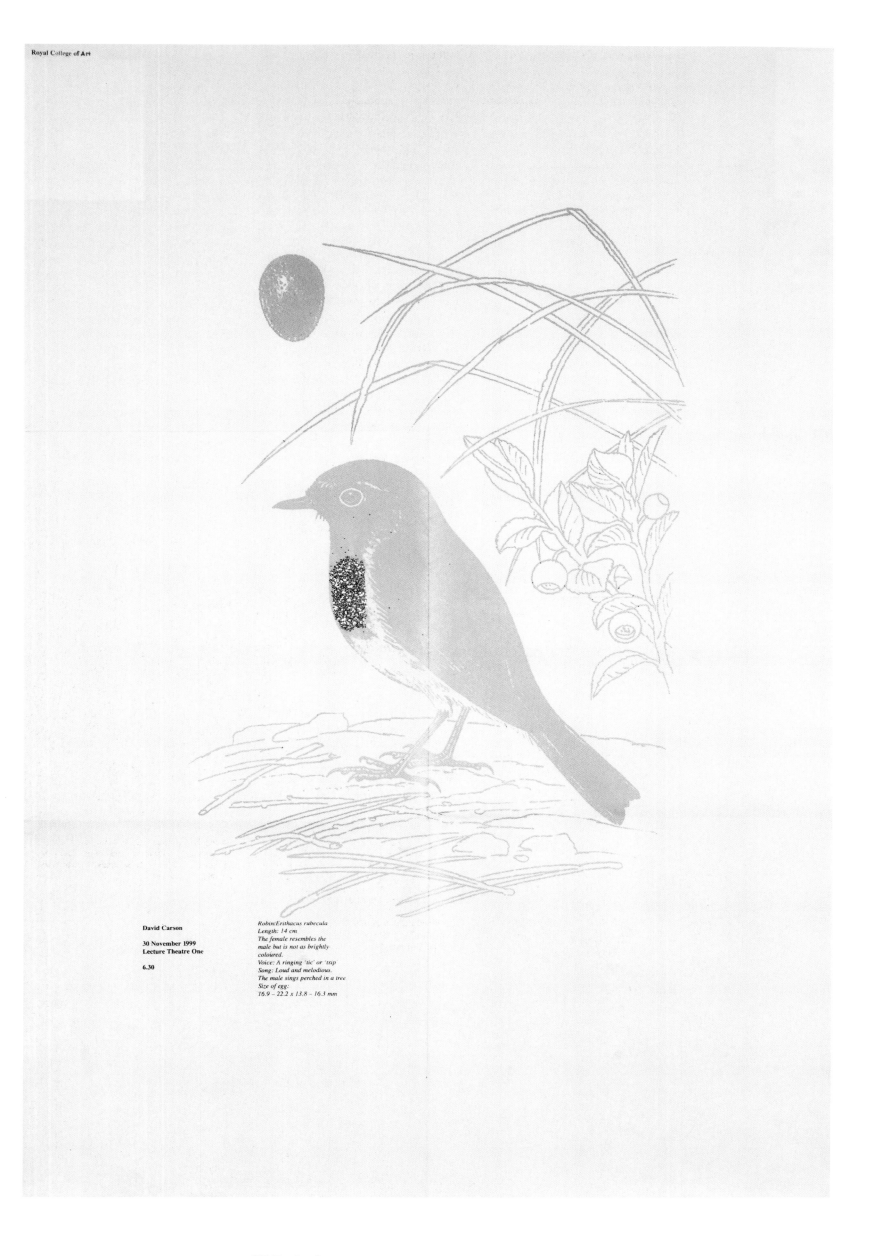

David Carson

30 November 1999
Lecture Theatre One

6.30

Robin/Erithacus rubecula
Length: 14 cm
The female resembles the
male but is not as brightly
coloured.
Voice: A ringing 'tic' or 'tsip
Song: Loud and melodious.
The male sings perched in a tree
Size of egg:
16.9 – 22.2 x 13.8 – 16.3 mm

images of my family are the woven photographs. The process of weaving the pictures (e.g. my father fishing and my mother with all my sisters), assisted in the idea of trying to get into the picture; to break the picture to create fantasy within memory.

Opposite **Glitter bird screen-printed poster for a talk by David Carson**

A development of this idea would be the use of selected aspects of these 'representations' of images of association to create new analogous scenes of fantasy.

I think that the fantasy aspect of my work is a reaction to conventional design, especially in relation to computer-dependent graphics.

My design is about working beyond the computer, using it merely as a tool to put the work together, to get it ready for print. It is important for me to explore many different techniques in order to reach the core of what I am trying to achieve. If one uses a hands-on approach like screen printing, letterpress, or making things that you photograph afterwards (really getting your hands in there), you can give your work a special kind of depth – a new type of landscape.

I would like to see more primitivism within graphics, to see graphic designers getting their hands dirty again in order to move towards creating a refreshing approach.

I once came across a very cool project in a church in a small town north of London. Someone in the community had thought it was a good idea to have cushions on the seats of the church benches. Everyone who attended the church was invited to find a favourite image, which would then be embroidered and made into a cushion – a beautifully honest and straightforward collaboration. I find the 'accidental beauty' that evolved from this idea inspiring."

Top left **Collaboration with fashion designer Peter Jensen. Denim cut-outs of 'Namibia meets Sweden' poster animals sewn onto a white sweatshirt. Original photograph taken in Peter Jensen/Abako studio, re-photographed by Anders Kjaergaard**

Left **Namibia meets Sweden Poster Designed by Kajsa Stahre and Frauke Stegmann**

Above **Red screenprint of a boy in cowboy suit onto an assemblage of sheets of release paper with stickers. Illustration by Nicolas Barba**

Below **Eley Kishimoto Invitation**
Screenprint onto newsprint. The text
invitation was photocopied onto 80gsm
paper and glued onto newsprint

Opposite **Miu Miu Invitation**
Two brushed layers of acrylic paint onto
release paper with three-colour screenprint
onto brushed layers. Art direction by David
James, designed by David James and Frauke
Stegmann for David James Associates

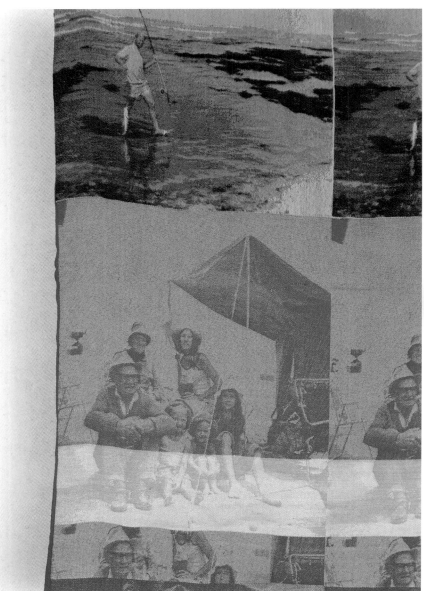

Above **Woven Pictures**
Jaquard-woven cushion of family photos.
Photographed by Anders Kjaergaard

Eley Kishimoto
Spring and Summer 2002 collection

cordially invite you to view their new work

Sunny

House of St. Barnabas-In-Soho
1 Greek Street, Soho Square
London, W1V 6NQ

Presentations by appointment only

Tuesday 18th 10.30am & 2.30pm
Wednesday 19th 10.30am & 2.30pm
Thursday 20th 10.30am & 2.30pm
Friday 21st 10.30am

Strictly R.S.V.P.
Limited numbers

Sales
Eley Kishimoto
Tel 0044 (0)208 674 7411
Fax 0044 (0)208 674 3516
E-Mail eleykish@dircon.co.uk

Press
Mandi Lennard Publicity Ltd
Tel 0044 (0)207 729 2770
Fax 0044 (0)207 729 2771
E-Mail access@ml-pr.com

Showroom/Sales appointments at
The House of St. Barnabas
Tel/Fax: 0044 (0)207 439 1567
15/09/01 – 21/09/01 9.00am – 8.00pm

Miu Miu invites

to the presentation of the
Spring/Summer 2001 Collection
Friday 6th October at 2pm Via Fogazzaro 36 Milan
RSVP 02 546701

Malcolm Garrett
executive design director AMX

"I was aware at an early age that I had a talent for drawing, and consequently was always asked to draw maps and illustrations to decorate the classroom walls, or to produce posters for school activities. Later I studied Typography and Graphic Communication at Reading University, but felt that the course was too academic for me at that time, so I transferred to Manchester Polytechnic and found a home on the more practical BA in Graphic Design.

At college, I drew much inspiration from Dada, Surrealism and other anti-artists and troublemakers of the early 20th century. In a desire to emulate such mentors, I saw potential for expression of 'art with a purpose' from within the nascent Punk explosion. I worked for the Buzzcocks while still at college and when I moved to London after graduating I went on to work for bands such as Duran Duran, Simple Minds and Culture Club, setting up a small studio called Assorted Images.

As Assorted Images grew, I began to experiment with emerging computer technologies and various digital media. By 1994, we devolved, leaving my partner Kasper de Graaf to maintain the print business, while I set up AMX to work primarily with interactive media.

The driving force at the beginning of my career was not really a concern for a particular graphic style, nor a specific way of doing things, but was everything to do with an attitude. The possibility of contributing to a revolution in a field that inspired me personally was paramount. I had the same feeling when we launched AMX. I wanted to champion design for interactive media, with a desire to contribute to a new revolution, but this time in an area which is much more significant than just another new haircut in the British music and entertainment industry. Throughout my career I have maintained many links with design education both in

the UK and abroad and am currently Visiting Professor at the RCA. It was in my capacity as External Examiner for the MSc Multimedia Systems course at Trinity College Dublin, that I was introduced to Niall Sweeney and his dynamic and influential work in that city.

I admire Niall for many reasons. He is a fantastic designer, with an incredible visual sensibility, which is both fresh and inspired yet exudes maturity. He brings a multi-disciplinary approach to his work in both print and interactive media, and his passions cross many boundaries from theatre, to fine art, to music and clubbing. He's what you might call a re-Renaissance man."

SPORT90 Exhibition
Completed early in 1990 this exhibition project for London's Design Museum was one of the first Garrett designed using only desktop computers. All layouts and illustrations for the catalogue, poster, leaflets, gallery information and signage, were produced without the need for 'conventional' artwork.

Perhaps most importantly Garrett was introduced to Apple's HyperCard software which, in partnership with Brighton-based new media company Cognitive Applications, Garrett used to build an interactive guide to the exhibition. This experience proved to be a defining moment for him as he was soon to devote his entire career to design for interactive media

Niall Sweeney
designer
Pony

"Engineering looked as though it might be a career path at one stage (possibly in homage to my grandfather). This quickly switched to film. But then I came across Dun Laoghaire College of Art in Dublin, which had both a hot film course and a hot graphics department. I reasoned that it would be better to do a graphics course, through which I could always fiddle with moving images. Graphic design appeared to offer ways of thinking and seeing that I could always apply to whatever I did in the future. At the time I saw film as being part of graphic design rather than the other way round.

Looking back it seemed like there could have only been a few hundred students in the entire college – which meant that swapping disciplines was the norm and positively encouraged – without any of the bureaucratic restrictions prevalent in larger schools. So I would find myself screen-printing with film-makers and ceramicists, or drawing type with photographers.

What I see now as the one thing missing is what I realise is my greatest influence – architecture.

After graduation I felt naked without screen-print and photo studios to hand, so in exchange for some teaching I stayed on at the college for a year to abuse the facilities. I had been freelancing through college, so it seemed natural to set up a small studio with some friends and carry on – we were a loose collection of designers, milliners, painters, photographers and a drag queen (my muse to this day). I think this model of constant collaboration is still my favourite and most fruitful method of working, and it comes as no surprise that the club scene has provided me the opportunity to create and produce – sometimes with teams of up to 50 people – some of my most enjoyed work.

The notion of working solely for someone else has never appealed to me, so though I have held a number of senior positions in creative organisations, my 'other' design work (including performance, video and club production) has always been an understood part of what makes me tick. It is the specific tensions and interplays between disciplines that I find so stimulating.

So working as creative director of the new media company X Communications in the early 1990s (where we designed for the London Underground, The National Gallery of Ireland and William Burroughs) sat perfectly and symbiotically with hauling all the machines and a team of people into some old print works to produce, perform and design a club event such as Elevator. Paradoxically I have always had a healthy cynicism for digital media, especially as I was in there at the start of the current band-wagon (or perhaps because of that). For me it's all about the content really, and how

D1 Recordings Packaging
D1 Recordings is an independent music label, based in Dublin. Born of a very Dublin take on the Detroit techno sound, this label remains focused and selective in its output, and is therefore a success. Sweeney had a fairly open brief, but the visual language is consistent, unique and evolutionary. The image of the houses sinking in the grass was the start of a long series of house images that spilt over into other work

the context of any given medium projects that to its audience. There must be honesty in design, or else it becomes marketing.

I have this habit of purging the way I work and my environment every few years, usually as a result of travelling (I quit X Communications after three years upon return from three weeks with my muse in Japan). But I feel like I take my studio with me wherever I go. The organisations I have worked for in the past are really just collaborators in my ongoing studio, which is where I happily reside today.

In 1997 I was flattered into a job as Artistic Director of a new media arts centre in Dublin. At the time it was an amazing proposition – one of the first purpose-built new media centres for artists in the world. I had just had a retrospective of ten years' work in Bordeaux, so the possibility of change appealed to me. The reality of an anti-artist and aggressively

paranoid management methodology combined with very-sick-building-syndrome made for a very frustrating year. So the lure of domesticity with two dogs, a piano player, and thoughts of doing an MA ten years after first graduating plucked me from the grips of Dublin and landed me in London.

At the end of 1999 I was holding a very healthy MA in Typographic Studies from the London College of Printing. I had realised that if I was going to go back to college it was not really to make more pretty pictures or to design a font (the last thing the world needs) – I had a need to write. I had ten years of flux that I had to get down on paper. My thesis, *Bastard Metropolis*, was a means of dealing with and challenging all of my preoccupations and interests to date, and to reset them so that I could start again. I was ambitious to nurture a greater control and understanding of language and the way it works across 20,000 words – which I pursued in a

sort of intuitive way and I suppose in a very Irish way.

You see, historically, Irish visual culture was banished; physically and systematically removed through a long and well-documented history of colonisations, invasions etc. Ireland always had a propensity towards language, but these events sealed its fate as one of the most proficient oral cultures in the world. And sure everyone likes – well, needs really – a good story. Like in Ray Bradbury's *Fahrenheit 451* – in Ireland people became the stories: people became the language. So graphic design is alien to Irish culture (whereas film is much a part of it). Only now are design and the visual arts emerging from doffing the cap to other countries. I still find it disorienting how many new bars and cafés in Dublin have acquired some bloody awful modern 'typographic' logo – marketing departments are working overtime, designers are working

under time. Actually, I still have a lot of ongoing projects in Ireland – I think it feeds my nomadic desire constantly moving workspaces over there and back here, crossing the sea.

The future? A favourite mix of ink, dancing about architecture, moving pictures and working with drag queens. I am happiest being buoyed along by very stormy weather."

Opposite & above **Makullas Retail Store, Dublin**
This was a maverick and extremely fruitful design collaboration with Frank Stanley

Above **Condensation 2000**
One of a series of perpetual video works

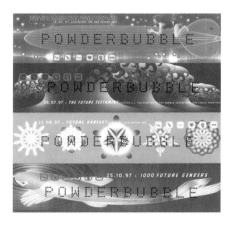

Left **Powderbubble Events**
A series of 14 performance-based club events from 1996–1998. A collaboration with Rory O'Neill and Trish Brennan. Pulling a capacity crowd of around 1500 participants, Powderbubble is now something of a legend in Ireland. It worked under the manifesto of a United Future Gender Agenda. Powderbubble won the Best Club Night in the Smirnoff Danceclub Awards in 1998

Below **H.A.M. Visuals**
H.A.M. was a weekly Friday club night in Dublin. Clubs provide a good forum for exploring narratives in work, whether through language or visuals or in combination. H.A.M. has been running for over four years, and therefore has provided a consistent platform through ads and flyers as well as installations and projections

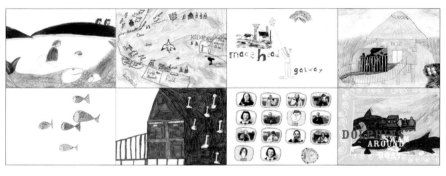

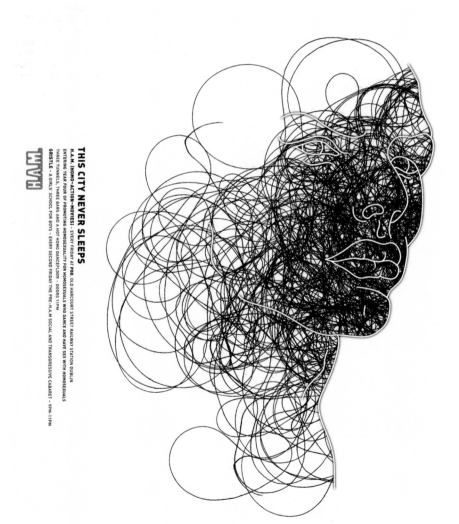

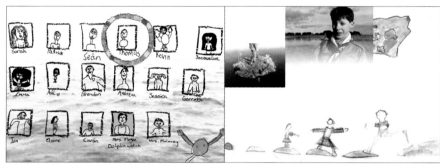

Above **Kids' Expo 2000**
Installed in the Irish pavilion at Expo 2000, this touch-screen interactive installation involves kids' work from all over Ireland and forms a kind of non-hierarchical diary cum sketchbook. It gathers together multimedia content generated by the kids themselves to re-express and re-present the kids' own responses and experiences of group adventures. Designed and built by Sweeney and Simon Spain. Produced by Simon Spain (Kid's Own Publishing)

Sonic Boom Exhibition catalogue 2000
Designed in collaboration with Joe Ewart for
Society, this catalogue for an exhibition of
sound works at the Hayward Gallery London
includes two CDs bound into the cover. The
cover itself opens completely flat, so that the
book within sits on its own small landscape

"I graduated from Elisava Art School in Barcelona in the 70s and after graduation got together with a group of people who were interested in underground comics and new ways of expression. As far as I am concerned people pay me for having fun and consequently I make funny things with lots of passion and intuition.

I opened Studio Mariscal in 1988, when the Barcelona Olympic Committee decided to choose my cartoon character Cobi as the official mascot. At first we were about graphic design, animation and illustration, but we quickly developed work in architecture and interior design. Now we also make public sculptures and gardens. Fortunately I've never had to look for work in my life.

My influences when I was younger were Pop Art, magazines like *Paris Match* and *Elle*, television, Matisse, Picasso, the Gitanes cigarette packet, Carnaby Street, LSD, Corbusier and the funny typography that Spanish bars have on their doors. I didn't know anything about graphic design, it wasn't until the 90s that I started to question the medium. I always feel as if I am a nobody when I am in a group of designers – like I have no pedigree. Maybe this is why I never win any prizes.

The most important thing for young people is to be curious and have ideas. It is because of this that I have chosen Tomato's Tom Roope. His work is really fantastic and innovative, but succeeds in touching reality."

Javier Mariscal
founder
Studio
Mariscal

Above **Nova Yardinia Identity**
Nova Yardinia is a tourist complex in southern Italy. It is a place that characterises leisure through its landscape and contact with nature. It occupies an area next to a natural park that has flora and fauna of great ecological value

Left **Calle 54 Poster**
'Calle 54' is a musical documentary. With graphics, Studio Mariscal wanted to communicate the vision that Fernando Trueba has of Latin Jazz.

The most interesting thing about this work is that within it jazz and cinema are combined, two topics that have traditionally had an excellent and productive relationship with graphic design. All the musicians have one thing in common, they are all virtuosos of their instruments and the connection to them is their hands... the hands, always disproportionate and exaggerated, characterise the illustration

Tomato
designer
Tom
Roope

"After leaving a degree in Psychology after just one term, I began assisting photographer Rankin Waddell on *Untitled Magazine*, the student union magazine produced for the London Institute.

Then I returned to education to take a degree in Film, Video and Photography at the University of Westminster, where I specialised in interactive media.

After leaving, I worked in a variety of roles including creative director and technical director. At the time the industry was very fragmented, so I really tried to work on anything interesting that came along. I deliberately avoided working at some of the larger companies such as Dorling Kindersley or Epic. My first job was working at a company called Trip Media. It was a small group of probably the best practitioners at the time, who had a few large commissions to create Cdi

projects for Phillips. Titles I worked on included Burn-Cycle and the Virtual Nightclub. After leaving Trip, I worked for First Call Interactive in Brighton.

After finishing in Brighton I began with a company called CHBi (later to be the London arm of Razorfish), a marketing-driven new media company, as creative director on a couple of projects. While working for CHBi, I was completing the production of Anti-Rom with several ex-university colleagues. The creative starting point for Anti-Rom, was seeing a CD-Rom called Blind-Rom, produced by a Dutch guy called Gerard VanDeKapp, which indicated that simple interactive experiments could be hugely engaging. With a small grant from the British Arts Council we produced Anti-Rom, a collection of these experimental pieces.

We were then approached by several commercial clients, which allowed us all to leave our jobs and

start a company, named after the CD-Rom. At the same time, I was developing a relationship with Tomato, working with them on projects that required interaction design. Anti-Rom was a collective of ten shareholders, and after four years our individual interests had begun to diversify. It was at the height of the dot com upturn, which excited some shareholders, while others wished to pursue more experimental, non-commercial activities.

By 1998 Anti-Rom decided to call it a day and three of us opted to start an interactive division under the Tomato umbrella. Tomato started ten years ago and although I have worked with them for seven years, it was just three years ago when we officially started Tomato Interactive. We now number five and our clients have included Sony, Levi Strauss, MTV, Ron Arad Associates, Toyota and Mitsubishi.

Anti-Rom
One of a multitude of interactive experiments

Clients have been extremely valuable creative partners. They are the lubricant for our creativity. We work hard to get into relationships based on trust and it is only in this kind of partnership that successful work can be easily produced.

Tomato's collective structure allows us to work in an extremely flexible way. It allows us to work together on large jobs as well as individuals on small productions. As all the creatives are freelancers, and get paid on a job-by-job basis, this gives us a healthy relationship to our labour. We often undertake work for free but that is the choice of the individual.

With regards to business, Tomato has a fantastic director called Steve Baker, who has created a space where the business is led by our creative aspirations, rather than vice versa. This structure allows the creatives to do what they do best – make stuff. I believe that our collective approach allows us to work in a different way to most designers. The flexibility has allowed us to produce great work with people outside of Tomato whom many would perceive as competitors.

My aspirations as a designer are pretty simple. I try to devise work that both touches and surprises people. The computer has proved to be a huge liberation for me creatively as I have always been very messy and have extremely bad handwriting. The technology liberates me from my clumsiness and allows me to express myself in a clearer way.

The computer is the catalyst, but it is now only one of a set of creative tools I use along with sensor technologies and more physical outputs such as motors and projection in water. Through using the computer I believe that I have developed a sense of what is a satisfying interactive experience, and I don't believe that this knowledge must only be applied to a digital environment. Nearly all my work draws on a multitude of media types but my main obsession is interactivity. Although interaction is not new, new technologies allow for a rigorous environment of development and debate, which take us somewhere we could not have arrived at before.

From the confidence I gained from my new tools I have been able to work in a varied number of fields such as interior design, window display design, branding, product interface design, film titles and TV idents, and I have worked with many, including Tom Hingston, Ron Arad and Mark Farrow, whom I find extremely inspiring. It is always a positive challenge to work with talented people, who invariably work in a different way than Tomato or myself. I get dismayed by designers who think that design is about surface rather than approaching it from the heart. Design can be learnt, but enthusiasm is innate. The likes of Neville Brody and Peter Saville have created an environment where design has become an important aspect of our culture. My personal view is that this process may have gone too far, and I believe we have to start addressing more fundamental structural issues such as what is the creative potential of these new technologies for communication. These issues are not aesthetic, but structural and cultural ones that have emerged over the last 30 years."

Tokyo Life for Selfridges
Top left **Inflatable characters controlled by street-based ultrasound sensors**
Above **Mechanical slats controlled by street based ultrasound sensors**

Above & top **Electro Luminescent Design and Haiku**

Levi Strauss ICD+
x-ray product browser
x-ray component browser
ICD+ European store locater

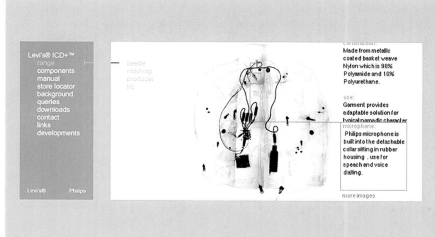

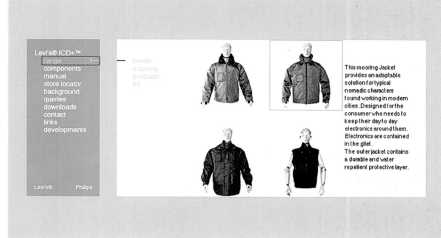

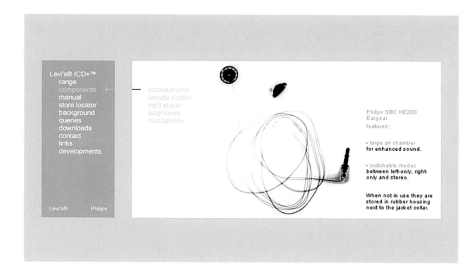

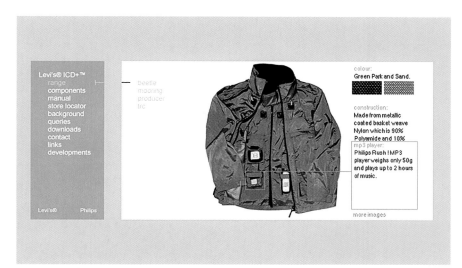

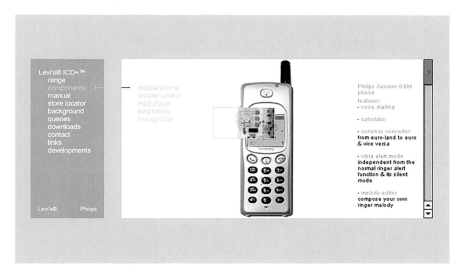

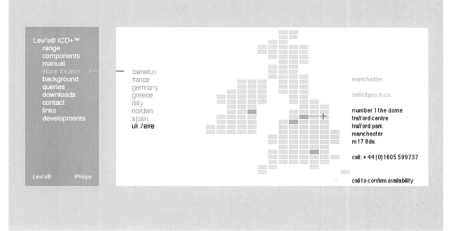

tomato three. london 020-7434-0955, new york 212-253-6055, sydney 02-9281 -6499, tokyo 03-5548-7075.

Above **Tomato 3**
Desktop application with all modules open

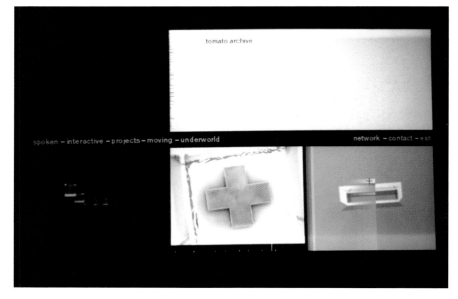

Above **Tomato 3**
Desktop application with a single module open

Below Laforet Cube
Light cube in situ at Tomato's Laforet
exhibition in Tokyo

Left & below **Laforet Ecoute CD**
Images from CD based on a piece made
with Ron Arad for his stand at the Milan
furniture show 2000

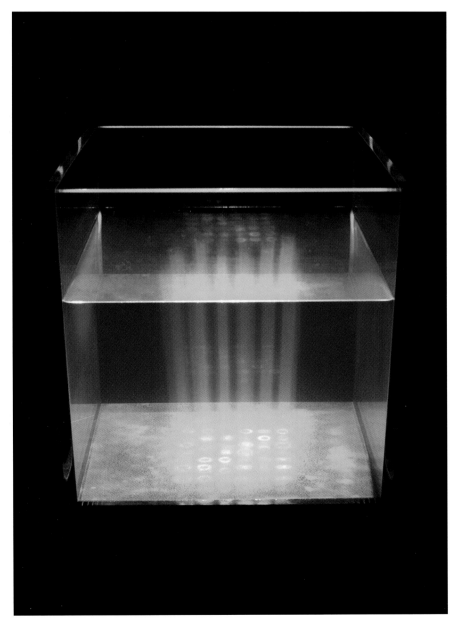

Jane Austin

Jane Austin has worked as a design and advertising journalist for 15 years. After gaining a degree in Cultural Studies, she began a career in publishing as a writer on *Creative Review*. She then went on to freelance for such titles as *Design Week, Marketing Week, Graphics International, Arena, Campaign, The Mail, The Independent, The Financial Times* and *The Guardian*. Austin was a section editor of *Campaign* and subsequently the editor of bi-monthly video magazine *shots*. She launched the advertising programme *Campaign Screen* and has contributed to a series of radio and TV programmes on advertising. She has also worked as an executive commercials producer. Austin is the co-founder of communications company Kushti Consulting. Kushti offers brand, identity, writing and communications strategies to clients. Austin continues to write for both trade journals and national newspapers on media-related subjects.

NB:Studio

NB:Studio is a consultancy
specialising in graphic design. It was
formed in March 1997, by former
Pentagram London designers Nick
Finney, Ben Stott and Alan Dye.

Rather than creativity being decorative
and driven by profit, NB: Studio
believe in solving problems for clients
through a balance of strong ideas, wit,
craftsmanship and professionalism.

NB:Studio is a consultancy
specialising in graphic design. It was
formed in March 1997, by former
Pentagram London designers Nick
Finney, Ben Stott and Alan Dye.

Rather than creativity being decorative
and driven by profit, NB: Studio
believe in solving problems for clients
through a balance of strong ideas, wit,
craftsmanship and professionalism.

D&AD

Founded in 1962, British Design & Art
Direction (D&AD) is a professional
association and charity representing
the UK's thriving design and
advertising communities. Our purpose
is to set creative standards, educate
and inspire the next creative
generation, and promote the
importance of good design and
advertising to the business arena.

For further information please visit our
website www.dandad.org or contact

D&AD
9 Graphite Square
Vauxhall Walk
London SE11 5EE
UK

Tel: +44 (0) 20 7840 1111
Fax: +44 (0) 20 7840 0840
E-mail: info@dandad.co.uk

The End